Another World Dalí, Magritte, Miró and the Surrealists

T0150627

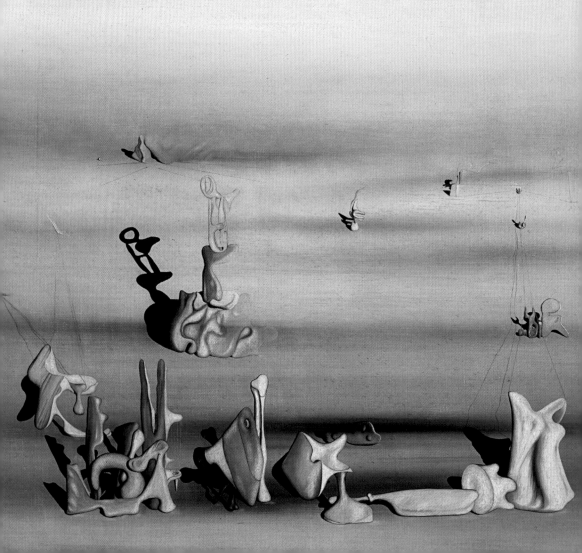

Patrick Elliott

ANOTHER WORLD

Dalí, Magritte, Miró and the Surrealists

National Galleries of Scotland
Edinburgh 2010

Published by the Trustees of the National Galleries
of Scotland to accompany the exhibition *Another
World: Dalí, Magritte, Miró and the Surrealists*,
held at the Dean Gallery, Edinburgh from 10 July
2010 to 9 January 2011.
Text © the Trustees of the National Galleries of
Scotland 2010

ISBN 978 1 906270 30 8

Designed and typeset in Sentinel by Dalrymple
Printed on Perigord 150gsm by Die Keure, Belgium

Cover: detail from René Magritte,
Threatening Weather, 1929, GMA 3887
Frontispiece: Yves Tanguy, *Never Again*, 1939,
GMA 4085
Back cover: Joan Miró, *Maternity*, 1924, GMA 3589

All works illustrated are in the collection of the
Scottish National Gallery of Modern Art unless
stated otherwise. Measurements are in centimetres.

National Galleries of Scotland is a charity
registered in Scotland (no.SC003728).

The proceeds from the sale of this book go towards
supporting the National Galleries of Scotland.

www.nationalgalleries.org

Foreword

It comes as a surprise to some of our visitors to find that the Scottish National Gallery of Modern Art owns a world-class collection of Surrealist art: it includes, for example, a dozen paintings and collages by Max Ernst, four paintings of the 1920s by Joan Miró, four by René Magritte and two great Surrealist sculptures by Alberto Giacometti. Our collection of rare illustrated books, catalogues, manuscripts and journals by Surrealist artists is one of the best in the world. This is all thanks to the acquisition of part of the Roland Penrose Collection and Archive, and to the Gabrielle Keiller bequest of 1995. This catalogue reveals the range of Surrealist works within the Gallery of Modern Art's collection, and gives a tantalising glimpse of the rich archival holdings.

The catalogue and exhibition cover a period from around the time of the First World War to the end of the Second World War, when other avant-garde movements emerged, many of them linked to abstraction. However, Surrealism did not die out; Desmond Morris, the only living artist included in the exhibition and catalogue, is still going strong in his eighties and Surrealism continues to have a profound influence on contemporary art.

The exhibition has been supplemented by about one hundred loans from public and private collections, some of which feature in this catalogue. For their help with loans we would like to thank Tate, especially Caroline Collier and Matthew Gale; at the Penrose Collection and Lee Miller Archives, Antony Penrose, Carole Callow, Lance Downie, Tracy Leeming and Kerry Negahban; James Mayor, and Niina Cunynghame, the Mayor Gallery, London; Andrew Murray; Dr Jeffrey Sherwin; Ernst Vegelin van Claerbergen and Barnaby Wright, The Courtauld Gallery, London; Mungo Campbell, Pamela Robertson, and Peter Black at the Hunterian Art Gallery, University of Glasgow; Kate Brindley, Middlesbrough Institute of Modern Art; Tim Craven at Southampton Art Gallery; Paul Green and Alexandra Francis, Halcyon Gallery, London; Robert Hall, Huddersfield Art Gallery; Maria Balshaw, Whitworth Art Gallery, University of Manchester; Sebastian Mennell; and to the private collectors who prefer to remain anonymous. We are also grateful to Patrick Elliott,

Senior Curator at the Gallery of Modern Art, who has written this catalogue and organised the exhibition. The catalogue depends on research by many others, but in particular we must signal Elizabeth Cowling's catalogue of the Gabrielle Keiller bequest: *Surrealism and After: The Gabrielle Keiller Collection*, 1997. We would also like to thank Professor Cowling for reading and commenting on the text.

Many of the works included in this catalogue have been acquired by the Gallery of Modern Art with generous support from The Art Fund, the National Heritage Memorial Fund and its successor the Heritage Lottery Fund; others have been donated through the Acceptance in Lieu scheme, administered by MLA (Museums, Libraries, Archives). A number of items in the Gallery of Modern Art Archive have been supported by the Friends of the National Libraries and by the Patrons of the National Galleries of Scotland. Without the support of these funding bodies, the Gallery would scarcely have a Surrealist collection.

Within the National Galleries of Scotland, many staff, past and present, have assisted with the preparation of the exhibition and catalogue. In particular, we would like to thank Ann Simpson, Senior Curator at the Gallery of Modern Art Archive & Library, who wrote the catalogue entries on the archival works; and Lauren Rigby, Curator, who wrote the catalogue entries on pages 127, 135 and 142; Olivia Sheppard and Christine Thompson in the Publishing Department; Kirstie Meehan and Kerry Watson in the Gallery of Modern Art Archive & Library; Adeline Amar, Anne Galastro, Helen Shipley, Meghan Weeks and Jessica Mander in the Curatorial Department; Richard Calvocoressi; Douglas Hall; Lorraine Maule, Lesley Stevenson, Alexandra Gent, Graeme Gollan, Toby Gough, Graham Taylor and Jamie Mitchell in the Conservation Department; and Rosalyn Clancey, Alanna Davidson, Bill Duff and Chanté St Clair Inglis in the Registrars' Department. The catalogue is dedicated to our former colleague, Kate Senior.

John Leighton *Director-General, National Galleries of Scotland*

Simon Groom *Director of Modern and Contemporary Art*

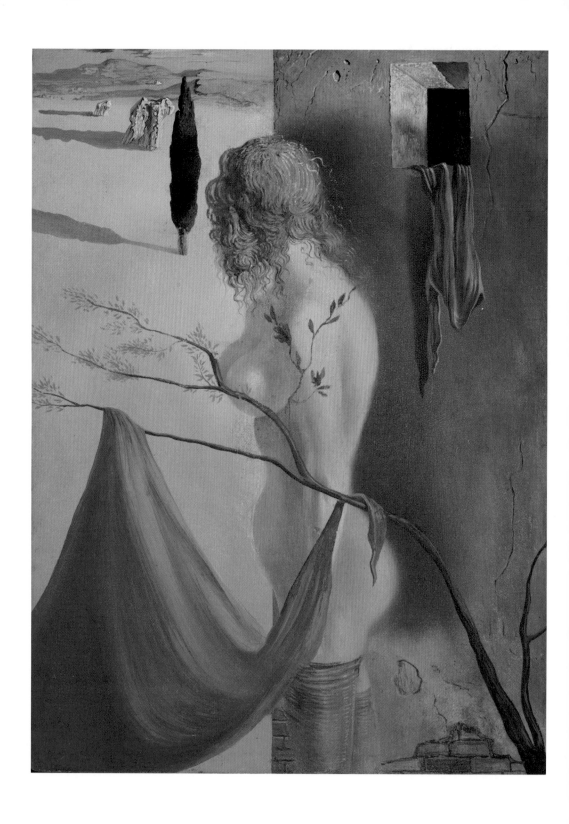

Salvador Dalí *The Signal of Anguish* c.1932 / 1936 GMA 3956

Surrealism An introduction

The germ of Surrealism lies in Dada. Dada sprang up in several cities almost simultaneously, during the First World War. Indeed it was the war that gave birth to it: Dada artists invariably discussed their passion for the irrational and the nonsensical in terms of a rejection of the bankrupt political, cultural and nationalistic values which, they argued, had created the war in the first place. The term 'Dada' first emerged in Zurich, in neutral Switzerland, where many artists and intellectuals had sought refuge from the fighting. The Dada group grew out of the Cabaret Voltaire, a club launched in February 1916 by Hugo Ball and Emmy Hennings, and whose core group included Jean Arp (also known as Hans Arp), Richard Huelsenbeck, Hans Richter and the Romanians Marcel Janco and Tristan Tzara. The name Dada was coined just a couple of months later. There is no consensus on who coined the term or why it was chosen, but it was appropriately childish and nonsensical. In June 1916 the first and only issue of the *Cabaret Voltaire* journal appeared, and in it the movement was labelled Dada. A Dada manifesto appeared the following month. Dada took the form of performances, music, theatre, poetry and art, although its anti-art stance meant that much of the art was ephemeral and has not survived. In its iconoclasm it owed something to Futurism, but its love of the absurd was something new. There were performances at the Cabaret Voltaire and – indicative of its growing popularity – a major event at the Waag Hall in Zurich on 14 July 1916, when, among other events, Tzara's play *La Première aventure céleste de M. Antipyrine* was staged. It was published in book form that summer, as one of three publications produced under the Collections Dada banner (see p.30). The following year Tzara launched his own *Dada* journal.

A copy of Tzara's *La Première aventure céleste de M. Antipyrine* found its way to Marcel Duchamp in New York, and he acknowledged that this was the first time he had heard of Dada. Duchamp had moved from Paris to New York in 1915, around the same time as his friend Francis Picabia. Both artists already had a significant standing in avant-garde circles, thanks largely to their representation in the New York Armory Show of 1913, where Duchamp's *Nude Descending a Staircase*, 1912 had caused outrage. By the time war was declared, Duchamp had more or less abandoned painting, taking up an ironic, questioning stance, which partly took the form of selecting pre-existing, manufactured objects, and treating them as things that could be exhibited and published, like art. Duchamp called these objects, which included a hat rack and a bottle rack, 'Readymades' – or 'Assisted Readymades' if he slightly altered them. The Zurich Dada artists were noisy, anarchic and theatrical in spirit; Duchamp by contrast was laconic and ironic and Picabia was utterly irreverent and nihilistic. They found fertile ground in the New York art world, already softened by the Armory Show. Philadelphia-born Man Ray became a close friend of Duchamp. Other artists, writers and collectors gathered around them, and they acquired a focal point at Alfred Stieglitz's 291 gallery and through the *291* journal, launched in 1915. As yet the movement had no name; it was only later that it became labelled 'New York Dada': that was the title Duchamp and Man Ray chose for the magazine they produced in 1921 (see p.37).

A third main Dada centre was Paris, although it developed a little later – partly because, unlike Zurich and New York, the war had fractured its cultural life. The poet Guillaume Apollinaire, who coined the term 'sur-realism' in 1917, had been in contact with Tristan Tzara, and might have become the focal point of a Paris Dada group had his death in 1918 not extinguished that hope. There was contact from Duchamp in New York and Stieglitz's *291* journal circulated, as did Picabia's spin-off *391* journal, but, with the war still raging, this was not sufficient to start a movement in Paris. The beginnings of Paris Dada are usually associated with the launch in March 1919 of the journal *Littérature*, which was edited by André Breton, Louis Aragon and Philippe Soupault. After a few issues it shifted to the Dada cause. Tzara, who had been in correspondence with Breton, moved to Paris in January 1920 and henceforth published his *Dada* journal there. That year also saw the publication of *Les Champs magnetiques* (*Magnetic Fields*) a book written by Breton

La *Révolution Surréaliste*, no.1, 1 December 1924
GMA A42/2/GKL0446

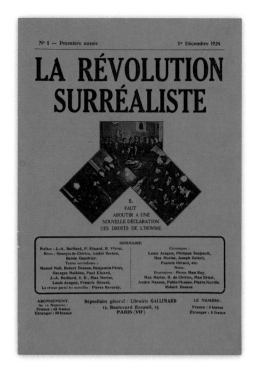

and Soupault which emphasised 'automatic' (in other words, unpremeditated) writing and Freudian psychoanalysis. It has often been called the first Surrealist book.

Other Dada centres emerged in Barcelona (thanks to Picabia's presence there from 1916 to 1918) and in Germany, notably in Berlin, where a Dada movement was launched early in 1918 by a group including Richard Huelsenbeck, George Grosz, John Heartfield and Hannah Höch. Whereas artists in New York and Zurich were distant from the fighting, and could thus afford to adopt a certain laconic reserve or absurdist humour, Berlin was at the very centre of a savage war, and this became manifest in the highly satirical and political nature of Berlin Dada. Dada groups also emerged in Cologne, around Max Ernst, and in Hannover, around Kurt Schwitters, although his faith in art (as opposed to anti-art) meant that he was shunned by the official Dada groups and ended up creating a solo movement he called Merz.

With the war over, and once passport issues were regularised allowing German nationals free movement, Paris became a melting pot for artists and writers who had spread around Europe and America during the war. Picabia moved there in 1919, Tzara and Arp in 1920 (Arp continued to return regularly to Germany), Man Ray and Duchamp in 1921 (Duchamp returned to New York the following year), and Ernst, who had shown his collages to great acclaim in Paris early in 1921, followed in November 1922. Inevitably for a movement that thrived upon discord and anarchy, Dada began to disintegrate and factionalise, and figures such as Breton, Picabia and Tzara were never likely to agree on policy or share control. It was during this period of infighting and implosion that Breton emerged as the ringleader, shifting Dada's focus away from its love of anarchy, negativity and nonsense, towards more intellectual pursuits involving automatic writing, dreams, psychoanalysis and chance. Breton had trained as a doctor and greatly admired the writings of Sigmund Freud, Jean-Martin Charcot and Pierre Janet, which dealt with issues of insanity and the unconscious; Breton even travelled to Vienna in 1921 to meet Freud, though the

encounter was not a success. Where Freud wanted to explain and account for dreams, and by doing so help his patients, Breton sought to retain their mystery. By 1922 Breton was using Apollinaire's term 'surrealist' and he was also masterminding sessions involving hypnosis, trance-like states, automatic writing and the exploration of dreams and the unconscious.

The main tenets of Surrealism thus existed in the early 1920s, and there were also a number of poets and writers (including Paul Eluard, Robert Desnos, Aragon and Soupault) and painters (most prominently Miró, André Masson and Ernst) who were interested in exploring these issues. However, the individual strands of this would-be group had nothing to bind them together and it was not until October 1924 that Breton galvanised the group by publishing his *Manifesto of Surrealism*. In it, Breton famously defined Surrealism as 'pure psychic automatism by which it is intended to express, either verbally or in writing, the true functioning of thought'. The slightly surprising thing about Breton's manifesto is that it scarcely mentions painting and is instead concerned – as Breton's definition indicates – with writing. He included just a brief footnote about Surrealist painting, in which he puts together an unlikely set of bedfellows, including Paolo

Uccello, Georges Braque, Pablo Picasso, Paul Klee, Duchamp, Picabia, Giorgio de Chirico and Masson.

Breton's manifesto was buttressed by a periodical, *La Révolution Surréaliste*, which first appeared in December 1924. Breton soon assumed editorial control and in issue four, in July 1925, published the first major text on Surrealist painting (one of the works he reproduced was Miró's *Maternity*: see pp.50–1). The first ever exhibition of Surrealist painting opened in November 1925 at the Galerie Pierre in Paris; one journal mistakenly billed it as an exhibition of 'Surdadaists', indicating that there was still some confusion over the distinction between the two movements. The exhibition included work by Arp, Ernst, De Chirico, Klee, Man Ray, Miró, Masson and Picasso – the latter was never properly affiliated to the group, but at the same time was the one artist Breton admired above all others and the one he wanted to court at all costs. A second exhibition of Surrealist painting followed in March 1926 at the Galerie Surréaliste.

For someone who had championed unpremeditated writing, and advocated working in a trance-like state, the kind of painting that appealed to Breton was also the automatic variety produced by Miró and Masson. This kind of painting was, in theory, the unfettered product of the unconscious mind, sidestepping old-fashioned aesthetic value judgements. However, in practice both artists mapped out their ideas in preliminary sketches and Masson acknowledged that it was much easier to make an automatic drawing than an automatic painting. Painting involved oil paints, brushes and canvas, and seemed inevitably to embrace delibera-tion, choice and time. However, important breakthroughs in technique expanded the repertoire of the Surrealist artist. Principal amongst these was collage – a technique which has a long history but was revived by Picasso and Braque in their Cubist papiers collés (see p.27). Ernst breathed new life into the technique in collages made in the early 1920s. Using engravings cut from melodra-matic 'pulp' novels, he cleverly swapped them around, inserting birds, wild animals and torrential rivers into bourgeois interiors. These collages eloquently mirrored a famous phrase coined by one of the heroes of the Surrealist movement, the nineteenth-century writer the Comte de Lautréamont: he had written of the 'Chance meeting on a dissecting table of a sewing machine and an umbrella', a sentence which bubbled with Surrealist pos-sibilities. Ernst likewise brought apparently unrelated things together in unexpected new ways. He began this approach in the collage novels *Répétitions* and *Les Malheurs des immortels*, both published in 1922, and per-fected it in the extraordinary *Une Semaine de bonté*, published in 1934 (see pp.80–1). Ernst's approach caught on among the Surrealist group and proved particularly popular among the poets and writers who had little artistic training. Breton, Eluard and E.L.T. Mesens all made collages of this type, creating enigmatic and incongruous images with some success. Another technique which developed from collage and soon became a standard part of the Surrealist repertoire was the 'Exquisite Corpse', in which three or four people drew or collaged a separate section of a human figure on the same sheet of paper, without seeing what the others had done, and by doing so created comical and monstrous new beings (see pp.86–7).

Ernst was responsible for popularising another technique, frottage, which involved placing a sheet of paper over a rough surface such as wood and rubbing with a crayon to transfer the grainy patterns (see p.56). A related technique, *grattage*, involved scraping paint on canvas placed over a rough surface (see pp.56–7). Other techniques which the Surrealists adopted were 'decalcomania', an old technique which involved transfer-ring sticky paint or ink from one surface to another, and was practised by Ernst, Georges Hugnet, Hans Bellmer and Oscar Domínguez; *fumage*, which was developed in the 1930s and involved blowing smoke across a paper (its principal exponents were Wolfgang Paalen and Conroy Maddox); and *coulage*, a technique which involved pouring paint and was used by Gordon Onslow Ford. New photographic techniques included Man Ray's Rayograms (also known as Photograms and Rayographs)

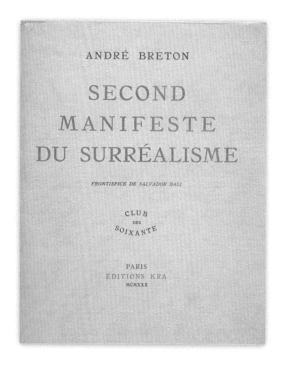

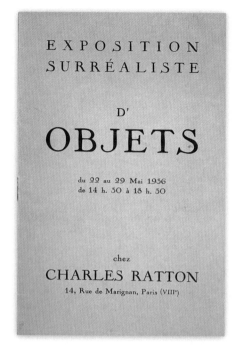

which were created in the darkroom, without a camera; solarised photographs, which Man Ray created in tandem with Lee Miller; and multiple exposure techniques invented by Raoul Ubac.

Surrealism was initially a Paris-based phenomenon. The movement nevertheless had international ambitions, fostered by its house journal *La Révolution Surréaliste* and, later, by foreign loans, exhibitions and lecture tours undertaken by Breton. Its principal outposts emerged in what were, perhaps, surprising locations: not New York, Berlin, Madrid or Moscow, but Brussels and to a lesser extent Prague. The Brussels Surrealist group was founded in 1926 by Belgium's answer to Breton, Paul Nougé, who was likewise a poet, theorist and communist. However, its trump card was René Magritte, who took the path opposite to the automatism proposed by Breton. Instead, taking his cue from De Chirico's haunting metaphysical paintings, he painted dream images with painstaking detail and deadpan realism. Magritte moved to a Paris suburb in 1927, and tried to integrate with the French

Surrealists, but the welcome was not warm and he returned to Brussels in 1930. In the second half of the 1930s Paul Delvaux also emerged as a force to be reckoned with in Brussels; he also took his cue from De Chirico. The kind of realistic dream painting practised by Magritte and Delvaux had its counterpart in Paris in the work of Yves Tanguy, another painter in thrall to De Chirico, and to a certain extent in Ernst's work: he managed, in works such as *Max Ernst Showing a Young Girl the Head of his Father* (see pp.60–1) to combine both approaches.

As the title of Breton's journal *La Révolution Surréaliste* implied, his ambitions were not limited to establishing an art movement; rather Surrealism was part of a full-scale revolution, and not just in the arts. Breton established links with the French communist party, although since personal freedom and individual expression were central to Surrealism, this was always going to be a difficult balancing act. Breton joined the French communist party in 1927 and remained a member until 1935. The Surrealists' involvement with Trotskyism and

their attitude towards Stalin was fraught and complicated, leading to expulsions, purges and quarrels within the group. Through his dictatorial control (he was known as the Pope of Surrealism) Breton was, however, broadly successful in keeping the group together; rival splinter groups were quickly snuffed out. However, one political front which Breton never really mastered, so to speak, concerned sexual politics. Although a number of women artists joined or orbited the Paris group in the 1930s (Jacqueline Lamba, Claude Cahun and Leonor Fini, for example), the Surrealist group of the 1920s looked upon woman as a muse or decorative accompaniment, and in the work of Masson and Giacometti, as an object of suffering – at times extreme and violent. And for one who championed individual freedom, Breton was also notoriously silent on the matter of homosexuality.

Breton's book *Le Surréalisme et la Peinture* appeared in 1928 and his *Second Manifesto of Surrealism*, in 1930. These important texts clarified the nature and ambitions of the Surrealist movement, but in terms of visual art itself, of equal importance at this time was the emergence of Salvador Dalí. The Spaniard scripted the film *Un Chien Andalou* (made in collaboration with Luis Buñuel), which caused a sensation on its release in Paris in June 1929; and in November that year he held his first exhibition in Paris, at the Galerie Goemans. Breton had misgivings about Dalí's political leanings and his bizarre obsessions, but he also recognised his extraordinary talent and charisma. Accordingly, he wrote the catalogue introduction for the Galerie Goemans exhibition, and invited Dalí to provide the frontispiece for the *Second Manifesto of Surrealism*. The sculptor Alberto Giacometti also became associated with the Surrealist group at around the same time. He produced objects that were, he said, exact replicas of things that had appeared to his mind's eye, without enquiring what they were or what they meant. They often carried enigmatic, sexual overtones. Breton saw one of these sculptures at the Galerie Pierre in Paris in 1930, bought it and promptly asked the young sculptor to join the Surrealist group. Surrealism did not come very naturally to sculptors, since the traditional sculptor's materials, bronze and marble, were not obviously suited to automatic methods or to representing transitory dreams. However, sculpture did feature large in the Surrealist repertoire in the 1930s, through the agency of the 'object' and the 'found object'. Such works had their origins in Duchamp's Readymades. Dalí, Miró, Picasso, Breton and Man Ray were among the many artists who produced object sculptures. Like collages, object sculptures challenged conventional fine art techniques and aesthetic codes, and just as importantly, they could be made by almost anyone. The principles of artistic talent and technical prowess were thrown wide open when a weird-looking stick or a strangely shaped stone seemed more interesting and more surreal, than a carefully crafted bronze. In 1933 there was an exhibition of object-sculptures at the Galerie Pierre Colle, followed by another larger show in 1936 at the Charles Ratton Gallery, both in Paris. At the *International Exhibition of Surrealism*, held at the Galerie des Beaux-Arts in Paris in January 1938, the entrance passageway was flanked by mannequins dressed up by artists including Ernst, Miró, Dalí and Masson (see pp.116–17).

Although Surrealism had become a potent force in many countries by the 1930s, in Britain interest was only just beginning to stir. In London, works by De Chirico featured in a show of Italian art at the Lefevre Gallery in 1925 and in October 1928 there was a solo exhibition of his work at Tooth's Gallery. The Mayor Gallery re-opened in Cork Street in April 1933 with a mixed show including work by Miró, Picabia, Arp and Ernst; in June and July the same gallery held shows of Ernst and Miró. There were two Dalí exhibitions at the Zwemmer Gallery in 1934, the bookshop-cum-gallery which also stocked French Surrealist books and periodicals. In the late 1920s and early 1930s, a small band of British artists, including Paul Nash, John Banting, Edward Wadsworth and John Armstrong, were responding to continental Surrealism, and a couple of English-language periodicals – specifically *transition* and *This Quarter* – made reference to Surrealism around the same time. However, this activity

did not constitute anything like a movement. The exception to this rule was Roland Penrose who had moved to Paris in 1922 to study art, and in 1926 developed a friendship with Ernst. Penrose exhibited widely in Paris at the time, holding a solo exhibition at the Galerie Van Leer in 1928. Around July 1935, Paul Eluard introduced Penrose to a precocious English teenager, David Gascoyne. Gascoyne had published the 'First Manifesto of English Surrealism' in the May 1935 issue of *Cahiers d'Art*, and was working in Paris on *A Short Survey of Surrealism*, which appeared in November 1935 with a cover by Ernst.

That same month, Penrose read what he regarded as an uninformed opinion of Surrealism in *The Listener*, and he wrote to the journal, stating: 'It would be very useful if a large retrospective exhibition of super-realist painting could be arranged in London to clear away some of the existing confusion as regards this movement and show that it is not so much a school as an attitude ... ' Even the name Surrealism did not yet have an accepted English translation and 'Super Realism' and 'Sur-Realism' were often used instead.

What Penrose's letter omitted to mention was that he was already planning such an exhibition, in collaboration with Gascoyne, Herbert Read, Hugh Sykes Davies and a posse of artists including Nash and Henry Moore. Helped by Breton, Eluard, and the Belgian art dealer and sometime artist E.L.T. Mesens, they quickly put together a formidable loan list. Their plans led to the great *International Surrealist Exhibition*, held at the New Burlington Galleries in London in June 1936 (see pp.136–7). When it opened, the exhibition provoked enormous controversy. Featuring about 400 works by artists from thirteen different countries, it included all the leading names in the Surrealist group. Over 1,000 people attended the opening and some 23,000 saw the exhibition during its twenty-three-day run. Breton attended the opening and gave a lecture; famously, a couple of weeks later, Dalí tried to deliver a talk wearing full diving gear, but nearly suffocated in the process.

If the continental Surrealists had rallied to a common cause and consciously formed a group, in Britain it was a different story. Instead, the artists selected for the exhibition

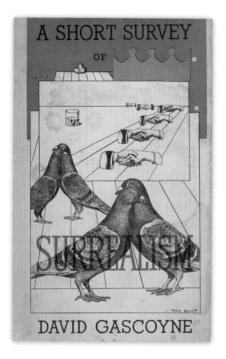

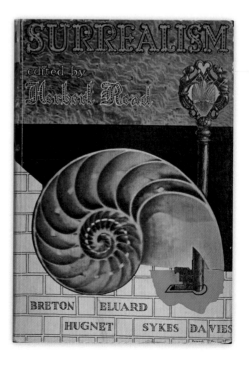

often discovered that they were Surrealists only when Penrose and Read came knocking at their doors, and informed them of the fact. Some of the artists who were chosen (Cecil Collins, Edward Burra and Julian Trevelyan, for example) later acknowledged that they did not have much in common with the Surrealists; others, notably Conroy Maddox, who was feverishly committed to Breton's hard-line Surrealist ideals, declined to participate because they felt the selection process was a bit woolly. However, in just about every other respect the exhibition was a triumph. A couple of months after the show had ended, Read's book *Surrealism* was published, with additional essays by Breton, Georges Hugnet and others. In Birmingham, a significant outpost of Surrealist activity was established, thanks to Maddox, John and Robert Melville, Emmy Bridgwater, Oscar Mellor and Desmond Morris.

In November 1937 the London Gallery (in Cork Street, close to the Mayor Gallery and a stone's throw from the New Burlington Galleries) staged an exhibition entitled *Surrealist Objects and Poems*, which echoed the exhibition *Surrealist Objects* shown at the Charles Ratton Gallery in Paris the previous year. Just a few months later, Penrose, who had come into some money, bought the London Gallery and installed Mesens as its manager. In the next couple of years, they staged exhibitions of Magritte, Delvaux, De Chirico, Ernst, Man Ray and others; a core part of their policy was to have Surrealism on show somewhere in the gallery at all times. Their house journal, the *London Bulletin*, became the mouthpiece of the British Surrealist movement and it still offers valuable source material for anyone researching the art of the period. Despite the ambitious programme, Mesens later noted that he never made a single sale to a museum in Britain.

The war dealt a serious, but not fatal blow to Surrealism in Britain. Meetings continued to be held at the Barcelona restaurant in Soho, where the likes of Mesens, Penrose, Ithell Colquhoun, Bridgwater, Edith Rimmington, Maddox, Grace Pailthorpe, Reuben Mednikoff and George Melly (the jazz musician, who worked at the London Gallery) would meet.

The last number of the *London Bulletin* appeared in June 1940. Mesens assumed the role of leader of the British Surrealist group, but took exception to Toni del Renzio, who assumed a rival position. The history of Surrealism in Britain during the war is partly a history of infighting rather than of the production of masterpieces. In France, too, the war led to the partial break up of the Surrealist group. Breton, Kurt Seligmann, Kay Sage, Tanguy, Ernst, Masson, Duchamp and Onslow Ford all moved to New York; Man Ray and Dalí settled in California. The end of Surrealism as a vital force is often linked with the exhibition *Le Surréalisme en 1947*, held at the Galerie Maeght in Paris that year. Conceived by its organisers, Breton and Duchamp, to mark the return of Surrealism to Paris following the war, it did that, but it also served to show that the younger generation, including artists such as Francis Bacon, Alan Davie, Eduardo Paolozzi and Richard Hamilton, was moving in a different direction. Likewise, in Britain the British Surrealist group fell apart in 1947 and the London Gallery closed in 1951. Surrealism continued to exist after the war in Europe, but largely in the hands of the artists who had pioneered it in the 1920s and 1930s. Ernst was partly resident in the south of France; Breton lived until 1966 and Magritte until 1967; Delvaux continued painting in Belgium until his death in 1994; Conroy Maddox remained a passionate proselytiser for Surrealism until his death in 2005; and Desmond Morris, the only artist represented in this catalogue who is still alive and painting, continues to be a passionate defender of Surrealism as a living, relevant force. As has often been said, Surrealism is not a style but a way of life.

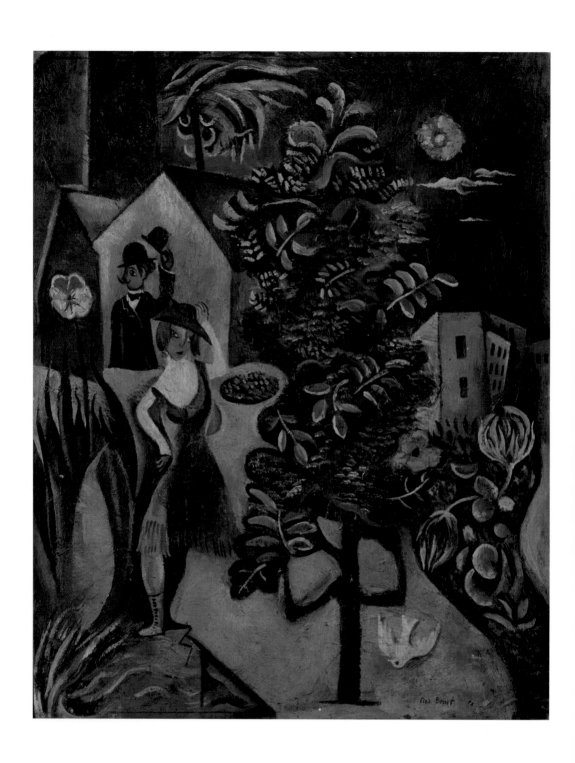

Max Ernst *Hat in Hand, Hat on Head* c.1919 GMA 4169

Surrealism at the Scottish National Gallery of Modern Art
A history of the collection

The Surrealist movement was launched in Paris in 1924 but it was not until 1936 that the British responded by creating their own Surrealist group and staging their own Surrealist exhibition. If it is true that British artists were reluctant to join the movement, it is also the case that British museums and galleries proved recalcitrant in joining in. The first broadly Surrealist painting to enter a public collection in Britain was probably De Chirico's triptych *The Philosopher* of 1928, which was given by Sir Michael Sadler, through the National Art Collections Fund (now The Art Fund), to the Whitworth Art Gallery in Manchester in 1931. It was not until 1941 that the Tate Gallery in London acquired its first example of continental Surrealism, Ernst's *The Entire City*, 1934; a painting by Masson was presented by the Contemporary Art Society in 1946 and a De Chirico work was bought in 1951. Tate's first work by Magritte was bought in 1964 and its first Dalí (a gift) was acquired in 1968.

The Scottish National Gallery of Modern Art opened in Edinburgh in 1960, as the 'modern' arm of the National Galleries of Scotland, which already constituted the National Gallery of Scotland and the Scottish National Portrait Gallery. Before the creation of the Gallery of Modern Art, very few works by living artists were acquired for the national collection, indeed there was an internal rule that an artist had to have been dead for ten years before their work could be considered for acquisition. From 1960 things changed slowly. The first painting by a Surrealist artist to enter the collection was an untypical late work by Masson, *River in Winter*, 1951, bought in 1967. More impressive was Giacometti's *Woman with her Throat Cut* (pp.78–9), which was purchased in 1970. Perhaps the most celebrated of all Surrealist sculptures, it comes from an edition of just five bronze casts, all of them now in major public collections. Magritte's *Black Flag* (p.97) was bought in 1972, Miró's *Painting* (p.54) in 1979 and Ernst's *Great Lover I* (pp.58–9), formerly in Breton's collection, in 1980. With one-off acquisitions such as these, mainly acquired through London dealers, the Gallery of Modern Art assembled a reasonably good collection of Surrealist art.

We now travel back to late Victorian London, to 1900 and the birth of Roland Penrose. Penrose's father was a noted painter while his mother came from the wealthy Peckover banking family. Penrose studied at the University of Cambridge and, through the economist John Maynard Keynes and the critic Roger Fry, was introduced to modern art. With Fry's encouragement, in the autumn of 1922 he moved to Paris, where he studied under the Cubist artist André Lhote. During his early years in Paris, Penrose worked in a Cubist style, and socialised mainly with English-speaking artists. Around this time he saw and was impressed by the work of De Chirico and began to show an interest in Surrealism. Searching for a new studio, in 1926 he met Ernst: a friendship soon blossomed and through Ernst Penrose met other members of the Surrealist group. Penrose was unique among British artists of the time in being embedded in the French Surrealist group.

Following a chance meeting with David Gascoyne, who was researching a book on Surrealism in Paris in 1935, Penrose determined that they must galvanise support in Britain and organise a major exhibition of Surrealism. Herbert Read and others were brought in to help, leading to the great *International Surrealist Exhibition*, held in London in 1936 (pp.136–7). In the months before the opening, Penrose travelled backwards and forwards between London and Paris, meeting artists, dealers and collectors. Almost by default, the opportunity to purchase works presented itself. Following the death of his mother in 1930 and his father in 1932, Penrose had come into his inheritance. His new-found wealth had already enabled him to help finance Ernst's great collage novel, *Une Semaine de bonté*, 1934 (pp.80–1), and it also meant that he was in the perfect position to buy the work of his friends – many of whom were experiencing financial hardship in the wake of the Wall Street Crash. His first major purchase was Ernst's jungle landscape, *The Joy of Life* (p.93), acquired in 1935 before it was even finished. He must have bought Giacometti's wood-carving, *Disagreeable*

Nouvelle évaluation de la collection
Chirico – Picasso – Miró
(ancienne coll. Gaffé)
au 1er mars 1940

Nº	Titre	Prix d'achat en 1937	Valeur actuelle
	CHIRICO		
1.	Nu (1912)	£ 112.10.0	£ 200
2.	Portrait de G. Apollinaire (1913)	£ 45.0.0	£ 90
3.	Intérieur métaphysique (1915-16)	£ 45.0.0	£ 90
4.	Mélancolie du Départ (1915)	£ 112.10.0	£ 200
5.	La révolte d'un sage (1916)	£ 112.10.0	£ 180
6.	L'Ange Juif (II) (1916)	£ 135.0.0	£ 250
	Total	£ 562.10.0	£ 1010
	MIRÓ		
1.	Nu (1921)	£ 135.0.0	£ 200
2.	Danseuse nègre (1921)	£ 45.0.0	£ 150
3.	Maternité (1924)	£ 135.0.0	£ 250
4.	Portrait de Mme B. (1924)	£ 90.0.0	£ 200
5.	Tête de paysan catalan (1925)	£ 67.10.0	£ 180
6.	Dessin (1926)	£ 9.0.0	£ 15
7.	Dessin (1926)	£ 9.0.0	£ 15
8.	L'Adultère (1928)	£ 67.10.0	£ 120
	Total	£ 558.0.0	£ 1130

First page of Roland Penrose's list of acquisitions made from René Gaffé in 1937; written 1 March 1940, with the purchase price listed on the left and the 1940 valuations on the right.
GMA A35/1/1/RPA180

Roland Penrose at his house at 21 Downshire Hill, Hampstead, in 1939. Behind him are works by André Breton, Max Ernst and René Magritte which now belong to the Scottish National Gallery of Modern Art.
GMA A35/1/3/RPA113

Object, to be Thrown Away (p.76), around the same time, since Penrose is listed as the owner in the catalogue of the *International Surrealist Exhibition*. He is also listed as owner of De Chirico's *The Torrent of the Poet*, which he bought from Paul Eluard. Penrose said that one of the motivating factors in buying art after his return to England in 1935 was that he missed his Paris friends and wanted at least to be surrounded by their work. He acquired a few more items after the exhibition, notably Picasso's papier collé, *Head*, 1913 (p.27) which he bought from André Breton early in 1937. By this date Penrose owned a small but choice group of Surrealist works.

In July 1937 Penrose transformed his collection, when he acquired a group of works belonging to the Belgian collector and businessman René Gaffé, who had lent generously to the 1936 exhibition. Gaffé had recently offered forty pictures by Picasso, Miró and De Chirico, for sale at the Zwemmer Gallery in London (his doctor had told him that he was terminally ill, so Gaffé sought to provide some funds for his wife; the diagnosis proved

incorrect). The works attracted little interest, so Penrose, prompted by his dealer friend E.L.T. Mesens, offered to buy the lot. During the run of the show, six of the paintings sold to other buyers, leaving Penrose with thirty-four major works: these he bought for £6,750, less the price of the works which had already sold. Three years later Penrose wrote out an insurance list, giving details of the purchase prices. Two masterpieces by Miró, *Maternity* and *Head of a Catalan Peasant*, were included in the sale (see pp.50–3).

But Penrose's greatest coup as a collector came in August 1938 when he bought more than 100 Surrealist and Cubist works from his friend Paul Eluard – who in turn had acquired many of them directly from the artists. The collection included no less than forty works by Ernst, five paintings by De Chirico, seven paintings and a sculpture by Miró, four works by Magritte, three by Dalí, and ten works, mainly drawings and watercolours, by Picasso, as well as individual works by Tanguy, Klee, Marc Chagall, Giacometti, Man Ray and others. The total price was

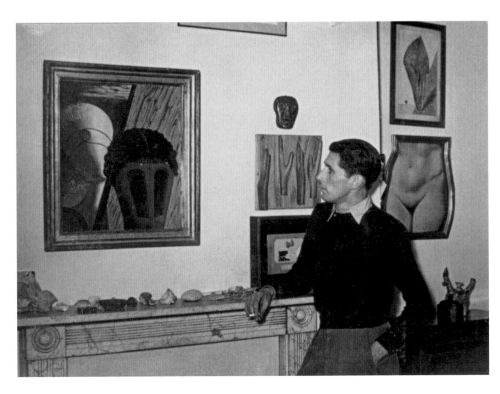

Collection Paul Eluard
bought Aug. 1938.

1 - Chirico L'Incertitude du poète (1913) √ 105×94
2 - " Le salut de l'ami lointain (1916) √ 47×35
3 - " Intérieur métaphysique (1917) √ 45×30
4 - " La surprise (1914) √ 103×75
5 - " Portraits Gala et Paul Eluard (1924)√ 72×62
6 - " Le poète et le philosophe (1913) dessin √ 31×24

7 - Picasso Sculpture (1914) en bois 41×27
8 - " Fin d'un monstre (1937) dessin √ 56×37
9 - " Les danseurs (1915) aquarelle √ 14×12
10 - " Le crayon qui parle (1935) aquarelle √ 51×34
11 - " Le verre (1922) √ Herbert Read 20×14
12 - " Portrait de Nusch Eluard (1937) lavis √ 44×29
13 - " Carte postale (1937) dessin √ 32×22
14 - " Minotauromachie (1935) gravure - viendra 69×49
15 - " Grand air (1936) gravure en collon avec P.Eluard √ 42×31
16 - " Personnage en fil de fer (1937) √ 20×6

17 - Ernst L'Eléphant de Célèbès (1921) √ 125×108
18. " - Oedipus - Rex (1922) √ 102×92
19. " - La Révolution la nuit (1923) √ 115×89
20. " - La Mariée du vent (1924) √ C. Richards 99×79
21. " - La Rose du désert (1925) √ care de Legrain Mesens 74×59

First page of Roland Penrose's list of the acquisitions
made from Paul Eluard in August 1938
GMA A35/1/1/RPA138

£1,500 – a price suggested by Eluard who was keen to sell the collection to a friend who would love the works as much as he had. Suddenly, Penrose had a collection of museum importance hanging on the walls of his Hampstead home. Again, a full list of the acquisitions and their prices exists in the Penrose Archive. The works which Eluard sold to Penrose and which subsequently came to the Gallery of Modern Art include Ernst's *Hat in Hand, Hat on Head* (p.28), Man Ray's *Aviary* (pp.38–9), Schwitters's *Mz 129* (p.44), Magritte's *Threatening Weather* (pp.66–7) and *Representation* (pp.98–9), Dalí's *Bird* (p.70) and Tanguy's *Outside* and *Ribbon of Excess* (pp.74–5).

After the Second World War, Penrose co-founded the Institute of Contemporary Arts in London, and he also organised major exhibitions of works by Picasso, Ernst and Miró, and wrote numerous books. His classic biography of Picasso was published in 1958. Around that time he met Douglas Hall, then Deputy Director of Manchester City Art Galleries. Hall was appointed the first Keeper of the Scottish National Gallery of Modern Art in November 1961, and a few months later he took the opportunity to renew his contact with Penrose, asking for the loan of a work by Paul Klee. Hall visited Penrose in London in May 1962 and saw the collection for the first time. Periodic and friendly correspondence continued throughout the 1960s and 1970s, mainly concerning potential loans. In 1980 Hall wrote to Penrose, explaining that a new National Heritage Memorial Fund had come into existence, and that if ever Penrose wished to dispose of works, purchases might possibly be made with assistance from this fund. Ever the gentleman, Hall was always assiduous in pointing out that the Tate Gallery, of which Penrose was a Trustee, naturally took first priority, but that the Scottish National Gallery of Modern Art might be considered an ideal second choice. Hall had made similar overtures to the Edward James Foundation in Sussex, home to a fabulous collection of Surrealist works by Dalí and Magritte amongst others, but since a museum of Surrealist art was then being mooted for West or East Sussex, he did not press his case.

From time to time Penrose did sell individual works, often giving the Tate Gallery first refusal on major pieces. In 1981 he offered Tate a fine Cubist painting by Picasso, *Guitar, Gas-Jet and Bottle*, 1912–13, but since the Tate declined to buy it, it was instead offered to the Scottish National Gallery of Modern Art, and was bought in 1982. This was the first acquisition the Gallery made from the Penrose Collection. At about the same time, Hall and Antony Penrose, Roland's son, were in discussion regarding loans to the Gallery of Modern Art's Miró exhibition, proposed for summer 1982. Out of the discussion it emerged that a group of seven works by Picasso, Miró, Moore and others, which had belonged to the photographer Lee Miller (Roland's wife and Antony's mother; she had died in 1977) could be lent to the Gallery. Richard Calvocoressi, who took over from Douglas Hall as Keeper in 1987, concentrated the majority of available acquisition funds in this area, conscious that while the purchases might stretch the budget, this was the last opportunity to acquire such masterpieces. In 1991, Calvocoressi and Antony Penrose together worked out an acquisition strategy that was to bring the Gallery of Modern Art many benefits over the next decade. Miró's *Maternity* (pp.50–1) was purchased in 1991, with help from the National Heritage Memorial Fund and The Art Fund, and Henry Moore's *Helmet* (pp.148–9) was bought the following year. Breton's *Poem-Object* (p.84) was added to the collection in 1993.

In 1994 the Gallery of Modern Art acquired Roland Penrose's magnificent library and archive, which included a large number of rare books by artists such as Wassily Kandinsky and Picasso, and a wealth of correspondence between Penrose and his artist friends. Many of the books had been given to Penrose by the artists and authors, and some bear dedicatory inscriptions and drawings. The acquisitions were made thanks to grants from the National Heritage Memorial Fund and The Art Fund. When Britain's first National Lottery was launched late in 1994, the Gallery of Modern Art was an early beneficiary of its grant-giving arm, the Heritage Lottery Fund. A grant of £3 million, awarded in 1995,

Gabrielle Style (Keiller) at the Swiss Ladies'
Open Golf Championship, Geneva, 1948
GMA A42/3/1/12

allowed the Gallery to buy a collection of
twenty-six paintings and drawings from the
Penrose Collection, including works by Dalí,
Delvaux, Ernst, Man Ray, Magritte, Masson
and Picasso – all of them fully documented
in the Penrose Archive. The purchase, and
indeed most of the purchases made over
the years from the Penrose Collection, was
negotiated through the Mayor Gallery in
London. Individual items bought since then
include Max Ernst's *Hat in Hand* (p.29)
and two of Ernst's original collages for *Une
Semaine de bonté* (pp.80–1). Miró's *Head of a
Catalan Peasant* (pp.52–3) was bought in 1999
(and paid for over a three-year period) in col-
laboration with Tate in London. This was the
first time the two galleries had made a joint
acquisition, but the agreement to exchange
the painting every three years has worked
remarkably well.

 Just a few months after the main acqui-
sitions had been made from the Penrose
Collection in 1995, the Gallery of Modern Art
received easily the most important gift in its
history, the collection of Gabrielle Keiller.
Although she never lived in Scotland, Mrs
Keiller (née Ritchie) had, by chance, been
born north of the border, when her father
and heavily pregnant mother were taking a
golfing holiday. Under her previous married
name Gabrielle Style, she had become one
of Britain's leading female golfers, playing
for England and often competing on the
continent. Her father, Jack Ritchie, was
an American, and his stepfather owned a
million acres of cattle grazing land on either
side of the Palo Duro Canyon in Texas. The
land remained with the family until after the
Second World War, when Gabrielle sold her
share; the funds allowed her to indulge her
passion for collecting.

 After two failed marriages, in 1951
Gabrielle married Alexander Keiller, the heir
to the famous Dundee marmalade firm and a
man of considerable wealth in his own right.
His profession was archaeology: he financed
the excavation of the great Neolithic henge
monument at Avebury in England. Alexander
Keiller also had a passion for the bizarre,
collecting books on witchcraft and demonol-
ogy, and also, with Gabrielle, amassing a huge

collection of 'cow creamers' (pottery cream
jugs in the shape of cows). Twenty years older
than Gabrielle, he died in 1955. His interest
in the unusual and his love of collecting seem
to have rubbed off on her. In 1960 Gabrielle
Keiller went on a trip to Italy, where she met
Peggy Guggenheim in Venice. Guggenheim's
collection of Surrealist art proved an impor-
tant turning point in Keiller's life, as too did
her visit to the British Pavilion at the Venice
Biennale, where she saw work by the sculptor
Eduardo Paolozzi. From that moment on, her
energies were devoted to building a collection
of Surrealism and the work of Paolozzi. Much
of what she acquired was modest in scale,
to suit her house; occasionally she bought con-
temporary art, for example, work by Francis
Bacon, Richard Lindner, Andy Warhol and
Richard Long. She was also passionate about
the literary aspect of Surrealism, putting
together a magnificent library and archive, full
of rare books and manuscripts. Keiller had a
passionate desire to share her collection with
others. By 1970 she had decided to bequeath

her collection to the Hunterian Art Gallery at the University of Glasgow, where she was on good terms with the Director, Professor Andrew McLaren Young. However, the Trustees' decision to sell eleven paintings by James McNeill Whistler in 1980 provoked a volte-face and she revoked her decision.

Keiller had met Penrose in about 1974 and they became good friends. Some of the works in her collection were acquired directly from him; like Eluard, Penrose preferred to sell to friends and museums rather than to dealers or through auction. Keiller bought Magritte's *Representation* (pp.98–9) from Penrose in 1979 and Giacometti's *Disagreeable Object, to be Thrown Away* (p.76) from him in 1982. She also owned a number of works by Penrose, which she displayed in what she called her 'Penrose corner', at her home in London. Douglas Hall established contact with Keiller in January 1976, when he visited her. On his return he wrote, thanking her for her welcome, and eloquently implying, without actually stating it, that the collection would receive an equally warm welcome if ever it found its way to Edinburgh. In June 1978 Keiller was co-opted onto the Scottish National Gallery of Modern Art's Advisory Committee, which dealt with new acquisitions. This was in no sense an honorary position: Keiller attended the meetings in Edinburgh and voiced her opinions with a vigour backed by expertise. She was also well placed to view works on offer from London dealers, such as Miró's *Painting* of 1925 (p.54), and report back to Hall. She remained on the committee until 1985, when it was disbanded.

Richard Calvocoressi got to know Keiller when he worked as a research assistant at the Gallery of Modern Art in the late 1970s, before moving to the Tate Gallery. In London he met up again with Keiller, who was one of the first volunteer guides at Tate. When he returned to Edinburgh in 1987, Calvocoressi revived the Gallery of Modern Art's relationship with Keiller, leading to the exhibition of her collection in 1988, as part of the Edinburgh International Festival. As a result of this, Keiller decided to bequeath her collection to the Gallery of Modern Art.

The Scottish National Gallery of Modern Art's Surrealist collection thus grew beyond recognition in the space of a few years. In view of its importance and the need to display at least part of it on a permanent basis, a new annex building was opened in March 1999. The Dean Gallery (so-called after its location in the old Dean village, to the west of Edinburgh city centre) lies opposite the Gallery of Modern Art and has a large room densely hung with Surrealist paintings, African and Oceanic sculptures, and assorted curiosities. The hanging takes its inspiration from the 1936 London Surrealist show, in which everything was mixed together and double- or triple-hung. Penrose and Keiller hung their collections in the same manner. In this way, the Gallery of Modern Art's Surrealism displays continue and embody the patterns established by their great benefactors.

Overleaf: detail from Paul Delvaux
Street of the Trams 1939 GMA 3962

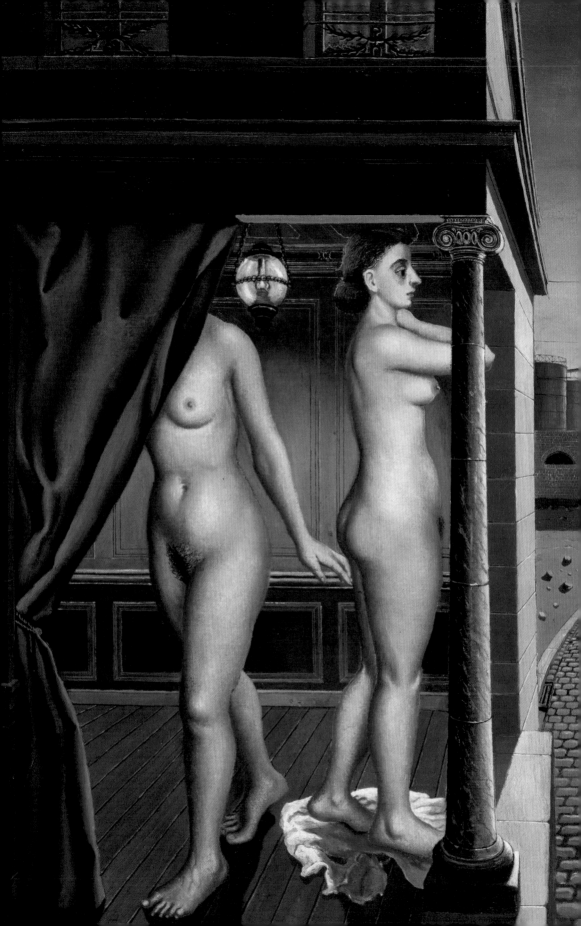

Another World

Dalí, Magritte, Miró and the Surrealists

Henri Rousseau 1844–1910
Statue of Diana in the Park (La Statue de Diane au parc c.1909

A self-taught artist, Henri Rousseau was championed as one of the forerunners of Surrealism. He worked in Government offices in Paris as a customs officer, hence his nickname, Douanier Rousseau. He only took up painting full-time when he was forty-nine years old. He regarded himself as a serious, academic painter, remaining apparently oblivious to the naivety of his style and the bizarre inconsistencies in scale in his paintings. It was precisely this strangeness, coupled with Rousseau's skewed self-image, which appealed to the avant-garde and the Surrealists. Picasso and André Breton were great admirers and collectors of his work.

This painting shows the Tuileries Gardens in Paris. The statue depicts the goddess Diana with a dog at her feet. This is almost certainly the statue by Louis Lévêque, which was sculpted in 1866 and installed in the Tuileries Gardens in 1872. Following Rousseau's usual practice, it was probably painted after a postcard or photograph rather than from life. The painting is undated; some have argued that it is a very early work dating from the late 1880s, others that it is a very late work, dating from the last years of his life. Elizabeth Cowling notes its similarity to Rousseau's painting of the monument to Chopin in the Luxembourg Gardens, Paris, which is dated 1909.

Oil on canvas laid on board, 23.5 × 11.2
Bequeathed by Gabrielle Keiller 1995
GMA 4078

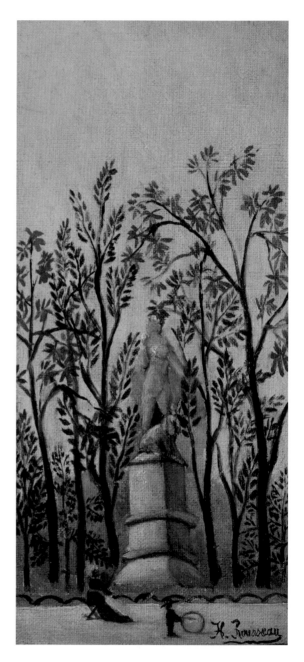

Giorgio de Chirico 1888–1978
The Mysterious Dream (Le Rêve mystérieux) c.1913–14

Giorgio de Chirico was born in Greece to Italian parents. He settled in Florence in 1910 and embarked upon a series of paintings which showed empty city squares populated by statues and hidden figures casting long shadows. He called them 'metaphysical' paintings. In 1911 he moved to Paris where his work attracted keen interest among artists and poets, including Guillaume Apollinaire. In the 1920s he became an important influence on the Surrealists, particularly Magritte, Dalí, Ernst and Tanguy, but at the very same moment he began to turn his back on his earlier work and instead restyled himself as a classical painter.

This small drawing, probably executed in Paris where he lived from 1911 to 1914, is titled at the bottom 'The mysterious dream'. It shows four apparently unrelated motifs – a tower, a train, a dog and an archway – brought together to suggest that there might be some connection between them.

Pen and ink on paper, 20.9 × 13.5
Bequeathed by Gabrielle Keiller 1995
GMA 3949

Marcel Duchamp 1887–1968
Coffee Mill (Moulin à café) 1911

Born in Normandy, Marcel Duchamp was
the younger brother of the sculptor Raymond
Duchamp-Villon and the painter Jacques
Villon. Through his brothers he became
interested in Cubism and Futurism around
1911. He attended meetings at Jacques's
home at Puteaux, in the suburbs of Paris:
here, a group of Cubist artists became
interested in the theory and representa-
tion of movement. *Coffee Mill* highlights
Duchamp's interest in movement, in the
way in which the coffee grinder's handle is
diagrammatically shown turning. It is his
first depiction of a machine – a subject which
was to become central to Duchamp and the
Dadaists. Furthermore, this curious, intel-
lectual reaction to an ordinary household
object would become a feature of Duchamp's
work. It has often been pointed out that the
grinding mechanism in *Coffee Mill* is similar
to the mechanism in his masterpiece, *The
Bride Stripped Bare by her Bachelors, Even*
(see pp.102–3). *Coffee Mill* was made as a gift
for Raymond Duchamp-Villon, to be hung
in his kitchen.

Oil and pencil on board, 33 × 12.7
Tate, London, purchased 1981

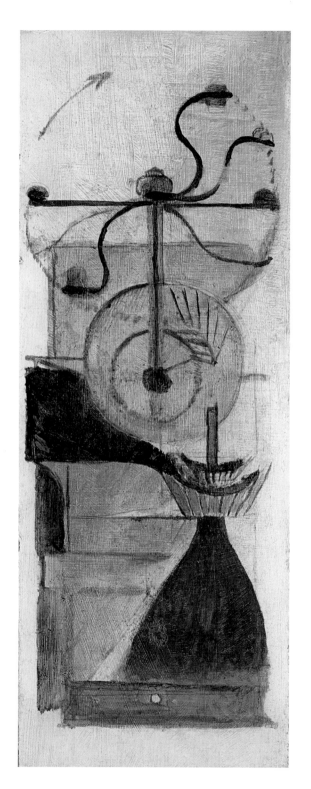

Pablo Picasso 1881–1973
Head (Tête) 1913

Head was made in the spring of 1913, when Pablo Picasso was staying in Céret, in the French Pyrenees. One of Picasso's most abstract papiers collés (pasted papers), it is made up of a few strips of coloured paper: only the chalk lines defining the nose, eyes and the back of the head are easily decipherable. Around this date, Picasso used almost the same shapes to depict musical instruments and still lifes. This ability to suggest the metamorphosis of one form into another was hailed by the Surrealists as one of Picasso's great achievements. Although it pre-dates the founding of Surrealism by more than a decade, *Head* has an important place in the history of Surrealism. It belonged to the leader of the Surrealist group, André Breton, who bought it in 1923. Breton made it the first illustration in his seminal book *Le Surréalisme et la Peinture*, 1928, and he lent it to the great exhibition of Surrealist art held at the New Burlington Galleries in London in 1936. Roland Penrose, who co-organised the exhibition, tried to buy it at the time but Breton declined. A few months later, Breton changed his mind (Jacqueline, his wife, had just left him; he was left to provide for their daughter and he had little money). However he sold the picture with a heavy heart: 'I am madly keen to keep this little picture which took me years to track down ... It is also the last Picasso I have, and I fear, that when I no longer have it I will feel poorer still.'

Papiers collés with black chalk on card, 43.5 × 33
Purchased with assistance from the Heritage Lottery Fund and The Art Fund 1995
GMA 3890

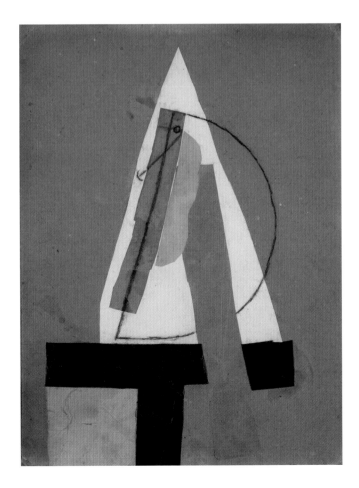

Max Ernst 1891–1976

Max Ernst was one of the major figures of Dada and Surrealist art and the Gallery of Modern Art's collection has three early examples of his work. He was born in Brühl, near Cologne in Germany, and studied philosophy before taking up painting in 1909; he was self-taught. *Landscape with Horse and Rider* was only discovered when *Hat in Hand, Hat on Head* came into the collection in 1997: an old backboard was removed to reveal this landscape on the back. *Landscape with Horse and Rider* dates from around 1913 to 1914. It depicts a horse and rider, with a large, angular tree standing to the left, a telegraph pole to the right and a sun in the top right corner shining over a dark, fragmented landscape. The subject matter relates to Kandinsky's *Blue Rider* and the horse and rider recall works by Franz Marc and August Macke. *Hat in Hand, Hat on Head* has since been reframed to show both sides of the painting.

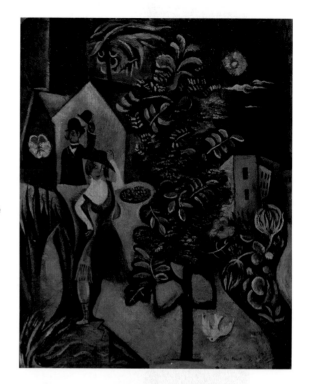

Towers seems, with hindsight, to be a transitional work. It reflects Ernst's knowledge of Cubism, particularly Robert Delaunay's views of Paris and the Eiffel Tower (Ernst had met Delaunay in 1913). It may represent an abstracted view of Laon or Soissons in France, where Ernst was stationed in the army from 1915 to 1916. At the same time, the painting's precariously assembled tower-like structures point forward to the enigmatic and ironic Dada works Ernst made in Cologne between 1919 and 1920, such as *Hat in Hand, Hat on Head*. The subject of this work – a man and woman greeting each other in a city park – is typical of the Expressionism of artists such as August Macke and Heinrich Campendonk, but Ernst seems to be satirising that imagery: the bourgeois gentleman lifts his bowler hat, only to reveal another one underneath. The painting is also an early instance of Ernst's interest in the theme of the forest, while the dead bird, which appears to have fallen from the tree, hints at the imaginary 'Loplop' bird character which inhabits Ernst's works from the mid-1920s onwards.

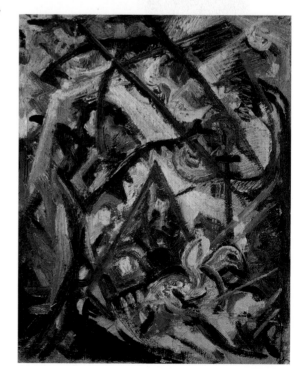

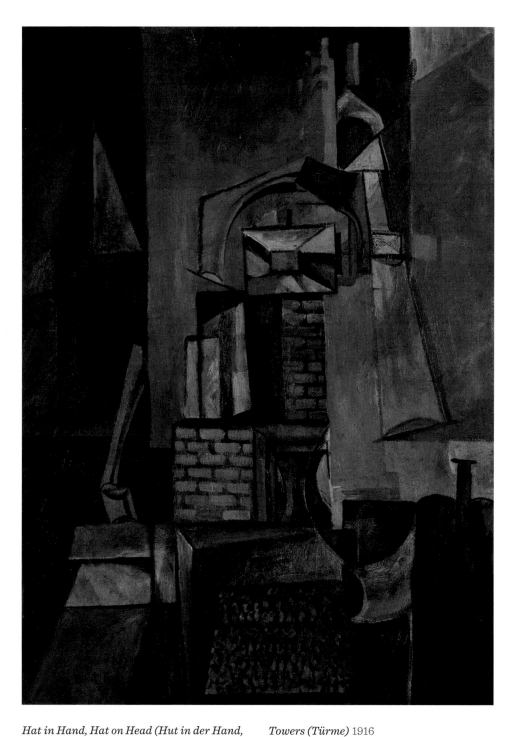

Hat in Hand, Hat on Head (Hut in der Hand,
Hut auf dem Kopf) c.1919
Verso: *Untitled (Landscape with Horse and*
Rider) c.1913–14
Oil on board, 36.8 × 29.2
Purchased with assistance from The Art Fund 1997
GMA 4169

Towers (Türme) 1916
Oil on canvas, 60 × 43
Bequeathed by Gabrielle Keiller 1995
GMA 3969

Zurich Dada

Tristan Tzara, Marcel Janco and Jean Arp were among the founders of the Dada movement, which developed early in 1916 around the Cabaret Voltaire club in Zurich. Dada was a reaction against the horrors of the First World War and what were perceived as the corrupt, nationalistic values that had caused it. Dada assumed many forms, including outrageous performances, readings, nonsensical automatic poetry and the found object.

The Romanian poet, critic and theorist Tristan Tzara wrote some of the first Dada texts, among them his short play *La Première aventure céleste de M. Antipyrine*. This was his first major Dada work and it had its premiere at the Waag Hall in Zurich on 14 July 1916. Marcel Janco, an architect, artist and fellow Romanian, was in charge of the sets and costumes. When the play was to be published, Tzara asked Janco to make illustrations to complement rather than illustrate the text. Janco's woodcuts are expressionistic in nature, fluently combining abstract and figurative elements. When Tzara sent a copy to Marcel Duchamp in New York, Duchamp acknowledged that this was the first time he had heard of Dada.

André Breton kept abreast of Dada activities in Zurich through regular contact with Tzara. Following Tzara's move to Paris in 1919, bitter disputes developed between them, though they were later reconciled. This copy of the play was given by Tzara to Breton in 1921. Breton had it rebound and incorporated a photograph of a Dada event and a letter from Tzara, dated 5 March 1919, which includes discussion of Tzara's contributions to Breton's journal *Littérature*.

Tzara's early Dada verse of the period around 1916 to 1924 was written to confound and confuse. Obscure images, nonsense syllables, outrageous juxtapositions and inscrutable maxims served to perplex and to illustrate the limitations of language. Volumes such as *Vingt-cinq poèmes* and *De nos oiseaux* demonstrate his contention that words in Dada are used not as carriers of meaning, but as a vital force in their own right. *Vingt-cinq poèmes* was Tzara's first published collection of poems and is a classic example of anarchic Dada typography and design. It was one of several collaborations with Jean Arp. (Arp was born in Strasbourg and was christened Hans, but following the First World War peace treaties, the Alsace region came under French rule and he was required to use the French form of his name, Jean. Thereafter he called himself Hans when speaking in German, and Jean when speaking in French.)

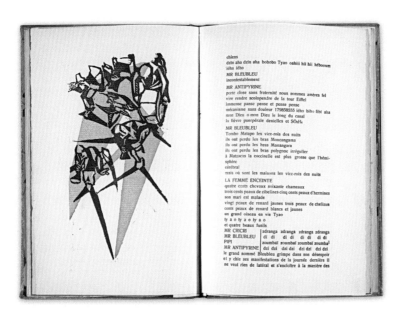

Tristan Tzara 1896–1963 and **Marcel Janco** 1895–1984
The First Heavenly Adventure of Mr Antipyrine (La Première aventure céleste de M. Antipyrine) 1916
Zurich, Collection Dada 1916
Book by Tristan Tzara with seven woodcuts by Marcel Janco, 23 × 16 (edition of 510)
Purchased with assistance from the Patrons of the National Galleries of Scotland 2003
GMA A33/3/DSL/054

Tristan Tzara 1896–1963 and **Jean Arp** 1886–1966
Twenty-five Poems (Vingt-cinq poèmes) 1918

Zurich, Collection Dada 1918
Book by Tristan Tzara with ten woodcuts by Jean Arp and a cover woodcut printed in gold, 20.5 × 14.7
Bequeathed by Gabrielle Keiller 1995
GMA 42/2/GKL0998

Tristan Tzara 1896–1963 and **Jean Arp** 1886–1966
About our Birds. Poems. Drawings by Arp
(De nos oiseaux. Poèmes. Dessins par Arp) 1923

Paris, Editions Kra c.1923
Book by Tristan Tzara with reproductions of ten drawings by Jean Arp, 18.4 × 12.9
Bequeathed by Gabrielle Keiller 1995
GMA A42/2/GKL0069

Marcel Duchamp 1887–1968
Fountain 1917 / 1964

Duchamp began to turn away from Cubism towards more cerebral activities in 1913. That year he made his first three-dimensional work, *Bicycle Wheel,* a bicycle wheel fixed upside-down to a stool. This was the first of his Readymades – ordinary household objects which in themselves held no artistic pretensions. In 1915 Duchamp moved to New York, where he gave up painting in favour of text, documentation and other forms of reproduction – including the Readymades; he also began work on *The Bride Stripped Bare by her Bachelors, Even* (see pp.102–3). Duchamp insisted that the Readymades were not chosen casually (or frequently: he did not make many) but that they had to fulfill various criteria. Chief among these was that they should be removed from their logical context and therefore acquire an entirely new meaning.

Duchamp submitted *Fountain,* an upturned porcelain urinal he had signed and dated 'R. Mutt 1917', to the Society of Independent Artists' exhibition in New York in April 1917. The name Mutt probably derived from Mott Iron Works, a plumbing showroom on Fifth Avenue, where he had bought the urinal. The Society claimed to show any work accompanied by the admission fee, but *Fountain,* which was submitted anonymously, caused misgivings since it appeared to have no artistic merit and to verge on the immoral. The Society, of which Duchamp was a founder-member and director, first put the work behind a partition and then seemingly removed it altogether. Duchamp later said that he would have been more disappointed had it been accepted. His intentions therefore seem to have been twofold: to test censorship and to question traditional aesthetic judgements. He resigned from the Society and in *The Blind Man,* a new arts review which he edited, Duchamp dedicated the May 1917 issue to the matter: 'Whether Mr Mutt with his own hands made the fountain or not has no importance. He CHOSE it. He took an ordinary article of life, placed it so that its useful significance disappeared under the new title and point of view – created a new thought for that object.'

The original version of *Fountain* was lost, but in the 1950s and 1960s Duchamp authorised several slightly different replica versions. Tate's version was made in 1964, under Duchamp's careful supervision, by the Milanese gallery owner Arturo Schwarz. It was painstakingly made from scratch and issued in a limited edition of eight copies. The faithful reproduction of an ordinary found object was in itself typical of Duchamp's questioning attitude, in that it remains unclear which is the 'original', or indeed where the 'originality' lies. Likewise, it is unclear if Duchamp's motives were artistic, satirical or philosophical, or all three. Unlike the 1917 version, the 1964 versions have a strip of four additional drainage holes.

Porcelain, 36 × 48 × 61
Tate, London, purchased with assistance from the
Friends of the Tate Gallery 1999

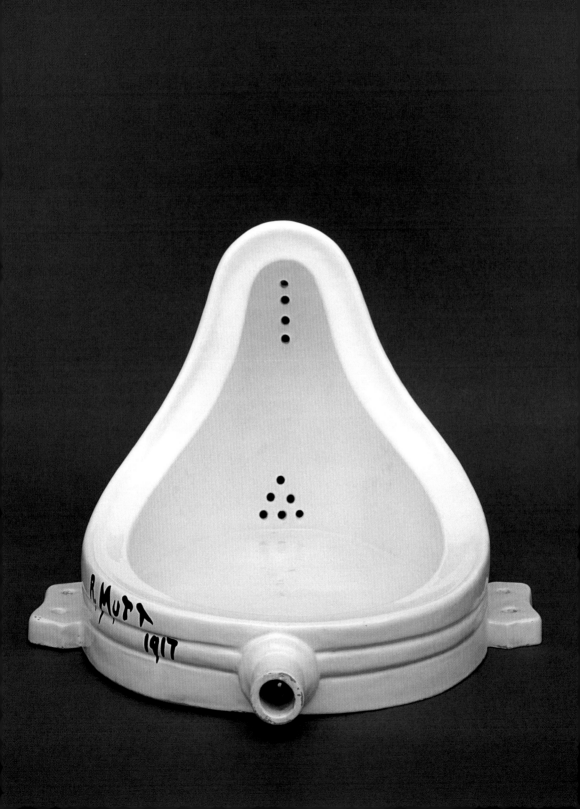

Man Ray 1890–1976
Man Ray 1914 1914

Man Ray was from Philadelphia. His full name was Emmanuel Radnitzky, but the family, who were Russian-Jewish immigrants, shortened and 'Americanised' the surname to Ray in 1912, when they lived in Brooklyn. Around the same time Emmanuel, who was known in the family as Manny, shortened his first name to Man. This little painting was made in 1914, the year before Man Ray met Duchamp, but he had previously encountered Duchamp's work at the famous Armory Show held in New York in 1913. It shows that the two artists already shared similar concerns regarding authorship and originality before meeting. It may appear at first to be an abstract or landscape painting,

structured by Cubist planes and fragmentation, but in fact the forms simply spell out Man Ray's name and the date of the painting. Famously, Picasso and Braque never signed their Cubist paintings, fearing an inscription might spoil their purity and harmony; here Man Ray makes the signature so big and dominant that it is hardly apparent. Although there is an almost Dadaist spirit to the work, it also springs from the artist's new identity, for he only became known as Man Ray a year or two before it was painted.

Oil on sketchblock, 17.3 × 12.3
The Penrose Collection

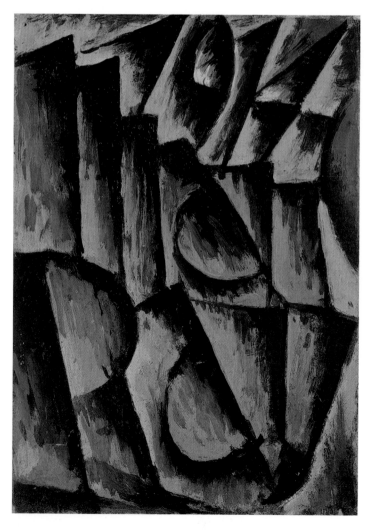

Francis Picabia 1879–1953
Girl Born without a Mother (Fille née sans mère) c.1916–17

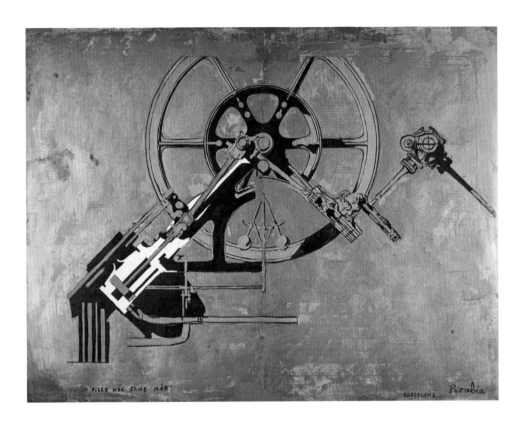

Francis Picabia came from a wealthy, cosmopolitan family; his father was Cuban and his mother French. His painting went through Impressionist, Fauvist, Cubist and abstract phases, before veering off in increasingly bizarre ways. Like his friend Marcel Duchamp, he moved from Paris to New York in 1915. That year Picabia stated that the move to America, land of the machine, had brought about a complete revolution in his methods: 'The machine has become more than a mere adjunct to life. It is really part of human life – perhaps the very soul. In seeking forms through which to interpret ideas or by which to expose human characteristics I have come at length upon the form which appears most brilliantly plastic and fraught with symbolism.' He embarked upon a series of drawings which use the machine as an ironic and nihilistic metaphor for human life, one of which was called *Girl Born without a Mother* (the title came from a Latin phrase book). He moved to Barcelona in 1916, and made

this second, much more elaborate version. It is painted over a printed illustration of a two-cylinder stationary steam engine. Picabia erased some parts and added others, to achieve an image which, by virtue of its title, parodies the piston-like motions of the sexual act, as well as referencing the creation of Eve from Adam's rib and the Virgin birth.

Gouache and metallic paint on printed paper, 50 × 65
Purchased 1990
GMA 3545

Dada Journals

One of the dominant vehicles of Dada was the magazine. Intellectually and visually challenging, they violated the conventions of the literary-artistic review with wild typographical experiments; sometimes there was no written text at all. They appeared at irregular intervals, some planned as single issues, some with continually changing titles; others were published in multiple versions to circumvent the censorship laws of different countries. The content reflected the wide variety of Dada's activities, in literature, the visual arts, music, philosophy, politics and architecture.

The first Dada journal, *Cabaret Voltaire*, edited by Hugo Ball, disappeared after one issue in 1916. The following year Tristan Tzara brought out the first number of *Dada*. The first four numbers were produced in Zurich between 1917 and 1919, after which Tzara and the publication moved to Paris. *Dada 1* and *Dada 2* are fairly conservative in appearance. From *Dada 3* (published in 1918 and containing Tzara's Dada Manifesto) Tzara's approach became more anarchic, with poems, texts and Arp's woodcuts jigsawed together on the page. Many different typefaces were used. Picabia became involved with *Dada 4/5*, and *Dada 6/7* was produced from his apartment in Paris. The last number, *Dada Intirol*, was published in Austria and contains Ernst's collage comic 'The preparation of glue from bones'.

Having moved to New York in 1915, Picabia and Duchamp formed, along with Americans such as Man Ray and Alfred Stieglitz, the core of the avant-garde scene. It was not until 1921 that Duchamp, Man Ray and their associates applied the term 'Dada' to their activities, but they had been shocking New Yorkers with works and gestures that were Dada in essence even before the term was coined in Switzerland in 1916.

The journal *291* was named after Stieglitz's 291 gallery, located at 291 Fifth Avenue in New York. It was large in format, experimental, iconoclastic and satirical, and characterised by bold confrontations of text and image. On his arrival in New York in June 1915, Picabia immediately became involved with *291*, contributing some of his first 'machine drawings'. The publication ceased in 1916 and in January 1917 Picabia released the first issue

of *391*. The longest-lived of the Dada periodicals, it appeared regularly in its first year of publication. After this, *391* continued to appear sporadically, production moving with Picabia to Barcelona, back to New York, then to Zurich and Paris. It ceased publication between 1921 and 1924. When *391* was re-launched for its final flourish, part of Picabia's purpose was to derail Surrealism.

New York Dada appeared only once and marked the beginning of the end of Dada in the city. Created by Duchamp and Man Ray, this magazine was the only New York journal to proclaim itself Dada (Man Ray asked Tristan Tzara for permission to use the term and was told that it belonged to everyone). The cover reproduces Duchamp's *Belle Haleine* – a bottle of perfume carrying a photograph of Duchamp in the guise of his female alter-ego, Rrose Sélavy. This is printed over a background of tiny, inverted letters spelling out the phrase 'new york dada april 1921'.

Francis Picabia 1879–1953, editor *391*

New York, Paris, Barcelona, 1919–24
Bequeathed by Gabrielle Keiller 1995
GMA A42/2/GKL0474
above: *391*, no.8, February 1919,
cover by Francis Picabia

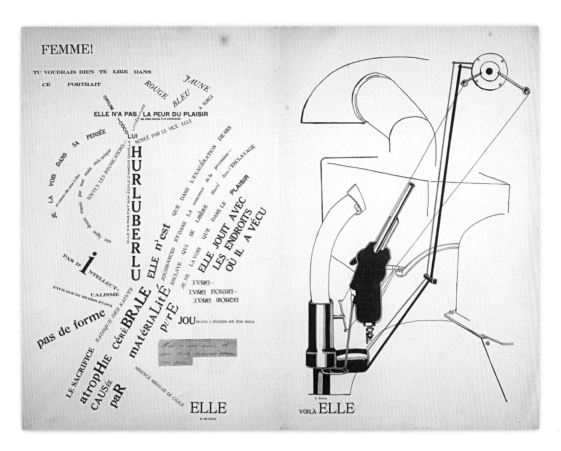

Tristan Tzara 1896–1963, editor

Dada. Literary and Artistic Review
(Dada. Receuil littéraire et artistique)

Zurich and Paris, 1917–21
Purchased 1997
GMA A33/3/DSL/005
below: *Dada 6,* March 1920

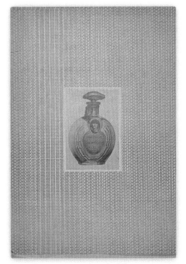

Alfred Stieglitz
1864–1946, editor
291

New York, 1915–16
Bequeathed by
Gabrielle Keiller 1995
GMA A42/2/GKL0473
above: *291*, no.9,
November 1915,
'FEMME ELLE',
by Marius de Zayas;
'Voila ELLE' by
Francis Picabia

Marcel Duchamp 1887–1968, editor
New York Dada

New York, April 1921 (single issue)
Purchased with assistance from the Patrons of the National
Galleries of Scotland 2005
GMA A33/3/DSL/059
above: *New York Dada,* April 1921, cover by Marcel Duchamp

Man Ray 1890–1976

Inspired by Picabia and Duchamp, newly arrived in New York in 1915, Man Ray began making paintings, collages and photographs of a mechanistic, Dada nature. For Dada artists, the collage technique was a means of de-personalising art, of negating the humanist values associated with traditional easel painting. Speaking of his work of this period Man Ray said: 'The new subjects were of pseudo-mechanistic forms, more or less invented, but suggesting geometric contraptions that were neither logical nor scientific.'

The word 'involute' means intricate and curled, and the collage *Involute* invokes the term both metaphorically and literally. It is composed of involuted, spiralling forms; the letters 'INV' coupled with the 'O' beneath and the cut-out metal 'lute' spell out the title in a visual pun. The long screw form on the left is echoed by the actual screw which holds the metal plate in place; the threads in a transparent wallet (Man Ray's parents both worked in tailoring), tacked on to the picture, refer to the strings of the lute.

Aviary depicts the artist's basement studio in New York, complete with dressmaker's dummy: Man Ray said it had been left there by his landlady, but it might equally have come from his father. The technique, airbrush, came from the world of commercial art and, like collage, was employed as a counterweight to traditional fine-art practices. The French title, *La Volière*, means 'Aviary' but is also slang for a 'hen house' or brothel.

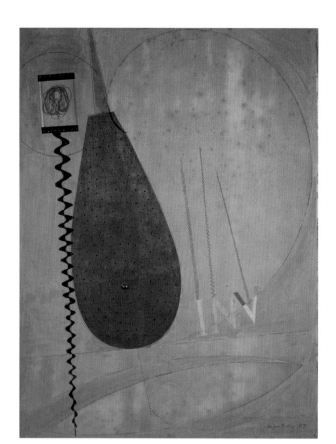

Involute 1917

Mixed-media collage on card,
laid on board, 61.5 × 46.5
Purchased 1978
GMA 2064

Aviary (La Volière) 1919

Airbrush, pencil and pen and ink
on card, 70 × 55
Purchased with assistance from
the Heritage Lottery Fund and
The Art Fund 1995
GMA 3888

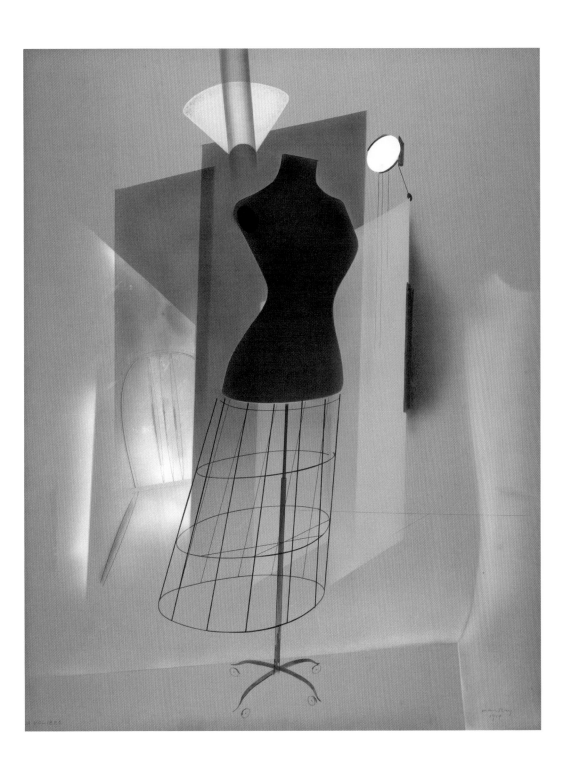

Marcel Duchamp 1887–1968
The Non-Dada 1922

Duchamp sent this 'assisted Readymade' to Man Ray in or around July 1922. Duchamp and Man Ray met in New York in autumn 1915, and their friendship developed as Duchamp learned English. They both moved to Paris in 1921. Duchamp returned to New York in January 1922 while Man Ray stayed in Paris. In a letter to Man Ray, which accompanied the pamphlet, Duchamp stated: 'This thing that I have sent you is a 'pamphlet' (real) that I found at the home of some friends.' Specifically, it is a religious pamphlet published by the Vocational Pupils at the School of the Four Cs (Caney Creek Community Centre, Pippopass, Knott County, Kentucky),

in April to May 1922. Duchamp added a scrap of paper torn from an envelope, on which he wrote '(Man Ray Collection) / The Non-Dada / Affectueusement, Rrose'. The title 'Non-Dada' suggests that the grinning schoolboy is the opposite of everything Dada represented. Rrose Sélavy (a pun which means 'Eros, c'est la vie' or 'Love is life'), was Duchamp's female alter-ego. Man Ray had made a series of photographs of Duchamp dressed in women's clothing, and posing as Rrose Sélavy, in 1921.

Printed brochure with ink inscription, 14 × 11
Bequeathed by Gabrielle Keiller 1995
GMA 3966

Photo by Joe Costa of the New York World

Man Ray 1890–1976 and **Tristan Tzara** 1896–1963
Tristan Tzara and Jean Cocteau c.1922

Born in Romania, Tzara lived in Zurich during the First World War, becoming one of the founders of the Dada movement which emerged early in 1916 around the Cabaret Voltaire club. The movement's name and ideals soon spread to Paris and New York. Tzara moved to Paris in 1920 and quickly became a central figure in the city's Dada group, which centred on the writers André Breton, Philippe Soupault and Louis Aragon. Man Ray moved from New York to Paris in July 1921 and, thanks to his friendship with Duchamp, was immediately drawn into the same Dada group. Man Ray and Tzara soon became close friends and for a while they both lived at the Hôtel des Ecoles in Montparnasse.

Man Ray had taken up photography in New York simply as a means of recording his paintings, but in Paris he quickly became the photographer of choice for the Dada group and also in the fashion world. This enabled him to socialise with a broad circle of artists and poets, including the poet Jean Cocteau, whose fame and success made him anathema to many Dadaists. This is a photograph by Man Ray of Cocteau (on the left, holding a banjo) and Tzara (on the right, using a walking cane as a trumpet), which has been drawn over in pen and ink by Tzara. Man Ray made another more formal portrait of Cocteau and Tzara, in which they are enrobed in a single piece of cloth, while a cut white lampshade spirals around their necks.

Black and white photograph and ink, 8.5 × 5.9
Bequeathed by Gabrielle Keiller 1995
GMA 4004

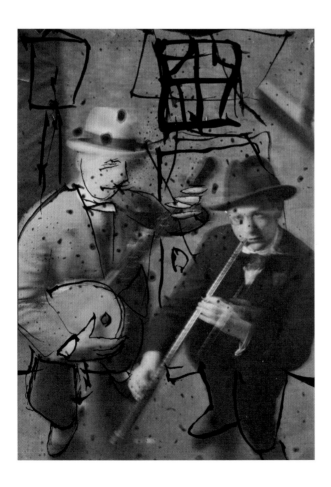

Max Ernst 1891–1976
Katharina Ondulata 1920

Made while Max Ernst was living in Cologne, *Katharina Ondulata* is infused with Dadaist whimsy and anarchy. It was inspired by a series of well-known, bawdy poems about the sexual adventures of a female innkeeper on the River Lahn in western Germany. In these poems, the innkeeper encounters all manner of sexual attention, to which she responds with athleticism and fortitude. The full title of the work, written along its bottom margin, is (in translation): 'Undulating Katharina, i.e. mistress of the inn on the Lahn appears as guardian angel and mother-of-pearl of the Germans on cork soles in the zodiac sign of cancer.' This cryptic text gives clues to the meaning of the imagery. Katharina appears to be represented by the revolving disc on the left (which could also be interpreted as a Catherine wheel), above which is a cog (her head). The unstable contraption on the right is her male admirer: his fuse is alight, ready to ignite his sexual desires. Mount Fuji, Japan's active volcano, is shown on the horizon, ready to erupt.

Although often referred to as a collage it is not one: instead it has been painted over a sheet of printed paper (possibly wallpaper) bearing a square, woodgrain motif. Most of the printed design has been obscured.

Gouache, pencil and ink on printed paper, 31.5 × 27.5
Purchased with assistance from the Heritage Lottery Fund and The Art Fund 1995
GMA 3885

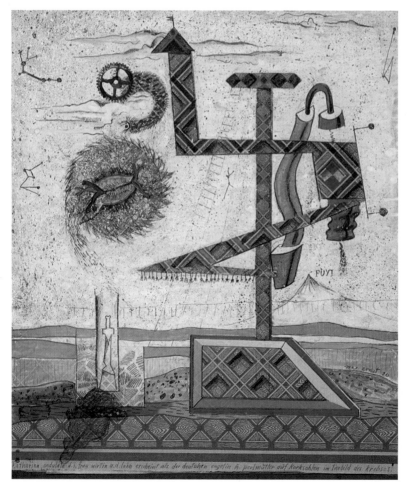

Max Ernst 1891–1976
Woman with an Umbrella (La femme au parapluie) c.1921

This little picture was probably painted in Cologne in 1921, the year before Ernst moved to Paris. In June 1921, Ernst held an exhibition at the Au Sans Pareil Gallery in Paris: Breton wrote the catalogue introduction and the show was much admired by the Paris Dada group. The imagery in *Woman with an Umbrella* appears to have originated in a sales advertisement for a pair of gloves, an umbrella and a pair of shoes, printed together on the same page. Using these pre-existing images, Ernst has created a figure around them – this is no doubt why the figure has such an awkward posture, and why her feet are splayed in such an uncomfortable way. The work seems to have been painted specifically for the ornate wooden frame; indeed, it seems to have been painted when the card was actually in the frame, since traces of the same blue paint are visible around the inside edge of the wood.

Gouache, crayon and pencil on printed paper, stuck on card, 16.5 × 10.5
Bequeathed by Gabrielle Keiller 1995
GMA 3970

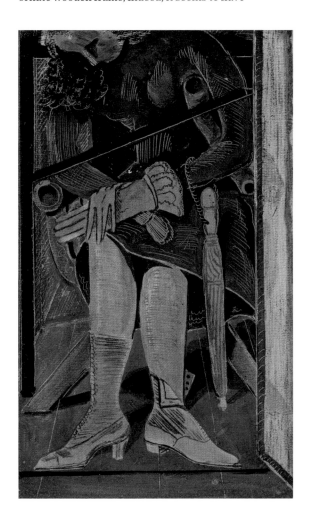

Kurt Schwitters 1887–1948

Kurt Schwitters's art underwent a radical change around 1917 to 1918. All of a sudden, he transformed from a traditional painter of landscapes and figures to an Expressionist, a Futurist, a Cubist and, in 1918, a maker of Dada collages. He had been called up for military service in 1917 (he was declared unfit a few months later) and the war had a profound effect on him. For Schwitters, collage was a rebellion against everything that the old order represented. The abrupt change in his art coincided with his meeting the Dada artists Arp, Raoul Hausmann and Höch. However, while some of the Dada artists proclaimed that art was dead, Schwitters insisted that his work was meant to be understood as art. This was perhaps why the Club Dada in Berlin refused his request to join their group.

Schwitters used a vast range of different materials in his collages, including tickets, ribbon, cloth, adverts, newspapers, lace, feathers, stamps, playing cards, photographs – anything that was reasonably flat and could be stuck down. Schwitters called these works *Merz*, a term he coined in 1919 and which derived from the cut-up letterhead of a bank called 'Kommerz und Privatbank'. The association of 'rubbish' with banks was deliberately ironic.

Schwitters first exhibited the *Merz* pictures in Berlin in July 1919. The series, which began in 1918 and continued to the 1930s, numbers more than 1000 works in total. The collages from 1919 to 1921 tend to feature odd scraps of paper torn or cut into a great variety of shapes, and the dominant compositional line often leans away from the perpendicular. By 1921 Schwitters was becoming a well known artist. He held an exhibition of *Merz* pictures in Hanover in February 1920, another at Der Sturm Gallery in Berlin in April 1921 and his work was also shown at The Société Anonyme in New York in 1920 and 1921. Schwitters formed a lasting friendship with Ernst; he became closely involved with the Berlin Dada group, contributed to various Dada publications and became known for his public recitals and 'sound poems'.

***Mz 129 Red on Top
(Mz 129 rot oben)*** 1920

Collage on paper, 10.6 × 8.3
(27.9 × 20.6 including mount)
Presented by Dr John Golding in
memory of Roland Penrose 2005
GMA 4764

***Mz 299 for V.J. Kuron
(Mz 299 für V.J. Kuron)*** 1921

Collage on paper, 18 x 14.5
(33.3 × 27.3 including mount)
Bequeathed by Gabrielle Keiller 1995
GMA 4081

George Grosz 1893–1959
Toads of Property (Die Besitzkröten) 1920

George Grosz was a founder member of Club Dada in Berlin in 1917; that year he had added an 'e' to his Christian name, adopting the Anglo-American version, George. Although he did make some wild and witty Dada collages, he also produced caustic, satirical drawings with a strong political sentiment, such as *Toads of Property*. Politically-charged work of this type was typical of German Dada but was not so common in French or New York Dada.

Toads of Property was probably made specifically to be turned into a photolithographic reproduction. It was published in a folio in 1921 and in another, *The Robbers*, in 1922. In the latter, each print was accompanied by a quotation from Friedrich Schiller's play *The Robbers*, 1780. This work carried the following text: 'Under my rule it shall be brought to pass, that potatoes and small-beer shall be considered a holiday treat; and woe to him who meets my eye with the audacious front of health. Haggard want, and crouching fear, are my insignia; and in this livery will I clothe thee.'

Pen and ink on paper, 52.7 × 41.1
Purchased 1979
GMA 2102

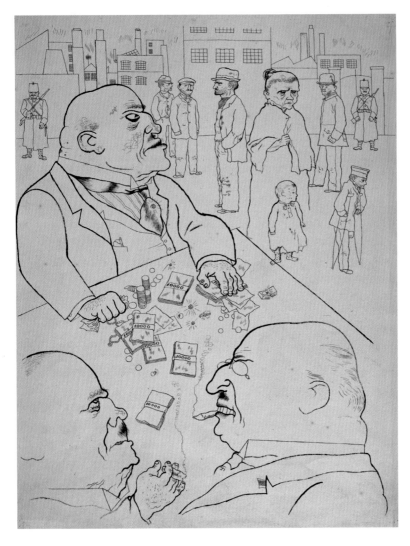

George Grosz 1893–1959
The Funeral of Ebert (Eberts Bestattung) 1923

The Funeral of Ebert is one of a number of 'corrected masterpieces' that Grosz made, using postcards of old master, or sometimes modern, paintings. This card, adapted from Titian's *The Entombment of Christ*, was sent by Grosz to his friend, the former Dadaist Georg Scholz. Grosz's message on the back of the card tells us that the person being entombed is Friedrich Ebert, the German president (1919–25), and that the man with the bowler hat is Hugo Stinnes, a leading capitalist. Ebert and Stinnes were both anti-communists. The identity of the other two heads is unknown. Born in Berlin, Grosz was a member of the communist party and had taken part in the Spartacist uprising in 1919. His satirical drawings fiercely lampooned politicians, army chiefs and authority figures.

Collage on postcard, 8.5 × 13.5
Bequeathed by Gabrielle Keiller 1995
GMA 3985

Hannah Höch 1889–1978
Untitled 1924

Born in Gotha in central Germany, Hannah Höch met the Dada artist Raoul Hausmann in 1915 and through him became involved with the Berlin Dada group. Although she did paint, she is best known for her collages and photomontages. From 1916 to 1926 Höch worked part-time as a designer at the publishing house Ullstein-Verlag in Berlin. There she created patterns for publications on crochet, knitting and embroidery. The white grid element in this collage is taken from the photographic reproductions of embroidery mesh which Höch would have used to prepare her designs. In some parts of the collage, she has blacked out – or highlighted in white – parts of the embroidery mesh, to create different patterns. The finished collage has the look of an austere, machine-age, Constructivist picture, but actually derives from popular embroidery patterns. This work was reproduced in the influential literary journal *The Little Review* in 1926.

Collage, gouache and ink, 26 × 18.5
Private collection, courtesy the Mayor Gallery, London

Hannah Höch 1889–1978 *From the Collection: from an Ethnographic Museum (Aus der Sammlung: Aus einem Ethnographischen Museum)* 1929

This work is from a series of seventeen photomontages executed between 1924 and 1930 and given the generic title *From an Ethnographic Museum*. They all incorporate reproductions of tribal sculpture coupled mainly with photographs from contemporary fashion magazines. The meeting of two different cultures is deliberately disturbing, creating weird hybrid figures. Here, Höch has stuck the head of an African sculpture (an ivory pendant mask from Benin) onto the body of a child and added a photograph of a woman's eye. The truncated figure sits on a carved lion's paw, originally belonging to a piece of furniture. The geometric elements around the figure recall the work of Piet Mondrian and the De Stijl group. Höch was associated with this group, and this collage formerly belonged to one of its members, Friedrich Vordemberge-Gildewart. Höch was also closely associated with Schwitters (see pp.44–5), with whom she collaborated on several *Merz* projects.

Collage and gouache on paper, 25.7 × 17.1
Bequeathed by Gabrielle Keiller 1995
GMA 3987

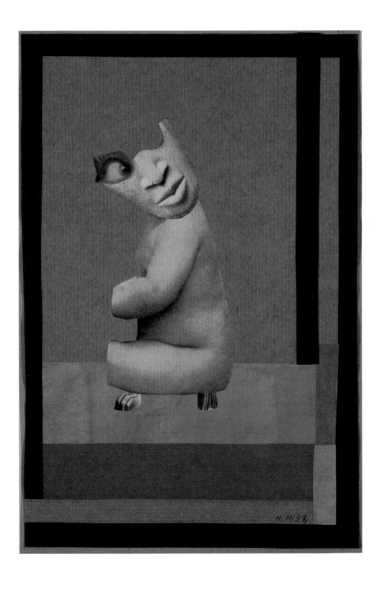

Joan Miró 1893–1983
Maternity (Maternité) 1924

Joan Miró was born in Barcelona. His early work conflated the angular forms of Cubism with the high-key colour of Matisse, but it also revealed an obsessive attention to detail. He first visited Paris in 1920 and moved there the following year, establishing contacts with Picasso and the Dada group. He found a studio in Montmartre, where André Masson was a neighbour: they became great friends, and through Masson Miró was introduced to the artists and poets who would form the core of the Surrealist group. Miró gradually abandoned Cubism for a world of strange, free-floating forms painted over uniformly coloured grounds. André Breton remarked that Miró's work of 1924 marked an important stage in the development of Surrealist art.

Maternity was probably painted in the summer or autumn of 1924 at Montroig, near Barcelona, where Miró's parents owned a country house. In August 1924 Miró wrote to the poet Michel Leiris, telling him that 'My latest canvases are conceived like a bolt from the blue, absolutely detached from the outer world (the world of men who have two eyes in the space below the forehead).' The motifs in Miró's paintings became drastically simpli-fied. However, the imagery in *Maternity* can be traced to a specific source: a postcard of a seated Spanish dancer wearing a décolleté dress. In two large drawings in coloured chalk on canvas and several small pencil sketches,

Miró reduced the dancer's head and neck to a black, keyhole shape, connected by a thin vertical line to a triangular body. The body of the 'mother' in *Maternity* is punctured by a large hole which echoes the polka-dot motif of the dancer's dress.

Miró returned to Paris early in 1925, bringing with him *Maternity* and other paint-ings he had recently made in Spain. Shortly afterwards he met André Breton for the first time. In April he signed a contract with Jacques Viot, who ran the Galerie Pierre in Paris, and in June he held his first exhibition there. *Maternity* featured in the exhibition. By this time Miró was well ensconced with the Surrealists. *Maternity* was reproduced in the journal *La Révolution Surréaliste* in July 1925, confirming Miró's status as one of the leading figures in the group. He participated in the very first Surrealist exhibition, also held at the Galerie Pierre, in November 1925.

X-ray and infra-red photographs show that *Maternity* was painted over an earlier landscape composition. The right edge of the painting was originally the bottom edge of the landscape.

Oil on canvas, 92.1 × 73.1
Purchased with assistance from the National Heritage Memorial Fund, The Art Fund (William Leng Bequest) and members of the public 1991
GMA 3589

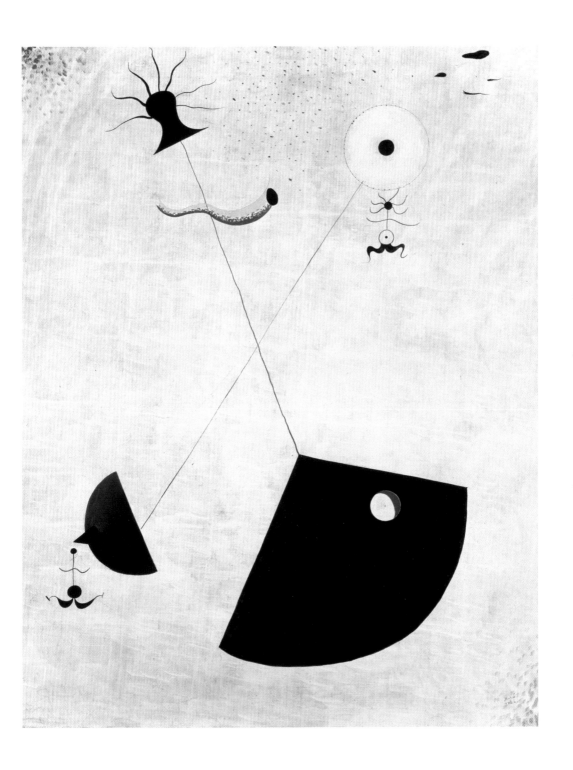

Joan Miró 1893–1983
Head of a Catalan Peasant (Tête de Paysan Catalan) 1925

The image of the Catalan peasant first appears in Miró's work in *The Hunter (Catalan Landscape)*, 1923–4, which, Miró stated, was inspired by the sight of a Catalan peasant out hunting, wearing his distinctive Catalan cap. Miró went on to paint four versions of *Head of a Catalan Peasant*. They came at a crucial moment in his work, when he was shifting away from a Cubist treatment of form to a new kind of painting in which cursive and biomorphic forms float freely in pictorial space. In 1924 Picasso stated that he and Miró were the only artists taking painting forward and in later interviews Miró said that it was his aim, during these years, to 'destroy' painting.

In each of the four paintings, the head is reduced to a cross with eyes at the ends of the horizontal bar, the red Phrygian-type cap at the top and, in three of the versions, a stylised beard. The first version of *Head of a Catalan Peasant* is dated 1924 and was probably finished in the autumn of that year. Painted on a yellow ground, it is in the collection of the National Gallery of Art, Washington. The second, which is dated 1924–5 and is the smallest of the series, is in a private collection. The present painting is believed to be the third version, dating from the early months of 1925. It is painted with a very thin, almost translucent wash of blue oil mixed with turpentine, over a primed, white canvas.

The fourth version, which is painted on a darker blue background, dates from spring 1925 (Moderna Museet, Stockholm). There is a fifth painting, dating from 1924, *Catalan Peasant with Guitar*, which is in the Museo Thyssen-Bornemisza in Madrid.

Although Miró's paintings of this period appear to be automatic works, drawn spontaneously and, as the artist said, in a dreamlike or hypnotic state (he referred to works of 1925 as 'dream paintings'), most of them were preceded by detailed preliminary sketches, often based on grid-like compositional structures. The preliminary drawing for this *Head of a Catalan Peasant* is inserted into the so-called Montroig notebook (Fundació Joan Miró, Barcelona). The head is composed within a rigorous diamond-shaped grid, with the beard occupying the bottom point and the eyes and hat forming the upper half of the diamond. The underdrawing for this grid structure is clearly visible under the thin blue wash in the painting.

Head of a Catalan Peasant was bought jointly with Tate, London, from the descendants of Roland Penrose. It is shown at both galleries, alternating on a three-year basis.

Oil on canvas, 92.4 × 73
Purchased jointly with Tate, London, with assistance from The Art Fund 1999
GMA 4252

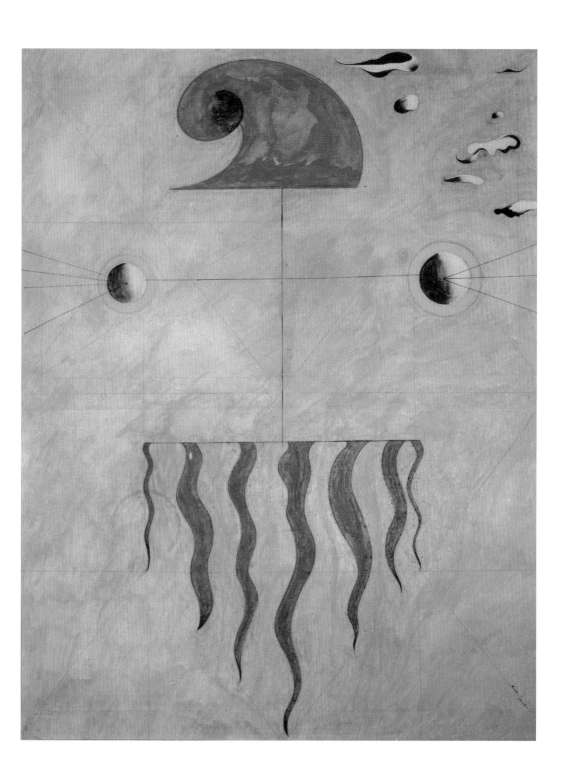

Joan Miró 1893–1983
Painting (Peinture) 1925

André Breton's *First Surrealist Manifesto* of 1924 defined Surrealism as 'Pure psychic automatism, by which one intends to express verbally, in writing or by any other method, the real functioning of the mind. Dictation by thought, in the absence of any control exercised by reason, and beyond any aesthetic or moral preoccupation.' Breton's ideas were much indebted to Sigmund Freud, who argued that subconscious urges underlie our everyday thoughts and actions. The Surrealists believed that the unconscious mind should be made to speak for itself in a process of pure creativity. One way to achieve this was through automatic drawing. It was hoped that the results would reveal hidden truths normally locked away in the unconscious.

Miró and André Masson were the most prolific and committed 'automatic' painters of the Surrealist group. Many of Miró's paintings of this period are simply called *Painting*. Miró explained: 'When the starting point of a work is to some extent the real world, I always write a title on the back of the canvas with my name and the date. For those conceived out of the void, I never put a title; it should be enough just to put "Peinture".' Miró sometimes referred to his work of this type as his 'dream paintings'.

Oil and black chalk on canvas, 140 × 113.5
Purchased 1979
GMA 2078

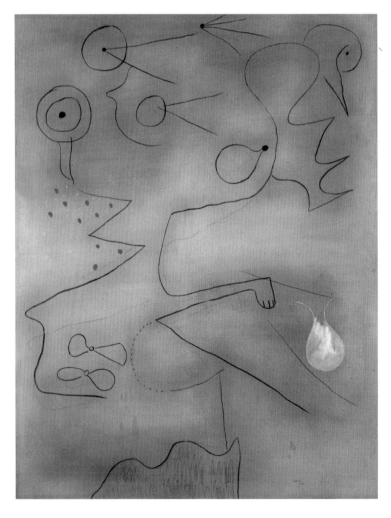

Joan Miró 1893–1983
Painting (Peinture) 1927

This was painted in Miró's studio at 22 rue Tourlaque (Jean Arp's old studio), which Miró occupied from January 1927. During this year he concentrated on his work to a remarkable degree, rarely going out or socialising. In February he wrote to a friend: 'I work a lot. I see very few people, only from time to time to show that I am alive. Nobody has seen what I did this past summer nor what I am doing now.' There is a pencil study for this painting in the Fundació Joan Miró, Barcelona. The form at the bottom appears with a number of variations in Miró's work as a profile of a man. The two figures can be traced back to the figure in *Maternity* (see pp.50–1). The star form appears in a number of paintings of this period. Gabrielle Keiller bought the painting from the Mayor Gallery, London in 1973. She owned another Miró painting, *The Cry* (*Le Cri*), 1925, but sadly this was damaged during a fire at Keiller's home in 1986.

Oil on canvas, 33 × 24.1
Bequeathed by Gabrielle Keiller 1995
GMA 4007

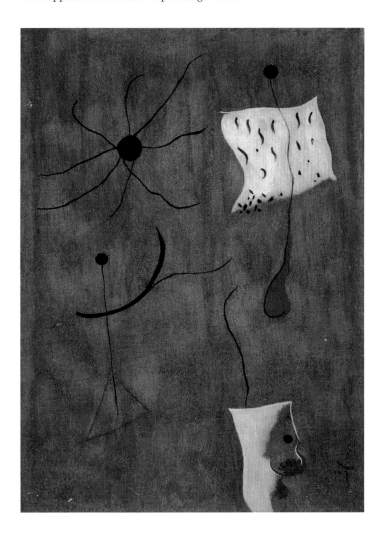

Max Ernst 1891–1976

Ernst said that he began using the frottage (rubbing) technique when staying in a hotel at Pornac in Brittany one rainy day in 1925. Struck by the grain pattern in the old, scrubbed floorboards, he later wrote that he 'drew from these floorboards a series of drawings by placing on them casually sheets of paper that I undertook to rub with a lead pencil ... I was surprised at the sudden intensification of my visionary faculties and at the succession of images, hallucinating and contradictory, superimposing themselves one above the other.' He soon branched out, making frottages from other kinds of textured surfaces including leaves and fabric. The frottage element in *She Keeps her Secret* seems to have been made primarily over a cloth surface rather than wood, hence the irregular folds. The background has been painted out to give a stark white sky.

She Keeps her Secret dates from 1925. It is one of thirty-four original frottage drawings which were published as a portfolio of collotype prints under the title *Histoire Naturelle* in 1926; it had an introductory text by Jean Arp. There were 300 copies of the portfolio published; the Gallery of Modern Art holds two sets, one from the Penrose collection and the other from the Keiller collection.

Frottage was suitable for drawings on paper, but the thick and textured nature of canvas made it a difficult technique to use in painting. *Sea and Sun* is one of a series of paintings dating from the mid-to-late 1920s in which the *grattage* (from the French: to scrape or scratch) technique was used. Instead of rubbing, Ernst scraped through the wet paint with a forked or combed instrument. The effects obtained by such methods were central to Ernst's Surrealist ideals, allowing chance rather than the conscious mind to play an important role. *Sea and Sun* depicts the sun's descent into the ocean. The imagery has been compared to old alchemical illustrations, which Ernst admired, and which dealt with themes of transformation and rebirth.

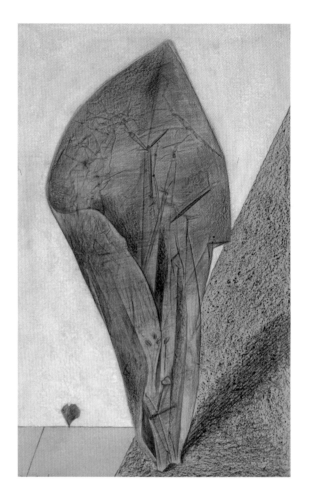

She Keeps her Secret
(Elle garde son secret) 1925

Frottage, pencil and white gouache on paper, 43 × 26.5
Purchased with assistance from the Heritage Lottery Fund and The Art Fund 1995
GMA 3899

Sea and Sun
(Mer et soleil) 1925

Oil on canvas, 54 × 37
Purchased 1970
GMA 1119

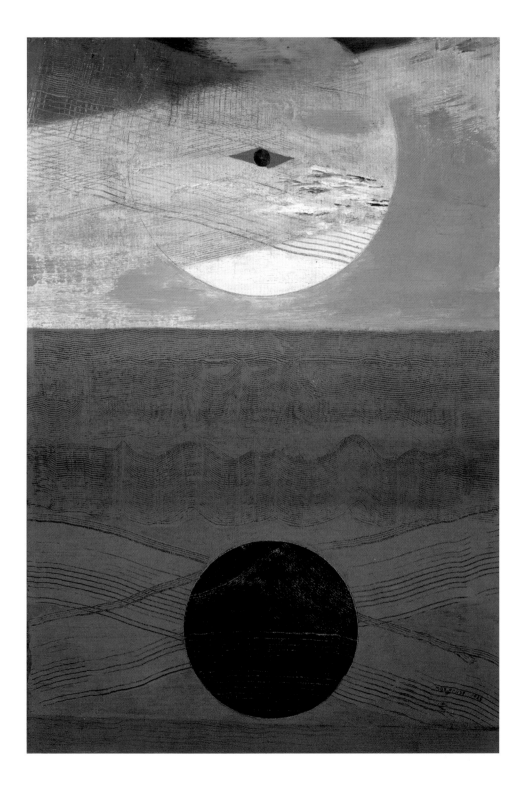

Max Ernst 1891–1976
The Great Lover I (Le Grand amoureux I) 1926

The bowler-hatted man in *The Great Lover*
is holding a female figure, whose breasts are
clearly visible, but whose head has almost
vanished. He holds the woman almost ten-
derly – a sentiment that is offset by his blank
eyes, bulky frame and threatening anonymity.
In 1926 Ernst and Miró worked on Sergei
Diaghilev's production of *Romeo and Juliet*
and it is possible that the couple in *The Great
Lover I* relate to this: the title certainly indi-
cates a connection, even if there is no strong
evidence of romance. The complex layering of
apparently conflicting themes and emotions
in *The Great Lover* – love and sexuality, vio-
lence and menace – is archetypally Surrealist.
Ernst was well equipped to deal with matters
of the subconscious since he had studied psy-
chology at university and was familiar with
Freud's writings. The section on the left and
the 'tyre mark' to the right were created by a
combination of frottage and *grattage*, in which
the canvas was laid over a rough surface and
the paint layer was rubbed and scraped. The
painting once belonged to André Breton,
who may have bought it as early as 1926. He
illustrated it in his book *Le Surréalisme et la
Peinture*, published in 1928. A second version
of *The Great Lover* also exists.

Oil and black crayon on canvas, 100.3 × 81.2
Purchased 1980
GMA 2134

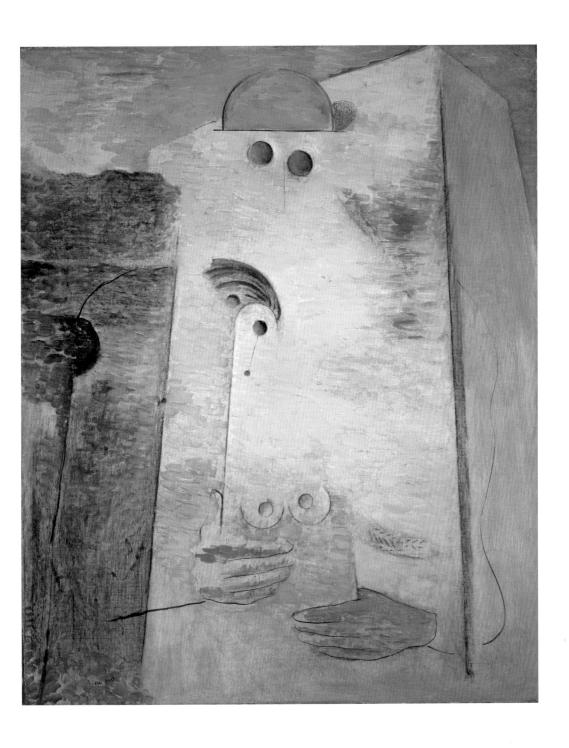

Max Ernst 1891–1976
Max Ernst Showing a Young Girl the Head of his Father 1926–7

The French title of this work, *Max Ernst montrant à une jeune fille la tête de son père*, is ambiguous. It could mean 'Max Ernst Showing a Young Girl the Head of *his* Father' – or alternatively *'her'* Father'. In an autobiographical text, Ernst stated that immediately after inventing the frottage technique in 1925, 'I saw myself, *showing a young girl the head of my father.*' So the father in question could be Ernst's – in which case the 'young girl' could be Ernst's beloved sister, who died when he was just six. Whatever the case, the painting is, like so many of Ernst's works, rife with Oedipal conflict.

It is executed in two different styles: the figures are painted with precision and some realism, while the forest behind them is done in the frottage technique. The forest was one of Ernst's favourite subjects (see p.69). Like *The Great Lover I*, André Breton reproduced this painting in *Le Surréalisme et la Peinture* in 1928.

Oil on canvas, 114.3 × 146.8
Accepted by H.M. Government in lieu of
Inheritance Tax and allocated to the Scottish
National Gallery of Modern Art 1998
GMA 3972

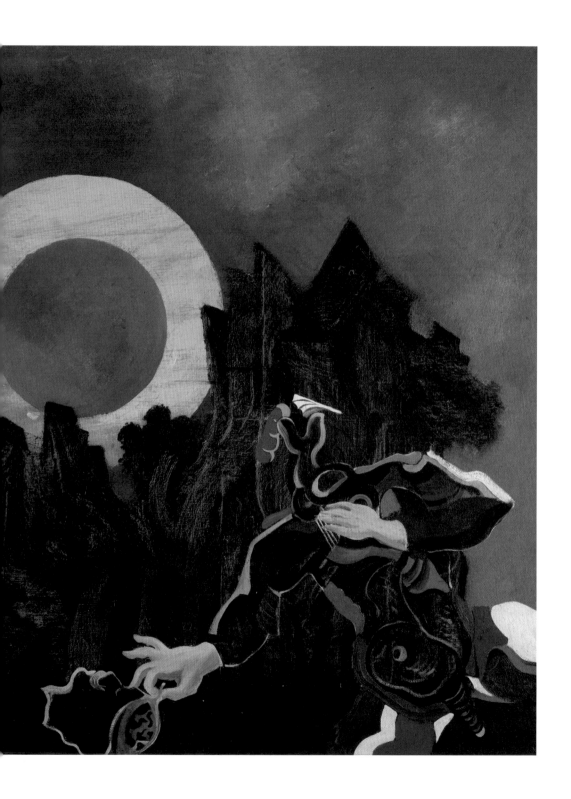

André Masson 1896–1987

Born in northern France and brought up in Belgium, André Masson was seriously wounded in the First World War; on being discharged he went to live in the south of France. He returned to Paris in 1922 and became involved with the Cubist group. Through his neighbour and close friend Joan Miró he also associated with members of the future Surrealist group. *The Rope* dates from 1924, when Masson was still attached to Cubism but was beginning to move in a Surrealist direction: the bottle has a bird-like head, which appears almost to be pecking the headless figure in the background; the cord itself looks remarkably animated. Masson's first solo exhibition was held at the Galerie Simon, Paris – the 'home gallery' of the Cubists – in February 1924. André Breton bought one of the paintings and met Masson for the first time. Masson had been making automatic pen drawings for some months already, but acknowledged that he

found it more difficult to bring this approach to painting. It was only in 1926 that he hit upon a way of subverting compositional structure and bringing chance into his painting by throwing sand on them while they were still wet. Using this technique, Masson managed to produce unusual effects of metamorphosis.

Many of Masson's paintings and drawings of the late 1920s depict scenes of sex and unbridled violence. However, in 1934, following a move to Spain, he made a number of paintings of landscape and undergrowth, often featuring insects. Like many of the Surrealists, Masson was fascinated by the more macabre members of the insect world, particularly the female praying mantis, which sometimes devours the male after mating. The Gallery of Modern Art also holds the book *Le Con d'Irène*, 1928, by Louis Aragon with etchings by Masson, and an oil painting of 1951, *The River in Winter (La Rivière en hiver)*.

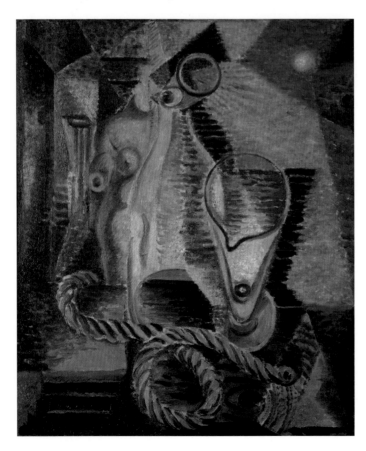

The Rope
(La Corde) 1924

Oil on canvas, 45.1 × 38.2
Purchased with assistance
from the Heritage Lottery
Fund and The Art Fund 1995
GMA 3889

In the Grass
(Dans l'herbe) 1934

Oil on canvas, 55.2 × 38.1
Private collection, courtesy
the Mayor Gallery, London

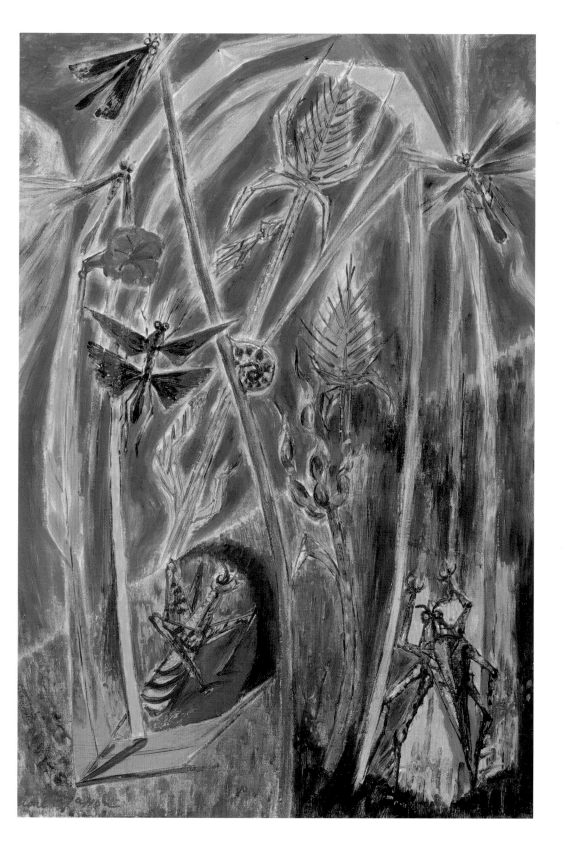

René Magritte 1898–1967
The Magic Mirror (Le Miroir magique) 1929

René Magritte was born in Belgium and,
apart from a few years spent in Paris in the
late 1920s, he lived there all his life. Unlike
those Surrealists who believed that the
unconscious could express itself through
chance and automatic techniques, Magritte
planned his paintings with meticulous rigour
and executed them with all the trompe l'oeil
skills of a traditional painter. The results are
surprisingly realistic images of seemingly
illogical scenes. Magritte's deadpan style
owed much to Giorgio de Chirico, and like De
Chirico, Magritte would undermine the logic
of illusionism by tampering with scale and
perspective and by placing unrelated objects
in unexpected settings.

 The Magic Mirror was painted in the
Parisian suburb of Le Perreux-sur-Marne,
where Magritte lived from 1927 to 1930. He
started using words in his paintings in 1927.
Miró had incorporated words into his paint-
ings at an earlier date, but Magritte used them
differently, to highlight the fraught relation-
ship between language and the things it
represents. In some of these 'word paintings',
the identity of the image is clear; in others,
including *The Magic Mirror*, it is not. Here,
the pale pink oval form, of indeterminate
dimensions, resembles a bathroom mirror or
a toilet seat. The words 'corps humain' mean
'human body', perhaps suggesting that this
is a bathroom mirror reflecting the written
equivalent of a person.

Oil on canvas, 73 × 54.5
Bequeathed by Gabrielle Keiller 1995
GMA 3997

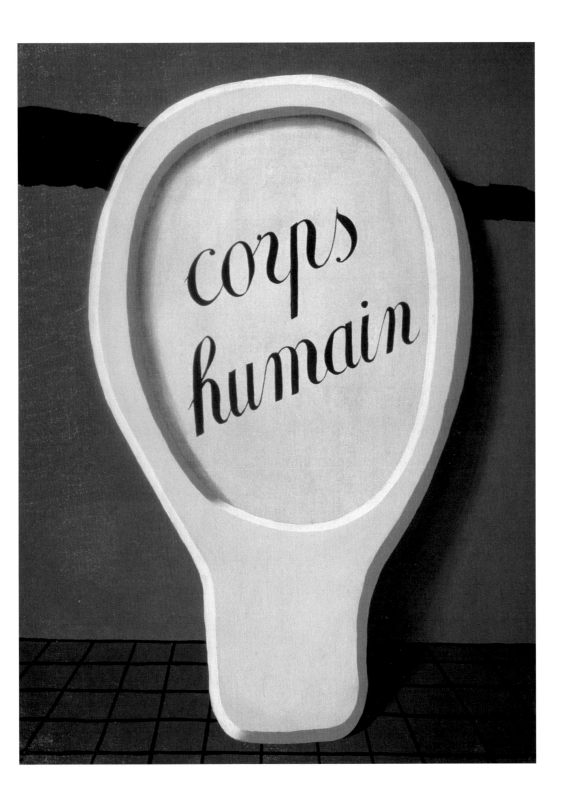

René Magritte 1898–1967
Threatening Weather (Le Temps menaçant) 1929

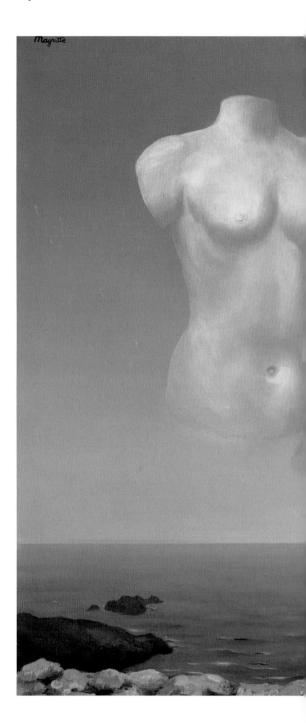

In August 1929, Magritte and his wife
Georgette, together with Paul and Gala
Eluard and others, spent a holiday near
Salvador Dalí's home at Cadaqués, on
Spain's north-east coast, near the French
border. This scene shows the bay near
Dalí's house; a number of Dalí's paintings
depict the same bay (see p.123). Instead of
clouds, three ghostly objects hover in the
sky: a female torso, a tuba and a chair with
a rush seat. The painting has a particularly
vivid palette, and it has been suggested
that this is a response not only to the
bright Mediterranean light, but also to
the paintings Dalí was making at the time.
The holiday in Cadaqués proved equally
important for Dalí, for he fell in love with
Gala Eluard, Paul's wife (Gala and Paul had
previously lived in a ménage-à-trois with
Max Ernst). Gala remained in Cadaqués and
later married Dalí.

The painting belonged to Paul Eluard,
who bought it directly from Magritte, pos-
sibly when they were both in Cadaqués.

Oil on canvas, 54 × 73
Purchased with assistance from the Heritage
Lottery Fund and The Art Fund 1995
GMA 3887

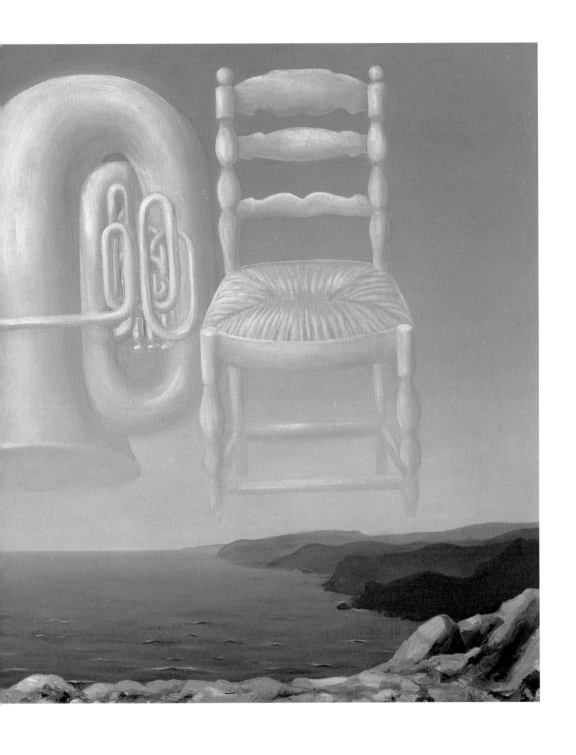

Francis Picabia 1879–1953
Subtlety (Sotileza) c.1928

Sotileza presents three unrelated portrait images layered over each other. There is the blue, bug-eyed image of the Madonna, partly copied from a Catalan Romanesque painting; a bullfighter's face appears within her face, accompanied by his montera hat and toreador's outfit and a poster in the background; and there is a pretty 'pin-up' portrayal of a woman in a mantilla beneath. Picabia's pictures of this type are known as 'Transparencies'. Picabia's father was Cuban but of Spanish descent and Picabia enjoyed travelling to Spain and often used Spanish subject matter. His use of unfashionable, kitschy imagery was done in deliberate opposition to the studied iconoclasm of Dada and Surrealist art. He produced an exhibition of Spanish paintings in 1923, thereby incurring Breton's disapproval. Picabia was unapologetic: 'There was a slight irony intended. It's a bit ridiculous to paint Spaniards, more so to exhibit them. But I find Spanish women beautiful and not having a speciality, like other painters and writers, I have no fear of compromising myself.' The particular imagery in this work may have been found on a summer holiday Picabia spent in Barcelona in 1927.

Gouache on paper, 75.7 × 55.7
Bequeathed by Gabrielle Keiller 1995
GMA 4074

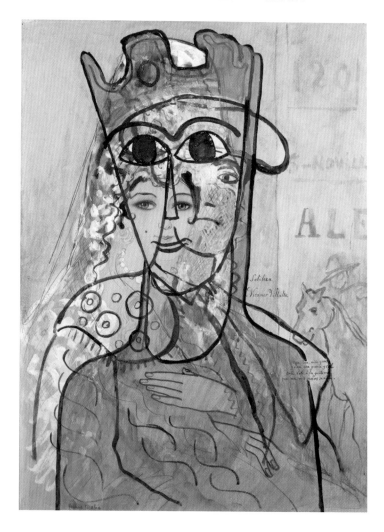

Max Ernst 1891–1976
The Forest (La Forêt) c.1928

As a child, Ernst often went for forest walks with his father. In an autobiographical outline, written in the third person, Ernst later wrote of one of his earliest memories: 'Max never forgot the enchantment and terror he felt when, for the first time ... the father led him into the forest. (Echoes of this feeling can be found in many of M.E.'s own Forests, Visions, Suns and Nights).' The dark, mysterious forest, a recurrent theme in German Romantic art, was one of Ernst's favourite motifs. His earliest representations of the subject are found in collages of 1920 in which trees are formed by narrow strips of wallpaper. Between 1927 and 1928 he painted a series of forest pictures using the same *grattage* technique previously employed in *The Great Lover* (see pp.58–9). In many of these works a disk representing the sun or moon descends on the horizon, to disappear into the impenetrable forest of night. Ernst's

feelings about forests were ambivalent. He wrote of 'the wonderful joy of breathing freely in an open space, yet at the same time the distress at being hemmed in on all sides by hostile trees'. It has been suggested that his many forest paintings refer to the border divisions in post-war Europe and to the stress of being a German resident in France in the 1920s, 'hemmed in' by 'hostile' anti-German sentiment.

Oil on canvas, 54.2 × 65.5
Presented by Miss E.M. Dolbey 1980
GMA 2217

Salvador Dalí 1904–1989
Bird (Oiseau) c.1928

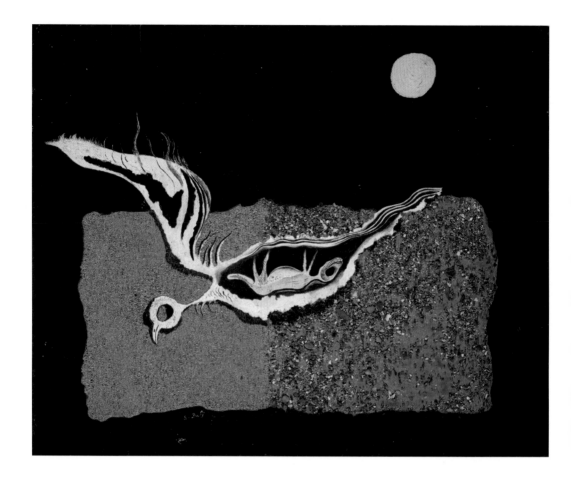

Although based in Spain, Salvador Dalí was keenly aware of recent developments in Surrealist art in France; he visited Picasso in Paris in 1926, and he also knew Miró. In 1928 he described himself, for the first time, as a Surrealist. *Bird* was painted in Cadaqués, a fishing village on the Costa Brava, where the Dalí family owned a house by the bay. Many of Dalí's works of this period depict beach scenes and *Bird* actually incorporates the beach: the patch on the left is sand, set into a thick layer of brown paint, while the patch on the right is shingle. As Dawn Ades has pointed out, the theme of this painting may be indebted to André Breton. In his book *Clair de Terre* of 1923, Breton recounted a dream in which he and some friends were swimming near a beach when they startled two birds. One of his friends shot at the birds, which then fell into the sea. By the time they had washed up on the beach, the birds had transformed into beasts resembling cows or horses. Some of Dalí's art criticism of this period is based on Breton's writings, so it is plausible that *Bird* has its origin in Breton's account.

The painting formerly belonged to the poet Paul Eluard. In the summer of 1929, Eluard, his wife Gala, and Magritte, spent a holiday with Dalí in Cadaqués (see p.66). Eluard may have acquired this painting at that time.

Oil, sand, pebbles and shingle on board, 49.7 × 61
Purchased with assistance from the Heritage Lottery Fund and The Art Fund 1995
GMA 3883

Salvador Dalí 1904–1989
The Signal of Anguish (Le Signal de l'angoisse) c.1932 / 1936

In the late 1920s Dalí had introduced double imagery into his work: here, the woman's tangled hair also reads as the profile of an old man with a bulbous nose. In his autobiography (much of which is unreliable), Dalí recalled an incident in which he watched a buxom woman up a ladder, picking linden blossom. Eager to get a closer look, he spied on her from a small upstairs window in his house. This and other alleged erotic encounters inspired a number of Dalí's paintings of the early 1930s. Many such works feature common elements: naked women, phallic cypress trees, shrouded figures, open windows and flaccid forms, set in landscapes with deep, raking shadows.

Dalí's erotic fantasies and anxieties had been given full rein after meeting Gala Eluard in 1929. Gala promptly left Paul Eluard, her then husband, and married Dalí in January 1934 – around the time *The Signal of Anguish* was painted. Henceforth, erotic imagery dominated Dalí's art. At the same time he adopted a meticulously detailed oil-painting technique. Dalí held exhibitions in New York in 1933 and 1934, and in London in 1934. By this date he had become the most notorious member of the Surrealist group.

This painting was reproduced in the art review *Minotaure* in May 1934; the work was substantially finished, but some minor changes were made in 1936, notably the addition of a branch which extends across the figure's arm and shoulder.

Oil on wood, 21.8 × 16.2
Bequeathed by Gabrielle Keiller 1995
GMA 3956

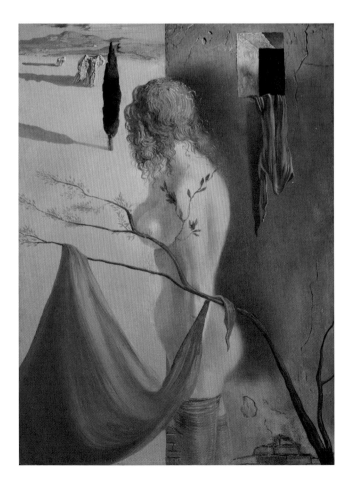

Salvador Dalí 1904–1989
Five Minutes about Surrealism (Cinq Minutes à propos du surréalisme)

Dalí's fascination with film-making is evident from his involvement in *Un Chien Andalou*, 1929, *L'Age d'or*, 1930, and his film script for *Babaouo* of 1932. In 1936 there was an abortive attempt to collaborate with the Marx Brothers; in 1945, his 'dream sequence' for Hitchcock's *Spellbound* proved more successful. He even collaborated with Walt Disney.

These pages, dating from the early 1930s, contain the outline for an unrealised documentary film about Surrealism. The first page states that this was to be 'A documentary film by Salvador Dalí made with the collaboration of the Surrealist group'. Included with the manuscript pages are three photographs: a photograph of six studies revealing the layered imagery of Dalí's painting *Invisible Sleeping Woman, Horse, Lion*, 1930; a black and white reproduction of his painting *The Persistence of Memory*, 1931; and a photograph of Man Ray's *Indestructible Object*, 1923. These were, no doubt, three of the 'Surrealist documents' that Dalí mentions on the second page of the script, and which he intended to use in the film.

The script sets out the basic schema for the film and the typescript is liberally illustrated with ink drawings by Dalí. The pages are divided into three columns headed 'Words', 'Images' and 'Sounds', from which it is apparent that this was to be a talking film with a separate sound-strand to create an aura of Surrealist disorientation. The 'images' column includes written descriptions as well as drawings, the latter often spilling across the page. The talking script starts with Freud and the concept of conscious and unconscious thought and ends with the appearance of Breton speaking about the effect of Surrealism's irrational and poetic activity on the future world.

The Gallery of Modern Art's collection also includes correspondence between Dalí and Breton: actual letters and postcards which Breton sent to Dalí; and draft copies of Dalí's responses, mostly in his hand, but with some transcribed by his partner Gala, whose writing in French was better. Breton's letters raise his concern for coherent and uniform action on the part of the Surrealist group, and include proposals for new issues of *Minotaure*, plans for Surrealist exhibitions, and accounts of the 'considerable success' of his and Eluard's lecture tour to Prague in 1935.

The most important part of the correspondence dates from 1934. It records Breton's strenuous efforts to make Dalí conform to Surrealist orthodoxy and contribute more regularly to the activities of the group. In his colourful replies, Dalí asserts his 'unconditional' adherence to Surrealism while at the same time retaining his right to express himself according to his own inner compulsions. Growing tension between the two men about Dalí's fascination with Hitler and dubious attitude towards Lenin culminates in a letter from Breton dated 3 February 1934; Dalí is informed that he has been excluded from the group for 'counter-revolutionary acts tending to the glorification of Hitlerian fascism'. Subsequently, Dalí's lengthy explanations and comical behaviour in defending himself eventually mollified Breton and the ban was rescinded.

Thirteen pages of typed text, with pen and ink drawings and photographs, fixed into an album, 33 × 24
Bequeathed by Gabrielle Keiller 1995
GMA A42/1/GKL001
Illustrated: p.9 and p.15

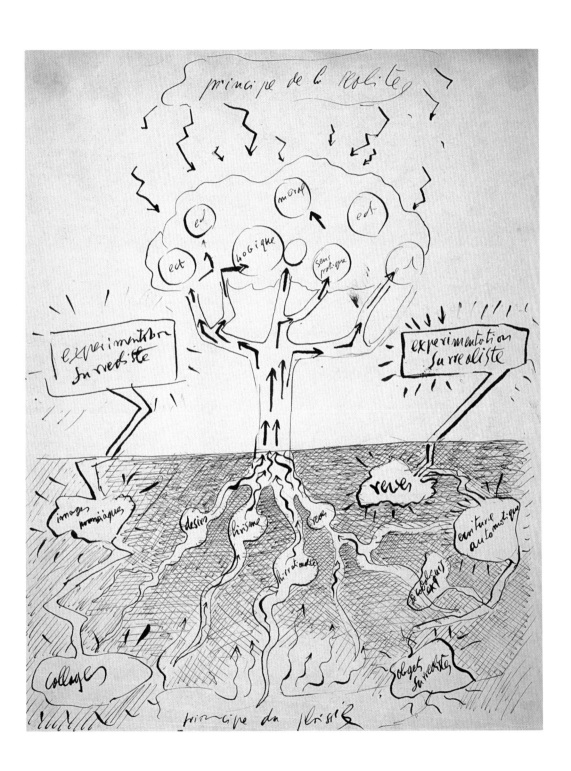

Yves Tanguy 1900–1955
Outside (Dehors) 1929

Yves Tanguy said that he decided to become an artist in 1923, when, while riding on a bus, he glimpsed two paintings by Giorgio de Chirico in the window of an art gallery. He had no formal art education or arts background: he had previously been in the merchant navy and worked in a press agency. But by 1925 he had met André Breton and joined the Surrealist group.

Tanguy's family came from the Finistère area of Brittany and as a child he spent his summer holidays there. The prehistoric menhirs and dolmens in the landscape left a strong impression on him, and they seem to reappear, as if in dream-like scenes, in his paintings. His background in the merchant navy may also be relevant, for the paintings suggest underwater landscapes. It is an elemental, half gassy, half liquid world, giving rise to primitive, amoeba-like forms. The themes of genesis and the birth of the world were popular among the Surrealists, particularly Miró, whose work exerted a strong influence on Tanguy. Tanguy was the most untheoretical of artists, preferring never to explain his work; indeed he said that it could not be explained. *Outside,* one of Tanguy's largest early paintings, belonged to the Surrealist artist Valentine Hugo, who sold it to her friend Paul Eluard (several of whose books she illustrated).

Oil on canvas, 116.5 × 89.5
Purchased with assistance from the Heritage Lottery Fund and The Art Fund 1995
GMA 3893

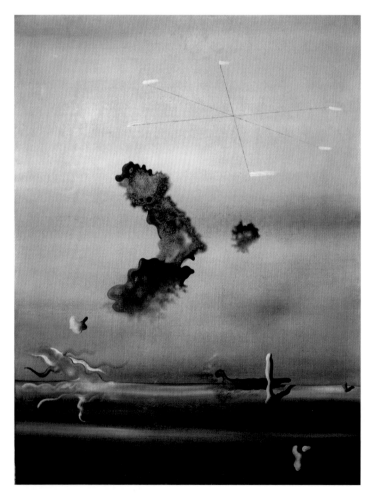

Yves Tanguy 1900–1955
The Ribbon of Excess (Le Ruban des excès) 1932

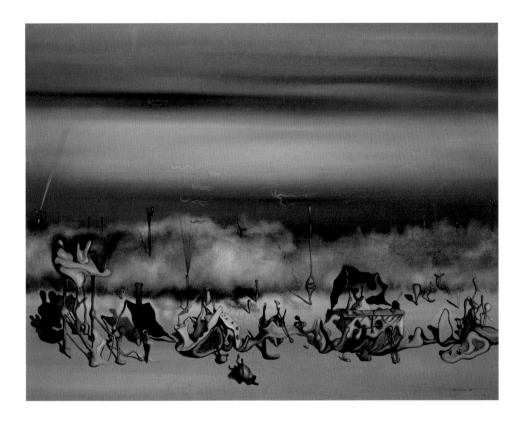

The Ribbon of Excess marks Tanguy's shift from the spacious 'underwater landscapes' of the late 1920s – as seen in *Outside* – to a world populated by intricate, bean-like forms, laid out as if on a stage. It was reproduced in the final issue of *Le Surréalisme au Service de la Révolution* in May 1933, and was shown in the *Exposition Surréaliste*, held at the Galerie Pierre Colle in June 1933. These works of the 1930s, in which weird objects cast long, hard shadows, suggest desert landscapes as much as a sub-aquatic world. Tanguy's trip to Morocco in 1930, and the sight of strange geological features in the Atlas Mountains, may have influenced this change in direction. Tanguy's friendship with sculptors including Giacometti and Arp may also have prompted this shift away from amorphous effects towards sculptural forms. Although he only made a few object sculptures, Tanguy described a project for making them in great detail in an article in *Le Surréalisme au Service de la Révolution*, December 1931.

Oil on wood, 35 × 45.2
Accepted by H.M. Government in lieu of Inheritance Tax and allocated to the Scottish National Gallery of Modern Art 1998
GMA 4084

Alberto Giacometti 1901–1966
Disagreeable Object, to be Thrown Away (Objet désagréable, à jeter) 1931

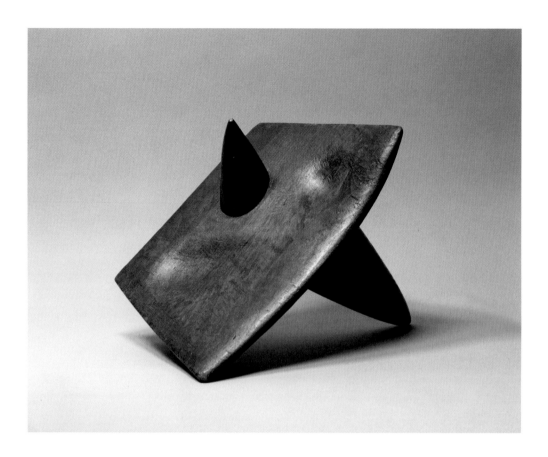

Alberto Giacometti was the son of the Swiss painter Giovanni Giacometti. In 1922 he moved from Switzerland to Paris. By 1930 Giacometti was making strange objects suggestive of cruelty, danger, sex and dreams; that year he joined the Surrealist group. In 1933 he referred to the works of this period: 'For some years I have only realised sculptures that have appeared to me in my mind in a finished state, I have reproduced them in three dimensions without changing anything, without asking myself what they mean.'

This sculpture can be picked up and played with and it stands up in a variety of positions. Giacometti made only a handful of wooden and marble sculptures of this type in the early 1930s (or rather they were made by craftsmen, following his designs). *Disagreeable Object, to be Thrown Away* – also known as *Object without a Base* – is at once funny and sinister, enigmatic and intriguing, offensive

yet satisfying to hold. It was shown in the *International Surrealist Exhibition*, London, 1936, and the catalogue lists Roland Penrose as the owner. Penrose's diary shows that he visited Giacometti in Paris on 24 October 1935, when he was preparing the London exhibition, and it is possible it was bought then.

Wood, 19.6 × 31 × 29
Purchased 1990
GMA 3547

Alberto Giacometti 1901–1966
Head / Skull (Tête / Crâne) 1934

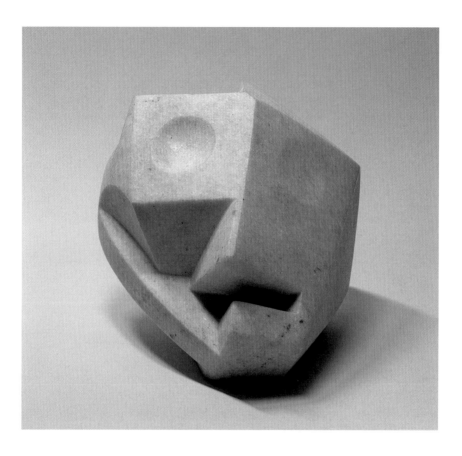

Giacometti had a keen interest in death; or, one could say, in life, and the moment before it ceases to function. This was also a central preoccupation of Existentialism, a movement with which Giacometti is often associated. *Head / Skull* presents a head which on one side appears living, its mouth gaping open as if gasping for breath, while the other side is jagged and skull-like. Giacometti had seen two acquaintances die by 1934, when this work was made, and he described the profound impact these events had upon him. The difference between life and death remained a central theme in his work: in 1951 he commented that, 'Bit by bit, the difference between seeing a skull in front of me or a living person became minimal ... The skull takes on a living presence ... A skull is not the same as a table, a fruit or an object, it is after all, closer to a living head than to anything else! ... and that has always troubled me ... Working from a living person – and this was almost frightening – I could practically see the skull.' Bronze versions of *Head / Skull* exist, as they do of *Disagreeable Object, to be Thrown Away*.

Marble, 20 × 20 × 23
Private collection

Woman with her Throat Cut is the most complex and macabre of all Giacometti's Surrealist sculptures. This figure appears to be a cross between a woman and some sort of insect. One of her arms ends in a kind of shovel, while the other is a cigar-shaped object. Giacometti said that this element referred to the nightmare of being attacked but not being able to lift one's hand to defend oneself. The slashed throat, splayed legs and jagged forms all conspire to suggest that the woman has been raped and left to die. But although she appears to be in the throes of death, her taut, aggressive form also suggests a trap, like a Venus fly-trap or a man-trap, primed to shut tight if the arched torso is touched. The resemblance to scorpions and praying mantis may be deliberate since in both cases the female sometimes devours the male after mating. The mantis uses sharp teeth on its legs – not unlike the spikes on the woman's leg in the sculpture – to cut its prey into digestible portions. The sculpture therefore embodies a range of conflicting states: pain and ecstasy, human and insect, attractive and repulsive, dying and alert. We are even invited to participate in the scene since the phallic 'hand' can be swivelled around on a hook.

Woman with her Throat Cut may have been inspired by a short story about the serial killer Jack the Ripper, written by Giacometti's poet friend, Robert Desnos in 1928. In his story, Desnos described the murder in detail, writing of the victim's suffocation and rising stomach, how her legs folded underneath the body, and of the cutting of the throat and disembowelment. Giacometti was very close to his mother and had a string of unsatisfactory relationships with women. To the astonishment of his closest friends, he married in 1949.

There are four other bronze casts of *Woman with her Throat Cut* (Guggenheim Collection, Venice; Centre Georges Pompidou, Paris; Alberto Giacometti Foundation, Zurich, on loan to the Kunstmuseum Basel; and Museum of Modern Art, New York). The present bronze is the fifth and final cast, made in 1949 or 1950.

The Gallery of Modern Art also owns a small drawing relating to the sculpture. It was reproduced in the periodical *Minotaure*, December 1933.

Woman with her Throat Cut (Femme égorgée) c.1932

Pen and ink on paper, 31.6 × 24.5
Bequeathed by Gabrielle Keiller 1995
GMA 3982

Woman with her Throat Cut (Femme égorgée) 1932

Bronze, 22 × 87.5 × 53.5
Purchased 1970
GMA 1109

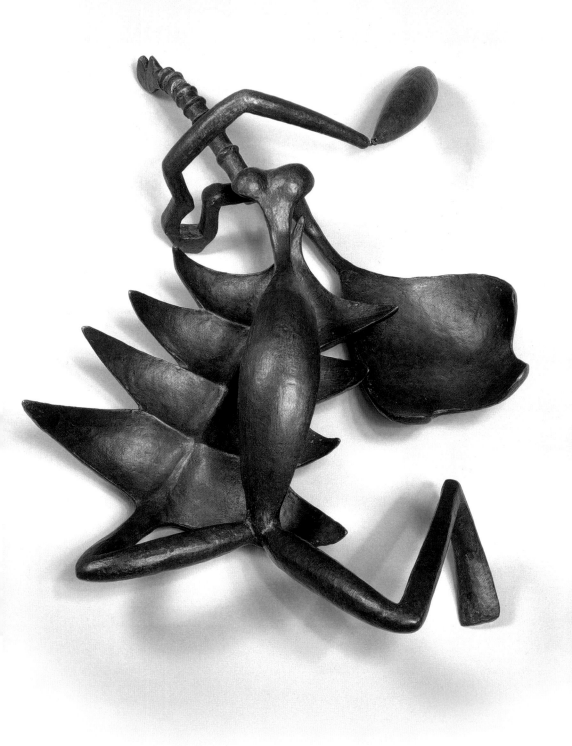

Max Ernst 1891–1976

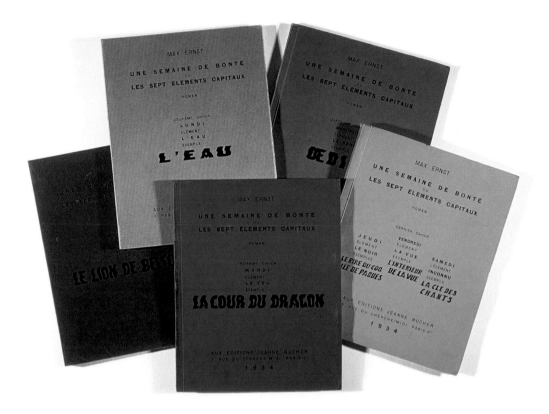

Une Semaine de bonté ou les Sept Eléments Capitaux. Roman 1934

Paris, Editions Jeanne Bucher 1934
Five volumes, each with a frontispiece etching, contained in slipcase, 28 × 22.5 (edition: no.X of XVI special copies)
Purchased with assistance from the National Heritage Memorial Fund and The Art Fund 1994
GMA A35/2/RPL1/0344

Ernst made two short collage novels in 1922 and, between 1929 and 1934, three much longer ones, each relying on cut-up nineteenth-century engravings: *La femme 100 têtes*, 1929; *Rêve d'une petite fille qui voulut entrer au Carmel*, 1930 and, in 1934, *Une Semaine de bonté ou Les Sept Eléments Capitaux* (A Week of Kindness or Seven Deadly Elements). The Gallery of Modern Art holds copies of all three of these longer books, including one of the twenty de luxe versions of *Une Semaine de bonté*, which also contain five original etchings. The 182 collages featured in *Une Semaine de bonté* were created over a period of just three weeks, during a holiday in Italy. By the judicious and economical use of collage, Ernst produced surprisingly plausible, nightmarish images.

Une Semaine de bonté was published by the Galerie Jeanne Bucher, Paris, between April and December 1934, in five volumes. The original intention had been to publish seven volumes, one for each day of the week, but financial constraints meant that three days were compressed into the fifth volume.

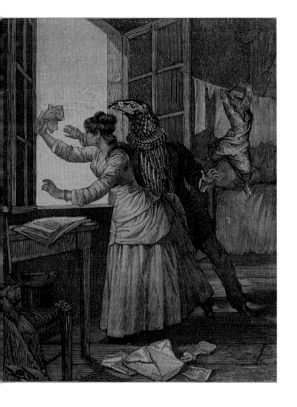

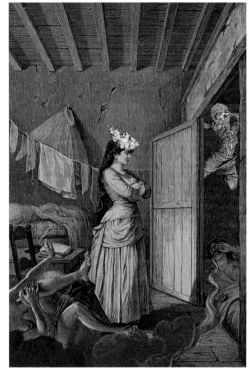

Unlike the earlier collage novels, *Une Semaine de bonté* has no preface or written captions. Jürgen Pech of the Max Ernst Museum in Brühl has identified Ernst's main source material for these two collages in wood engravings from Adolphe d'Ennery's pulp novel *Martyre!* of 1885. Many other images in *Une Semaine de bonté* come from engravings after the nineteenth-century illustrator Gustave Doré. The visual consistency in the 'base' images, and the consistency in Ernst's manipulation of the figures (several are given bat wings and bird heads) means that some kind of narrative is suggested, even if it is obscure.

The project was largely funded by Roland Penrose, who had recently come into his inheritance, following the death of his parents. The Gallery of Modern Art's Penrose Archive holds the correspondence between Penrose, Jeanne Bucher and Ernst, which documents the ups and downs of production. As a token of gratitude, Ernst gave Penrose two of the original collages which had been made for *Une Semaine de bonté* but were not eventually used.

Untitled (unpublished collage for *Une Semaine de bonté)* 1934

Collage of engravings on card, 15.3 × 12.1
Purchased with assistance from the Patrons of the
National Galleries of Scotland 2002
GMA 4475

Untitled (unpublished collage for *Une Semaine de bonté)* 1934

Collage of engravings on card, 20 × 13.5
Purchased with assistance from the Patrons of the
National Galleries of Scotland 2002
GMA 4474

Salvador Dalí 1904–1989 and
Le Comte de Lautréamont (Isidore Ducasse) 1846–1870
The Songs of Maldoror (Les Chants de Maldoror)

Le Comte de Lautréamont was the pseudonym of Isidore Ducasse. His macabre epic prose-poem *Les Chants de Maldoror* was first published in 1869. Along with the provocative writings of the Marquis de Sade, it was one of the most revered texts among the Surrealist group. On 28 January 1933 Dalí wrote to his patron, Charles de Noailles, excitedly announcing that he was about to sign a contract with the Swiss publisher Albert Skira to provide illustrations for a new edition of this iconic poem. It was, apparently, Picasso who had recommended Dalí to Skira.

The original intention had been to publish the book in an edition of 270 copies. But in the end, partly due to Skira's financial difficulties, only sixty copies of the book were printed, along with forty suites containing just the etchings; and the number of etchings in each copy had dropped from fifty-two to forty-two.

Dalí was the perfect choice to illustrate the text and his etchings for Maldoror rank, alongside Max Ernst's *Une Semaine de bonté,* as a highpoint in the Surrealist book. From Dalí's correspondence it is apparent that he was making drawings for the project in January and February 1934 and that he intended making the etchings on copper plates. The justification page records that the prints are original etchings. For many years this was accepted as fact, but Rainer Michael Mason recently established that the prints

are heliogravures, probably made on celluloid sheets and possibly done via a photographic procedure; some have been reworked extensively with etching tools.

The loose sheets seem to have no particular order, and do not illustrate the text. In the catalogue preface to the Galerie des Quatre Chemins exhibition Dalí wrote: 'It is glaringly obvious that the "act of illustration" could in no way restrict the course of my delirious ideas, but would, rather, encourage them to blossom. It could therefore only ever be a question of paranoiac illustrations.' Figures derived from Jean-François Millet's famous painting *The Angelus*, 1857–9, are scattered throughout the etchings, for, as Dalí explained in the catalogue, this icon of piety was the ideal 'delirious' illustration of Lautréamont's most notorious simile, 'Beautiful as the chance encounter, on a dissecting table, of a sewing-machine and an umbrella.'

The Gallery of Modern Art holds other books by Dalí, including *La Femme Visible*, 1930, *Le Revolver à Cheveux Blancs*, 1932 and *Onan*, 1934.

Paris, Skira 1934
Book with forty-two etchings by Salvador Dalí; loose-leaf in paper wrapper inside hardback binder and slipcase, 33 × 25.5 (edition: no.28/210)
Bequeathed by Gabrielle Keiller 1995
GMA A42/2/GKL0015

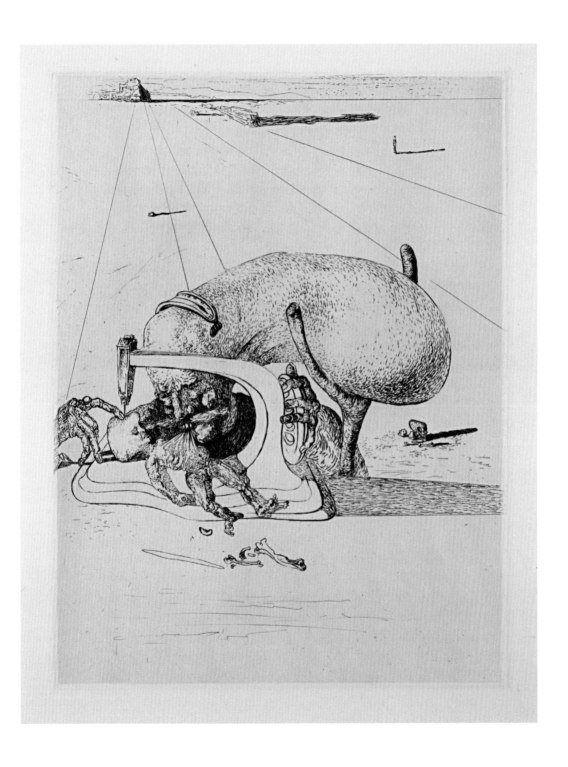

André Breton 1896–1966

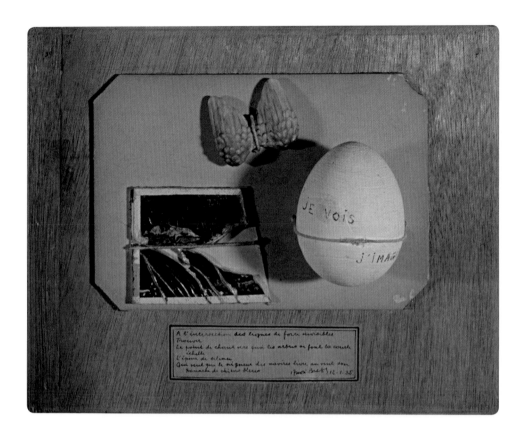

Poem-Object (Poème-Objet) 1935

Collage of objects and inscribed poem on card and
wood, 16.3 × 20.7
Purchased 1993
GMA 3737

André Breton was the leading figure in the
Surrealist movement yet he was neither
a painter nor a sculptor: instead he was a
poet, critic, organiser, director and, some
said, dictator. Serving as a medical auxiliary
during the First World War he was profoundly
affected by the writings of Sigmund Freud,
Jean-Martin Charcot and Pierre Janet,
which discussed issues of insanity and the
unconscious. He met poets such as Guillaume
Apollinaire and Louis Aragon, and artists
associated with the Dada group. In 1919 he
helped launch the avant-garde periodical
Littérature, which became linked to the Dada
cause. The following year he abandoned his
medical studies in order to concentrate on
literature and art. By 1924 Breton had become
a prominent figure in the Parisian avant-garde
and had gathered around him a group of poets
and artists interested in exploring the sub-
conscious. In October that year he published
his *Manifesto of Surrealism* and thereafter

LE DÉCLIN DE LA SOCIÉTÉ BOURGEOISE

*The Decline of Bourgeois
Society (Le Déclin de la société
bourgeoise)* c.1935–9

Collage on paper, 13.5 x 8.7
Bequeathed by Gabrielle Keiller 1995
GMA 3945

became the mastermind of the new Surrealist movement, attracting prospective members and expelling others in an autocratic style.

Many of the Surrealists, including Miró, Giacometti and Dalí, began making 'object sculptures' in the early 1930s: these developed from Dada constructions and from Duchamp's Readymades. A number of writers and poets also made collages and assemblages, for this was an artistic endeavour in which scissors and a vivid imagination counted as much as traditional artistic skills. Breton's collage *The Decline of Bourgeois Society*, which employs a typically Surrealist disjuncture between images, probably dates from the mid-1930s. Breton made about a dozen assemblages during the 1930s and early 1940s; incorporating poems, he gave them the generic title 'Poem-objects'. The fashion for Surrealist objects culminated in exhibitions held at the Charles Ratton Gallery in Paris in May 1936 and at the London Gallery late in 1937.

Poem-Object comprises a plaster egg with the words '*JE VOIS / J'IMAGINE*' (I see, I imagine) inscribed on it in ink, little porcelain wings, a broken mirror and a poem. The objects and poem enjoy a suggestive if ambiguous relationship. The poem reads, in translation: 'At the intersection of the invisible lines of force / find / The song's peak towards which the trees give each other a leg up / The thorn of silence / Who wants the Lord of the ships to give the wind his / panache of blue dogs. André Breton 12–1–35'.

Breton showed several Poem-objects in the exhibition at Charles Ratton's gallery in 1936, including this work. It was also included in the *International Surrealist Exhibition* held in London in June 1936. Most of the continental loans were arranged by Roland Penrose, who had meetings with Breton late in 1935 and in 1936. Penrose bought *Poem-Object* from Breton in July 1936.

André Breton 1896–1966, Jacqueline Lamba 1910–1993 and Yves Tanguy 1900–1955 *Exquisite Corpse (Cadavre exquis)* 1938

The 'Exquisite Corpse' game was explained as follows in the *Abridged Dictionary of Surrealism*, published in 1938: 'Game with a folded paper that consists in several people composing a sentence or a drawing, each ignorant of the preceding collaborations.' It is sometimes said that the Surrealists invented the game, but this is untrue: it was a popular Victorian parlour game and its ancestry can be traced to playing cards which are divided into three sections, which can be swapped about. The National Gallery of Scotland possesses a turn-of-the-century 'Exquisite Corpse' by the Scottish artists Joseph Crawhall, James Guthrie and E.A. Walton.

The term 'Exquisite Corpse' was, however, coined by the Surrealists. It arose when several of the group, playing the written version of the game (*Petits Papiers* – Little Papers), came up with the line: '*Le cadavre exquis boira le vin nouveau*' (The exquisite corpse shall drink the new wine). Breton said that they invented the game in 1925 at 54 rue du Château, the house that the writer Marcel Duhamel shared with Tanguy, Jacques Prévert and Benjamin Péret. The pictorial version of the game appealed to the Surrealists because it involved chance, the automatic and the unexpected and, as with collage, it was something everyone could do: participation did not require any artistic skill. So it was that several of the initiators of the game were writers rather than artists. According to Breton, 'With the *cadavre exquis* we – at last – had at our disposal an infallible method of overruling the mind's critical faculties and completely liberating its capacity for metaphor.'

This work was made on 9 February 1938 when Breton, his second wife Jacqueline Lamba, and Yves and Jeanette Tanguy were staying over the weekend with the art dealer Charles Ratton in Cinqueux, to the north of Paris. Unusually, it is a collage rather than a drawing, and since the paper is not folded, the sections must have been covered to prevent the next player from seeing them, or otherwise, as Elizabeth Cowling suggests, the three players worked together in collaboration.

Collage on paper, 31 × 21.1
Bequeathed by Gabrielle Keiller 1995
GMA 3946

Joseph Crawhall 1861–1913,
James Guthrie 1859–1930 and
Edward Arthur Walton 1860–1922
Untitled
(Game of Heads, Bodies and Legs)

Pencil on paper, 17.5 × 11.6
National Gallery of Scotland, Edinburgh,
Dr Camilla M. Uytman Gift, 1981
D 5102.44

E.L.T. Mesens 1903–1971
As They Understand It (Comme ils l'entendent) 1926

Edouard Léon Théodore Mesens was born in Brussels in 1903. He was known to his friends as 'E.L.T.' Incredibly precocious, he was composing and conducting avant-garde orchestral works in his teens. He became involved with the De Stijl and Dada groups in the early 1920s and was one of the founders of the Belgian Surrealist group in 1926; thereafter he became a picture dealer, selling Magritte's work in particular. He later became a major figure in British Surrealism, serving on the organising committee of the *International Surrealist Exhibition* at the New Burlington Galleries, London, in 1936, and exhibiting four collages in the show. He remained in London much of the following year and settled there in 1938 when, at Roland Penrose's request, he became Director of the London Gallery, at 28 Cork Street. Mesens and Penrose made the gallery the fulcrum of Surrealist activities in London, holding exhibitions of works by Magritte, Ernst, Man Ray, Miró, and Delvaux amongst others. They also launched the British Surrealist magazine, the *London Gallery Bulletin*. Although known as an organiser of Surrealist activities, Mesens also made some impressive photographs, drawings and collages. This work, conceived by Mesens but photographed by Robert de Smet, is one of a pair: the other, *As We Understand It*, shows the knuckle-duster gripped in the opposite way.

Photograph on paper, 17 × 12.8
Private collection, courtesy the Mayor Gallery, London

Paul Eluard 1895–1952
To Each his own Anger (A Chacun sa Colère) 1938

Paul Eluard (his real name was Eugène Grindel) was born in Saint-Denis, on the outskirts of Paris. As a teenager he suffered severe tuberculosis, and spent time in a sanatorium in Switzerland. There he became interested in poetry and met Elena Ivanovna Diakonova – known to all as Gala – whom he married in 1917 (she later left him for Salvador Dalí). He published his first volume of poetry that same year. Towards the end of the First World War he was drawn into the Dada and proto-Surrealist group emerging around André Breton. Hugely admired by many of the Surrealists, and a close friend of Picasso, he assembled an unrivalled collection of Surrealist art, much of it bought directly from the artists. In 1938 he sold the bulk of the collection to Roland Penrose (see pp.17–19), and much of it later found its way to the Gallery of Modern Art. Therefore, many of the works included in this book originally belonged to Eluard. He occasionally made collages and drawings, as did his second wife, Nusch Eluard. This work is clearly inspired by the collages of his close friend Max Ernst, with whom he worked on a number of book projects.

Collage of engravings on card, 30 × 26
The Penrose Collection

Hans Bellmer 1902–1975

The German artist Hans Bellmer became famous, or infamous, for the life-size dolls he made. The first, constructed in the summer of 1933, was a complex, life-size, articulated doll made of wood, metal, plaster and hair. He photographed the doll under construction and in various erotically suggestive positions: these were published in the sixth issue of *Minotaure*, in the winter of 1934 to 1935 and some were incorporated into two books, *Die Puppe*, 1934, and its French edition *La Poupée*, 1936. Photographs of a second doll appeared in *Les Jeux de la poupée* in 1949.

Die Puppe was produced privately in Germany and contains ten black and white photographs of Bellmer's first doll arranged in a series of tableaux vivants. The prose-poem describes the impulses that led him to construct the doll and thus achieve total 'erotic liberation'. Early in 1935 Bellmer visited Paris and met the Surrealists, who already admired his work. Eluard persuaded the publisher Guy Lévis-Mano to print a French edition of *Die Puppe*. The translation of the text took a long time, as Bellmer was determined to preserve the character of the original. When it finally came out, *La Poupée*

contained eighteen photographs, reproduced in a somewhat larger format. The Gallery of Modern Art Archive holds the German and French versions of the book.

Bellmer made another, more flexible doll in 1935. It consisted of various wooden ball-joints and appendages pivoting around a central ball-joint. He made over 100 photographs of this second doll. Fifteen hand-tinted versions of these were reproduced in *Les Jeux de la poupée*. Fourteen prose-poems by Eluard, composed in the winter of 1938 to 1939 in response to Bellmer's *Doll*, were included together with a long introductory text by Bellmer himself, translated into French by Georges Hugnet. Much of the preparatory work for the book, the text, translation, and prospectus designs are in the Gallery of Modern Art's archive. The publishing house originally involved in the project in 1938 was Christian Zervos's Editions 'Cahiers d'Art', but the outbreak of war put a stop to the book. It was not published until 1949, when it appeared with additional text by Paul Eluard. The Gallery of Modern Art holds Bellmer's typescript and other archival material relating to this edition.

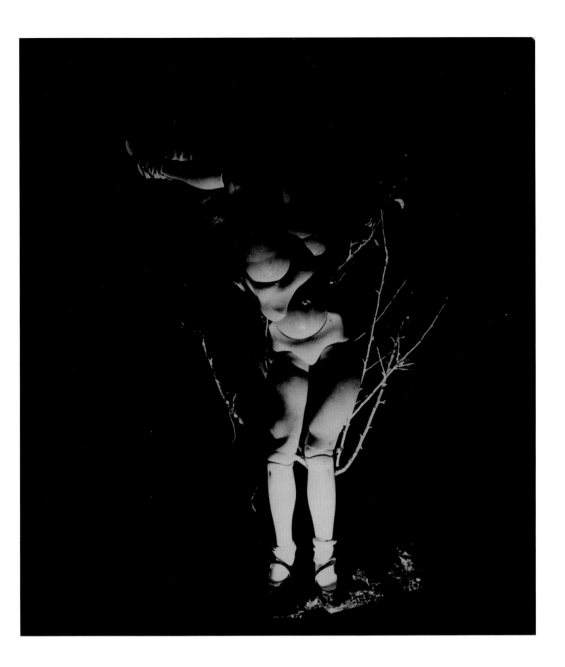

**The Doll's Games
(Les Jeux de la poupée) 1949**

Paris, Les Editions Première 1949
Book with text by Paul Eluard and fifteen hand-coloured photographs by Bellmer, 25 × 19.5
(edition: no.84/142)
Purchased with assistance from the Friends of the National Libraries 1999
GMA A33/3/DSL/023

The Doll (La Poupée) 1933–5

Silver gelatine print, 27.7 × 25
Purchased with assistance from the Patrons of the National Galleries of Scotland 2003
GMA 4681

Pablo Picasso 1881–1973
Nude Woman on the Beach (Nue sur la plage) 1932

Nude Woman on the Beach was painted at Boisgeloup in Normandy, where Picasso owned a property. Although Picasso was never an official member of the Surrealist group, he was much revered by them. His paintings were reproduced in Surrealist magazines and he exhibited at the first Surrealist exhibition, held at the Galerie Pierre in Paris in November 1925. The violent distortion which surfaced in his work in 1925 may be seen as a response to Surrealism.

Nude Woman on the Beach has two contrasting readings. Seen one way, her triangular head is to the left, and she is lying horizontally on the ground; seen another way, the sun with its rays becomes the figure's head and hair, and the dark serpentine form becomes her legs, splayed open, with her navel now transformed into her sex. The phallic anchor points suggestively at her centre.

Roland Penrose wrote that he bought this painting in 1935: 'I had seen reproduced in *Cahiers d'Art* a recent painting by Picasso dated 1932 which seemed to contain magic of a kind I had never known before and to fill me with a longing to see and if possible to own the original.' He asked Picasso if he could buy it and Picasso promptly drove him to his country house at Boisgeloup, where the deal was concluded. Elizabeth Cowling notes that the painting was reproduced in *Cahiers d'Art* in 1936 and that Penrose must have bought it in March 1937 and not in 1935.

Oil on canvas, 33 × 41.1
Private collection, c/o The Penrose Collection

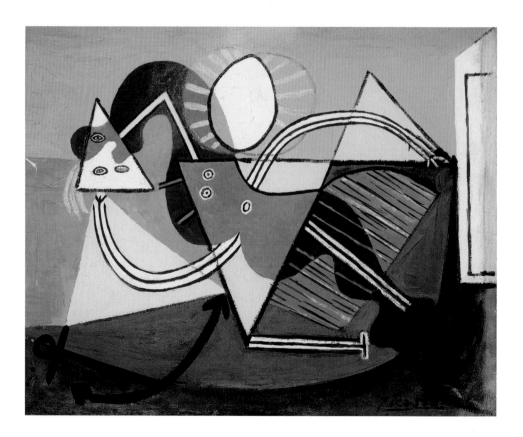

Max Ernst 1891–1976
The Joy of Life (La Joie de vivre) 1936

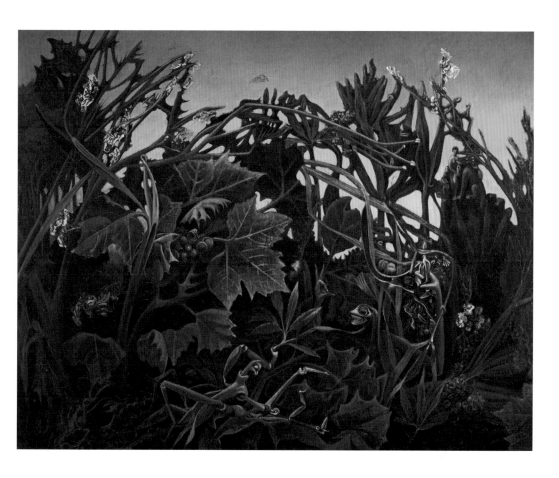

Ernst's paintings of the mid-1930s, which feature forests, ruined cityscapes and overgrown vegetation crawling with insects, have often been seen as his response to the rise of Nazism. In *The Joy of Life* (the title may be an ironic reference to Matisse's famous and joyous painting of the same name) monstrous insects dominate the undergrowth; a tiny human figure is perched up high in the right-hand corner. Ernst's painting seems to imply a battle for survival that has little to do with the joy of life. Although by this date Ernst had lived in Paris for more than a decade, he was still a German national. In 1938 he was interred by the French, then released, and then captured by the Gestapo. He managed to escape to New York in 1941.

This was the first major painting that Roland Penrose acquired. He saw it in Ernst's studio in 1935 and bought it, leaving Ernst to finish it the following year.

Oil on canvas, 73.5 × 92.5
Purchased with assistance from the Heritage Lottery Fund and The Art Fund 1995
GMA 3886

Lee Miller 1907–1977
Pablo Picasso 1881–1973

Lee Miller was born in Poughkeepsie, New York. Her father was a keen amateur photographer; Lee posed for him from an early age and began to take her own photographs. She spent a year studying theatre in Paris from 1925 to 1926, then moved to New York where she worked as a fashion model. She returned to Paris in 1929 and met Man Ray with whom she had a tempestuous three-year affair. Through Man Ray she met many of the Surrealists. She modelled, worked as a professional photographer, and also acted, starring in Jean Cocteau's film, *Le Sang d'un Poète* of 1930. She returned to New York in 1932, opening her own photographic studio. Her work featured alongside that of Man Ray, László Moholy-Nagy and others in a group exhibition at the Julien Levy Gallery in New York in February 1932, and in December she had a solo exhibition at the same gallery.

She met Roland Penrose in the early summer of 1937 at a Surrealist costume ball in Paris, and an affair began. They went together to Mougins, near Cannes, a short time later, joining Picasso, his new partner Dora Maar, and Paul and Nusch Eluard. Picasso had the

only room with a balcony and it was there that he painted, concentrating in particular on portraits. Besides portraits of the Eluards and of Dora Maar, he made five portraits of Miller. Penrose subsequently wrote: 'They were highly coloured, in contrast to *Guernica*, which he had finished only a week or two before in Paris ... Although he made drawings from life, chiefly of Nusch and Dora, most of the paintings were made without a sitter.' Asked about posing for the painting, Lee Miller confirmed: 'You do not sit for Picasso, he just brought it to me one day having painted it from memory.' Penrose bought the painting and gave it to Miller.

Portrait of Space was shot in the latter part of 1937 in Egypt, where Lee Miller lived with her first husband, Aziz Eloui Bey. During the war she worked as a staff photographer for British *Vogue* and then as an official American war correspondent. She covered the liberation of Paris and was the first photographer to enter the concentration camp at Dachau. Thereafter she took few photographs and refused to exhibit. She and Penrose married in 1947. Her work only came to widespread attention after her death in 1977.

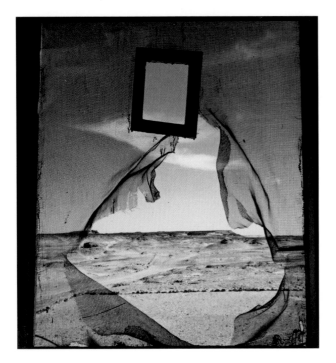

Lee Miller 1907–1977
Portrait of Space, near Siwa, Egypt 1937

Black and white photograph,
30 × 27.8
Lee Miller Archives

Pablo Picasso 1881–1973
Portrait of Lee Miller 1937

Oil on canvas, 81 × 60
The Penrose Collection

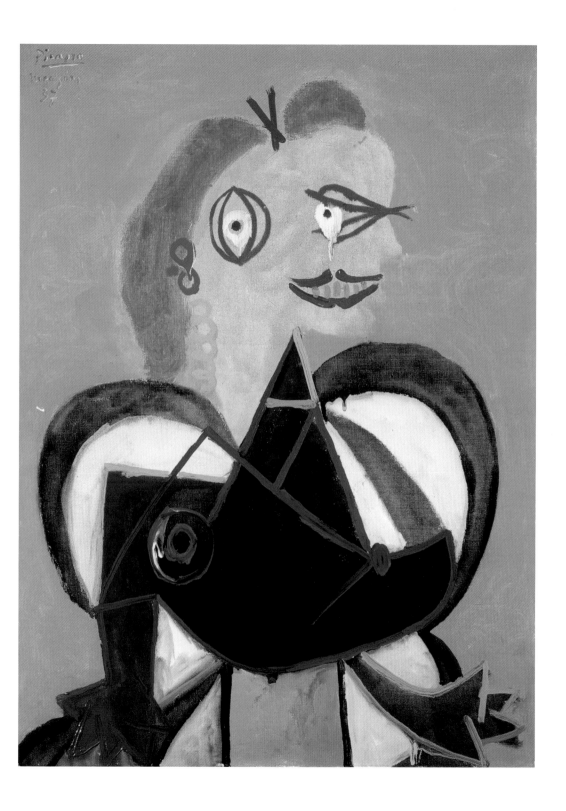

René Magritte 1898–1967
The Bungler (La Gâcheuse) 1935

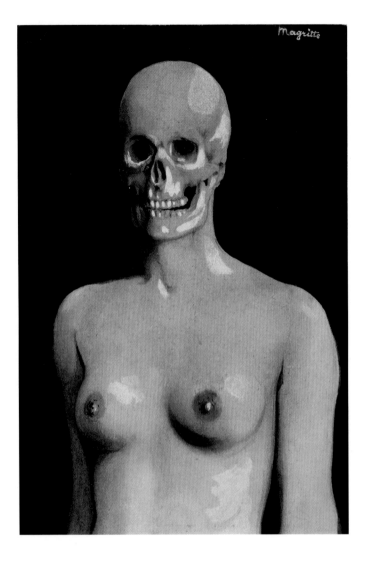

This arresting little picture was painted in
grisaille (grey tones) specifically so that it
could be reproduced in black and white on the
cover of the August 1935 issue of the *Bulletin
international du Surréalisme*. Magritte seems
to have made an oil painting based on the
gouache, but it no longer exists. The simple
expedient of swapping motifs to present an
unexpected new form is a recurrent feature
of Magritte's work. *The Bungler* parallels a
gouache in the collection of Tate, London, *The
Mathematical Mind*, 1936–7, which shows
a mother with a baby's head, holding a baby
with a mother's head.

Gouache on paper, 20 × 13.6
Bequeathed by Gabrielle Keiller 1995
GMA 3998

René Magritte 1898–1967
The Black Flag (Le Drapeau noir) 1937

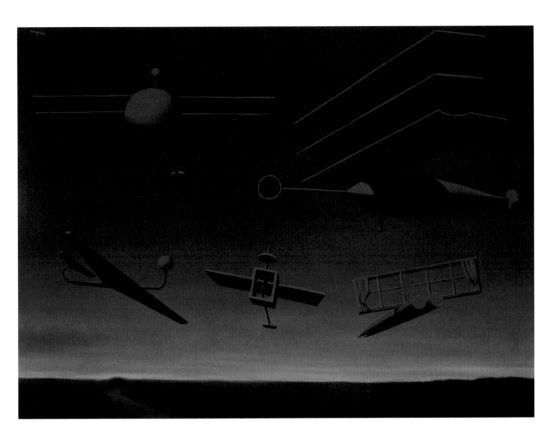

The strange planes in *The Black Flag* may relate to the German bombing of the Spanish town of Guernica in April 1937. Magritte later stated: 'The sense of chaos, of panic, which Surrealism hoped to foster so that everything might be called into question was achieved much more successfully by those idiots the Nazis, and then there was no getting away from it. I painted a picture, *The Black Flag*, which gave a foretaste of the terror which would come from flying machines, and I am not proud of it.' Historically, black flags and pennants have associations with communism, death and piracy, but it is unknown if Magritte had anything specific in mind when he fixed upon this title. He often invited friends to choose his titles, sometimes doing so as an after-dinner game. In fact, when it was first exhibited in December 1937, it was titled *Les Oubliettes de la nuit* (Secret Dungeons of the Night). This title is also inscribed, in Magritte's hand, on the back of the painting.

It was next exhibited at the London Gallery in April 1938 (Magritte's first show in Britain), where it was titled *The Black Flag*; it has been known by this title ever since.

The painting first belonged to E.L.T. Mesens, who co-ran the London Gallery. He allowed a group of British anarchists to use an image of the painting in around 1943, a move which caused friction between various figures in the British Surrealist movement. George Melly, the Jazz musician, who worked for Mesens, bought it in 1947. Melly also owned *The Bungler*.

Oil on canvas, 54.2 × 73.7
Purchased 1972
GMA 1261

René Magritte 1898–1967
Representation (La Représentation) 1937

A continuous theme running through Magritte's art is the complex and equivocal relationship that exists between reality, illusion and pictorial representation. These themes are communicated to great effect in *Representation*, Magritte's only painting with a specially shaped frame. Magritte had played with the idea of framing in earlier paintings, notably in *The Eternally Obvious (L'évidence éternelle)*, 1930, which shows a full-length, standing female nude, presented in the form of five framed rectangular paintings, each of which depicts a fragment of the figure. Magritte painted some landscapes in a similar vein, using several small, framed paintings to depict adjacent segments of a larger view, but with gaps between them. Framed sections of illusionistically painted segments of the body do in fact have a long history: there are, for example, a number of examples of eyes appearing on their own in Victorian miniatures.

Painted early in 1937, *Representation* was originally square in format. There is a photograph of Irène Hamoir, who was married to Magritte's close friend Roger Scutenaire, holding the square painting over her body, with her bare knees continuing the form of the painted thighs. By May 1937 Magritte had cut the painting to the precise contours of the torso, mounted it on plywood, and had a new frame specially made. That month, Magritte wrote to André Breton, telling him, 'I have done the framed section of a female body that I told you about in Paris. It constitutes a rather surprising object, I think.' Dalí had deployed shaped frames around a pair of 'portraits' he painted in 1936. These paintings, *The Couple with their Heads Full of Clouds*, were bought by the English collector Edward James in 1936 and Magritte would surely have seen them when he stayed with James in London, when he carried out a commission to paint three large works in February to March 1937. Magritte could also have seen the paintings reproduced on the cover of Dalí's *Metamorphosis of Narcissus*, published in 1937 by Editions Surréalistes. Shaped paintings do in fact have much earlier precedents, for example, in painted dummy-board figures used as fire screens and on recruitment and advertising signs.

When the painting was first exhibited, at the Palais des Beaux-Arts in Brussels in December 1937, it bore the title *La Répresentation* and was listed as belonging to Magritte's wife, Georgette. The following year Magritte gave it to Paul Eluard, in exchange for a painting by Max Ernst. Eluard sold the painting to Roland Penrose in 1938, along with numerous other works, and listed it as *Le Ventre (The Stomach)*. Penrose sold it to Gabrielle Keiller in 1979 and the Gallery of Modern Art purchased it from her in 1990.

Oil on canvas laid on plywood, 48.8 × 44.5 (frame 54 × 49.2)
Purchased 1990
GMA 3546

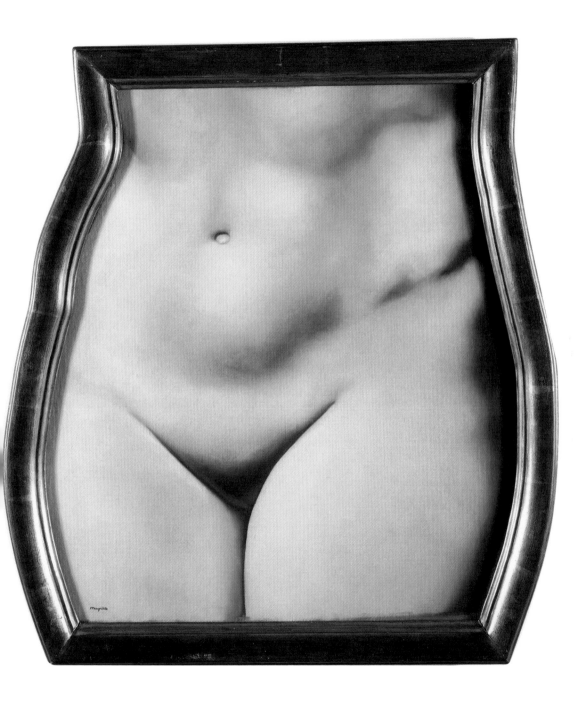

Paul Delvaux 1897–1994
Call of the Night (L'Appel de la nuit) 1938

With Magritte, Paul Delvaux was the most celebrated of the Belgian Surrealists. He studied architecture but also took evening classes in painting. He spoke of two moments of epiphany. The first came around 1929, when he visited the Dr Spitzner Museum (or The Great Anatomical and Ethnological Museum of Dr P. Spitzner, to give it its full name), housed at a Brussels fairground. The 'museum' contained a life-size reclining Venus which appeared to breathe. The sight of the naked figure being examined by clothed visitors stayed with Delvaux throughout his life. The second revelation was the De Chirico exhibition held in Brussels in 1934. De Chirico's deep perspectives, forbidding shadows and disjointed narratives found an echo in Delvaux's work thereafter.

The prehistoric menhirs, skull and skeleton in *Call of the Night* perhaps refer to the prehistoric cave and skeleton which were found in the village of Spy, where Delvaux spent his holidays. The mountain landscape, unlike anything in Belgium, may have been inspired by Jules Verne's novel *Journey to the Centre of the Earth*, 1864, which had a profound impact on the young Delvaux. Delvaux rarely spoke about his work, but when he did, he expressed his desire to evoke poetry and mystery, and he was scathing of psychoanalytical interpretations.

Oil on canvas, 110 × 145
Purchased with assistance from the Heritage Lottery Fund and The Art Fund 1995
GMA 3884

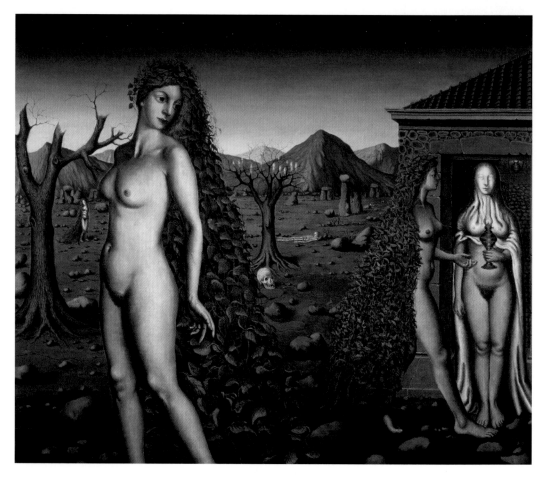

Paul Delvaux 1897–1994
Street of the Trams (La Rue du tramway) 1939

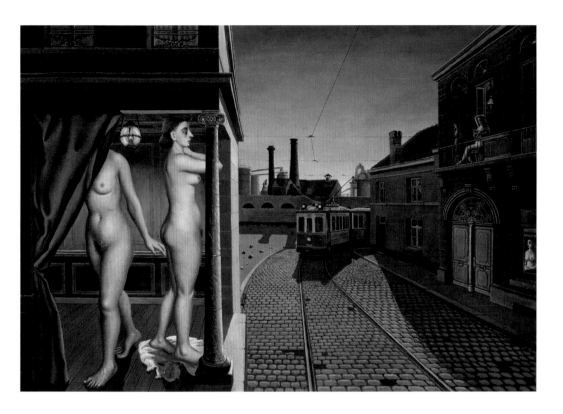

Despite Delvaux's scepticism about psycho-analysis, writers on the artist have drawn attention to his fraught relationship with his domineering mother. She died in 1933, and from this date his painting began to dwell on themes of sexual anxiety. Delvaux's nudes are almost interchangeable, reappearing in similar poses in different paintings. Trains and trams were also favourite motifs. Asked about their meaning, Delvaux stated: 'These things come from my childhood ... [they] have an intense sense of life, they are things which are an integral part of daily life, things that people use but don't see.' Delvaux owned an impressive collection of toy trains which he used as props in his paintings.

X-ray photographs of the painting show that a nude woman originally dominated the centre of the canvas. The tram and tramlines are painted over her, but her trace can still be seen by the naked eye. Delvaux gave the painting to his wife, Suzanne Purnal, whom he had married in 1937. Delvaux had hoped to marry another woman, but his parents opposed the union. It is possible that the languid, often passionless nudes which populate Delvaux's paintings refer to his problematic first marriage.

Oil on canvas, 90.3 × 130.5
Bequeathed by Gabrielle Keiller 1995
GMA 3962

Marcel Duchamp 1887–1968 *The Bride Stripped Bare by her Bachelors, Even*
'The Green Box' (La Mariée mise à nu par ses célibataires, même 'Boîte verte') 1934

The Green Box contains preparatory notes, sketches and photographs relating to *The Bride Stripped Bare by her Bachelors, Even*, 1915–23 – a tall and enigmatic work which Duchamp painted on glass (Philadelphia Museum of Art). Breton had discussed the notes in articles in *This Quarter*, September 1932, and *Surréalisme au service de la Révolution*, May 1933, and this may have prompted Duchamp to publish them. Duchamp began the project in February 1934, shortly after moving from New York to Paris. *The Green Box* is a triumph of ingenuity and persistence because, rather than simply reprint the notes in a book, he decided to produce exact facsimiles. The copies in *The Green Box* are all exactly the same size and colour as the originals: torn notes were reproduced exactly, folds and pin-holes were carefully recreated. Commenting on the idea behind *The Green Box*, Duchamp said: 'I wanted that album to go with the "Glass", and to be consulted when seeing the "Glass",

because as I see it, it must not be "looked at" in the aesthetic sense of the word. One must consult the book, and see the two together. The conjunction of the two things entirely removes the retinal aspect that I don't like.' Duchamp produced twenty de luxe copies of *The Green Box*. The present copy was made for Georges Hugnet.

Paris, Editions Rrose Sélavy 1934
Card box covered in green flock containing ninety-three separate sheets and pieces of printed paper, and one colour reproduction under transparent plastic, 33.2 × 28 × 2.5 (closed) (de luxe edition: no. XIII/XX)
Bequeathed by Gabrielle Keiller 1995
GMA A42/2/GKL1012

Marcel Duchamp 1887–1968
Box in a Suitcase (La Boîte-en-valise) 1935–41

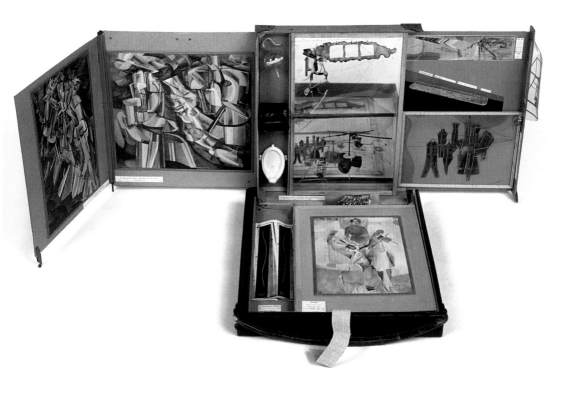

Duchamp was intrigued by the idea that ordinary mass-produced objects could be considered as art objects in their own right, an idea which led to the Readymades (see p.32). Commenting on *Box in a Suitcase*, Duchamp explained: 'Instead of painting something new, my aim was to reproduce the paintings and the objects I liked and collect them in a space as small as possible. I did not know how to go about it. I first thought of a book, but I did not like the idea. Then it occurred to me that it could be a box in which all my works would be collected and mounted like in a small museum, a portable museum, so to speak.' The leather case contains sixty-nine reproductions of paintings and objects made by Duchamp from 1910 onwards, including tiny facsimiles of his three-dimensional works, some of which swivel out on hinges and brackets. Twenty-four de luxe versions of the case were made, each featuring a different hand-coloured 'original' fixed to the inside of the case's lid. This 'original' is a small celluloid version of *The Bride Stripped Bare by her Bachelors, Even*; a second celluloid version of this work stands upright in the centre of the box. The Gallery of Modern Art's box is number two in the edition and is dedicated to the poet and bookbinder George Hugnet, who helped in the manufacture of the work. It is dated May 1941. Duchamp moved from Paris to New York in 1942 and subsequent copies of *Box in a Suitcase* were made there.

Leather covered case containing sixty-nine reproductions and miniature replicas of Duchamp's works, and one hand-coloured original, 10 × 38 × 35.7 (closed) (de luxe edition: no.2/10)
Presented by Gabrielle Keiller 1989
GMA 3472

Alexander Calder 1898–1976
The Spider 1938

The son of a successful sculptor, Alexander Calder was American but was based in Paris from 1926 to 1933. In the mid-1920s he made a number of little wire figures and animals which eventually formed a complete miniature circus. Bent and fashioned into complex forms, many of the figures could be manipulated to perform acrobatic movements in the circus ring. This was how Calder began making moving wire sculptures.

Calder began making abstract sculptures in 1930, following a visit to Piet Mondrian's studio. Some of his early works incorporated motors or primitive crankshafts while others moved of their own accord; Calder christened the works 'mobiles', a term suggested to him by Duchamp. Calder had trained as an engineer so he was well acquainted with the mechanical principles required to make the works balance and move freely; however he created mobiles by intuition. *The Spider* is among the earliest of these hanging mobiles, with their poetic, balletic forms. This mobile belonged to the British artist and designer Ashley Havinden. He stored it for Calder during the Second World War, and Calder later offered it to Havinden as a gift.

Metal, painted, 104 × 89 × 0.7
Purchased 1976
GMA 1586

Joseph Cornell 1903–1972
Untitled (Bird Box) c.1948

Joseph Cornell never went to art school, never travelled to Europe and led a quiet life at the family home in Flushing, New York. In 1931 he saw an exhibition of Max Ernst's collages at the Julien Levy Gallery in New York and he soon began making his own collages and assemblages; he exhibited them at Levy's gallery the following year. By the mid-1930s Cornell was making shadow-box constructions, filling them with the bits and pieces he found on his visits to New York bookshops and junkshops: mirrors, maps, postcards, glasses, dolls, balls, stamps and the like. These carefully crafted assemblages develop from the Dada and Surrealist constructions of artists such as Schwitters, Duchamp and Breton, though by the mid-1930s many of the Surrealists were making such object sculptures. Although Cornell often took part in exhibitions of Surrealist art, he was on the fringes of the movement and denied being a Surrealist. While many of the Surrealists were interested in the subconscious and in shocking imagery, Cornell's art was more personal and idiosyncratic. With its constant references to the past in the form of toys and old scrapbook images, his work conjures up a nostalgic and sometimes slightly sinister vision of childhood.

Mixed-media assemblage in glass-fronted box with electric light, 32 × 23.3 × 11.2
Bequeathed by Gabrielle Keiller 1995
GMA 3950

Georges Hugnet 1906–1974
Untitled Suite of Collages

According to his entry in the *Abridged Dictionary of Surrealism*, published in 1938, Georges Hugnet 'rallied definitively to Surrealism in 1932'. Bibliophile, artist, poet, critic, bookbinder, publisher and chronicler of Dada and Surrealism, Hugnet was a central figure within the Surrealist movement until a violent quarrel with André Breton in 1938. He began making collages in the 1930s and continued until the 1960s; some of these were combined into books: *La Septième face du dé*, 1936, and *Huit Jours à Trébaumec*, 1969. Little is known of Hugnet's intention for this suite of collages but they have been ordered into a quasi-narrative sequence on numbered pages. There are evenly-spaced, hand-ruled pencil lines on the pages opposite the collage, suggesting that Hugnet planned to add an accompanying text. Hugnet's collages were made up from diverse materials, including travel guides, postcards, film and fashion magazines, and nineteenth-century illustrations. Photographs from pornographic magazines take pride of place, with the overall theme being fulfillment of male sexual fantasies. The images used in the collages seem to date from the 1930s and 1940s.

Portfolio containing forty-two collages, 32.5 × 24.5
Bequeathed by Gabrielle Keiller 1995
GMA 3989

Georges Hugnet 1906–1974 *Automatic Portrait of the Automaton of Albertus Magnus (Portrait automatique de l'automate d'Albert-le-Grand)* 1938

To obtain this portrait, Hugnet used the automatic technique decalcomania. Black gouache is spread onto smooth paper, another piece of paper is placed on top, and once separated, the characteristic effect is random, spongy-textured and infinitely suggestive. Such markings were often interpreted by the Surrealists in terms of landscape and underwater scenes. The present portrait subject was not predetermined but decided after the head-like shape had appeared spontaneously on the paper. The inscription identifies the figure as the automaton of Albertus Magnus, the thirteenth-century German theologian, philosopher, natural scientist, mystic and alchemist who was a hero to the Surrealists. Hugnet often used decalcomania endpapers in his bookbindings.

Gouache on paper, 37.9 × 29.5
Bequeathed by Gabrielle Keiller 1995
GMA 3988

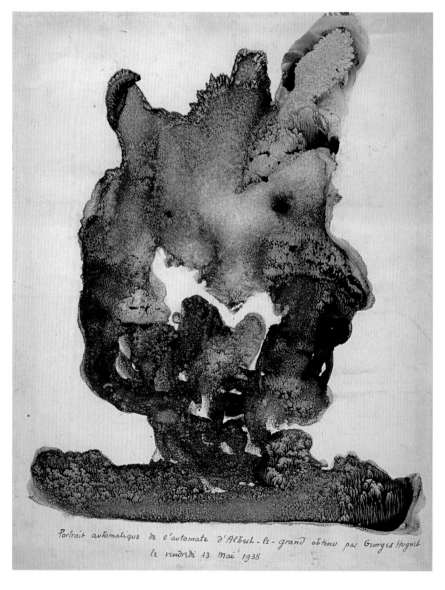

Portrait automatique de l'automate d'Albert-le-grand obtenu par Georges Hugnet
le vendredi 13 Mai 1938

Dora Maar 1907–1997
Portrait of Georges Hugnet 1934

Dora Maar ran a photography studio in Paris in the early 1930s. From 1934 she participated sporadically in the Surrealist movement, producing photomontages and more formal portraits of its members including this one of Hugnet. In 1936 she began an affair with Picasso. Maar became Picasso's photographic collaborator, recording the progression of *Guernica*, 1937 and working with him on a series of photograms and photographic etchings. After the Second World War, Maar concentrated on painting, living as a recluse in the south of France. A portrait of Hugnet taken by Man Ray in 1934 is also in the Gallery of Modern Art's collection.

Black and white photograph, 23 × 17.5
Bequeathed by Gabrielle Keiller 1995
GMA 3999

Kurt Schwitters 1887–1948 *Untitled: Relief with Red Pyramid (Ohne Titel: Relief mit roter Pyramide)* c.1927–30

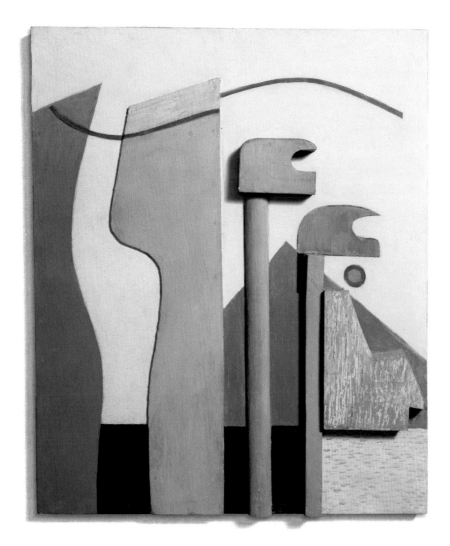

Aside from his *Merz* collages (see pp.44–5), Schwitters also produced numerous relief constructions. Incorporating shaped and painted pieces of wood fixed to a flat surface, they take the *Merz* concept into three-dimensional space. These works also parallel an architectural project Schwitters embarked upon in 1923, the *Merzbau* (*Merz*-house) in Hanover. This began as a tall column in a back room of his house but, as one piece of junk was nailed to another, it grew and grew over a period of fourteen years, until it became, as Max Ernst put it, 'a huge abstract grotto'.

Untitled: Relief with Red Pyramid may at first appear to be an abstract composition,

stylistically related to the work of the Constructivist and the Dutch De Stijl groups. However, it perhaps refers to the widespread passion in the 1920s for things Egyptian. The fashion was provoked by the discovery in 1922 of the tomb of Tutankhamen. This had a major impact in the art world, heavily influencing the Art Deco style. In Schwitters's relief, the vertical shapes mimic the stylised profiles found in Egyptian art, and the pyramid appears to sit on the horizon.

Oil on wood relief on plywood, 60 × 50.2
Purchased 1979
GMA 2077

Jean Arp 1886–1966
Rising up (S'élevant) 1962

Arp was born in Strasbourg, a German city until it was ceded to France in the peace treaty after the First World War. Christened Hans, he later adopted the French form of the name, Jean. He lived in Switzerland during the First World War, becoming a founder member of the Zurich Dada group. During this period and in the 1920s he made wooden reliefs, collages and drawings. He moved to France in 1925 and only began to make free-standing sculptures in the 1930s, producing smooth, vegetable-like forms he called 'human concretions'. This type of work had parallels in the painting of artists such as Miró and Tanguy and is sometimes referred to as 'Biomorphism', a term used by Alfred Barr (then Director of the Museum of Modern Art in New York) in 1936. Arp continued to work in this way until his death in 1966. He did not consider these works as abstract, but rather as organic forms which had occurred naturally, commenting: 'Art is a fruit that grows in man, like a fruit on a plant, the fruit of the mother's womb. But whereas the fruit of the plant, the animal, the fruit of the mother's womb, assume autonomous and natural forms, art, the spiritual fruit of man, usually shows an absurd resemblance to the aspect of something else.' A thirty centimetre-tall plaster maquette for *Rising up* exists: this would have been enlarged to the present scale with the help of professional marble carvers.

Marble, 176.5 × 44.5 × 44.5
Purchased 1971
GMA 1253

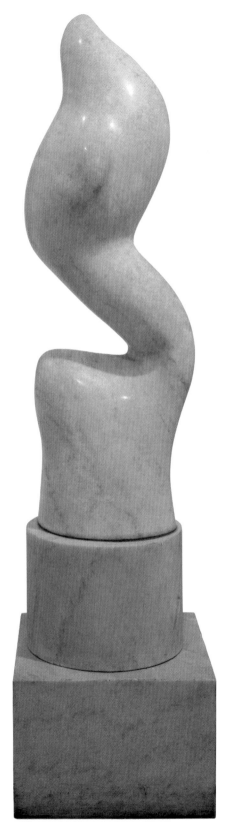

Yves Tanguy 1900–1955
Never Again (Plus Jamais) 1939

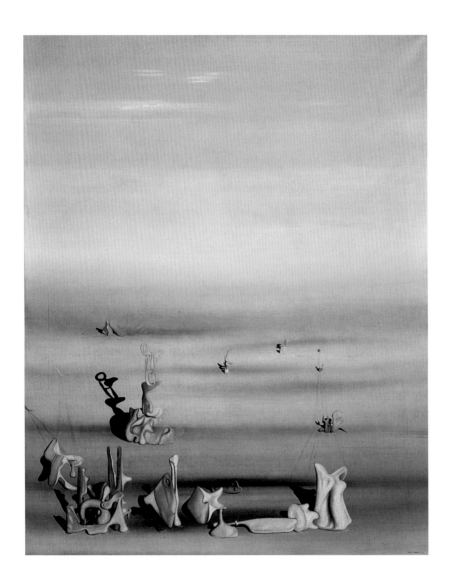

Tanguy left Paris for New York in November 1939 and remained in the USA thereafter. This work was painted shortly before his departure. It is often noted that Tanguy's palette lightened and brightened after his move to the USA, but this work shows that such a development was already happening when he was still living in Paris.

Never Again was consigned to Tanguy's dealer, Pierre Matisse, the son of Henri Matisse, whom Tanguy had known in Paris. Gabrielle Keiller bought it from the Robert Fraser Gallery in London in 1966.

Oil on canvas, 92 × 73
Bequeathed by Gabrielle Keiller 1995
GMA 4085

Kurt Seligmann 1900–1962
Sabbath Phantoms c.1945

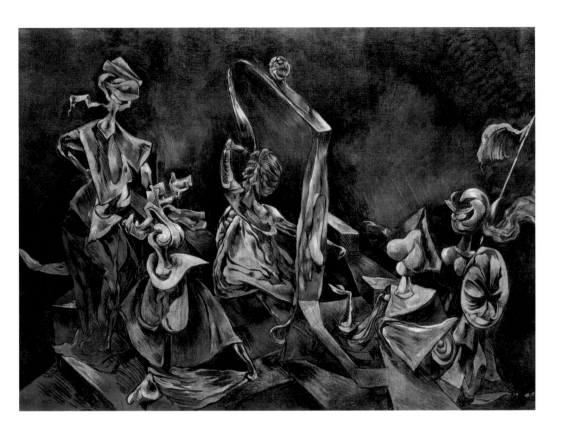

Born in Basel, Switzerland, Kurt Seligmann studied painting in Geneva and moved to Paris in 1929. Through his compatriot Giacometti he became peripherally involved with the Surrealists, although he only formally joined the group in 1937. He produced one of the mannequins shown at the Surrealist exhibition at the Galerie des Beaux-Arts in 1938 (see pp.116–17). He moved to New York in September 1939, two months before Tanguy, with whom he remained in close contact. Seligmann subsequently moved to a farm in Orange County, in upstate New York, where this work was painted. Lucy Lippard concisely described Seligmann's work: 'His illusionistic paintings resemble curiously animated swathes of cloth, blowing into empty space or forming figures'. He had a particular interest in medieval history and heraldry (as evidenced in the figure in armour seen here on the right), magic and the occult, publishing scholarly articles on magic, as well as a standard book, *The Mirror of Magic*, 1948. Seligmann gained American citizenship after the war and like other Surrealists resident in the New York area, such as Tanguy and Masson, is widely credited as having a role in the development of Abstract Expressionism in America.

Oil on canvas, 94 × 130
The Mayor Gallery, London

Man Ray began taking photographs simply to keep a record of his paintings. He subsequently encountered the photographer Alfred Stieglitz at the 291 gallery on Fifth Avenue, New York, and became increasingly interested in photography. When he moved to Paris in 1921 he was known for his paintings, aerographs and strange object sculptures. However, he was soon spending more time working on photography. He was introduced to the great fashion designer Paul Poiret and became his favoured photographer. Soon his photographs were appearing in upmarket American and French fashion journals, as well as in Dada and Surrealist reviews.

Man Ray's fame as a photographer obscured his work as a painter; indeed, he seldom painted during the 1920s. He had for a number of years conducted a relationship with the artists' model Alice Prin (better known as Kiki). Soon after that finished, in the summer of 1929, Lee Miller (see pp.94–5) turned up at his door and announced that she was his new student. She proved more than capable as an assistant and soon became his lover. Around this time Man Ray began to devote more time to painting, taking a separate painting studio where he usually worked in the mornings. He made a series of automatic paintings there, sometimes squeezing the paint directly onto specially prepared silvered panels.

Man Ray and Miller split up in 1932, though after a while they re-established their friendship. Both these works belonged to Lee Miller. The painting is inscribed on the reverse 'My Visiting Card to Lee' and is dated 1942. By this time the artists were living on different continents: Miller lived in London and Man Ray was living in Hollywood. On moving from Paris, Man Ray had to leave behind many of his paintings; upset about this, he set about repainting them. *Visiting Card* relates closely to the 'automatic' paintings of 1929. It was presumably given to Miller as a gift at a later date. The tiny pen drawing must also have been a gift to Miller. Both these works are unrecorded and unpublished until now.

Untitled
(Nose, Nude and Cigarette) 1939

Pen and ink on paper, 7 × 4.2
The Penrose Collection

Visiting Card 1942

Oil on canvas board, 29.5 × 39.8
The Penrose Collection

The *Exposition Internationale du Surréalisme*, held at the Galerie des Beaux-Arts in Paris in 1938, was organised by André Breton and Paul Eluard. Marcel Duchamp was brought in as a generator of ideas and an arbitrator between Breton and Eluard; Salvador Dalí and Max Ernst acted as advisors.

Duchamp was also responsible for the mise-en-scène and produced an astonishingly radical design. It took the form of a site-specific 'installation' within which over 200 paintings, sculptures and objects by artists from ten countries were placed. Visitors first crossed a courtyard containing Dalí's *Rainy Taxi* – a taxicab in which two shop mannequins were drenched by jets of water. They then passed through a long indoor street lined with a further sixteen mannequins, each dressed by an artist or writer. The ceiling of the main hall was hung with Duchamp's installation featuring 1200 coal sacks. Four beds, one in each corner, brought the world of the Paris brothel to the show. The walls were densely packed with artworks; the floor was covered in six inches of sand and autumn leaves. The whole was dimly lit by Duchamp's brazier in the centre. This was the only fixed point of lighting, so visitors used loaned flashlights to view the exhibition.

The exhibition was a huge success and a number of photographers, including Denise Bellon, Man Ray and Raoul Ubac, recorded it. As the central part of the exhibition was in darkness, they tended to concentrate on the mannequins. To accompany the exhibition, Breton and Eluard wrote their *Abridged Dictionary of Surrealism* which contained sarcastic biographies of the artists and the lexicon needed to understand them.

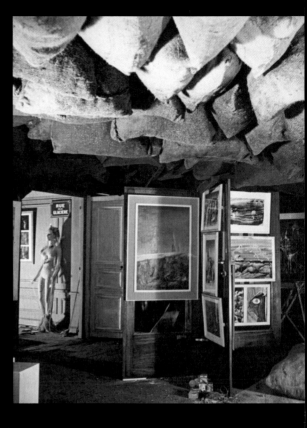

Denise Bellon 1902–1999
Installation shot at the *Exposition Internationale du Surréalisme* including Marcel Duchamp's 1200 coal sacks 1938

Denise Bellon was born in Paris. She studied psychology at the Sorbonne, Paris but in 1934 embarked upon a career as a photographer. She produced photographic reportage, and was an active member of the French Resistance during the Second World War. Some of her best-known images derive from her documentation of the *Exposition Internationale du Surréalisme* in 1938. The Gallery of Modern Art holds thirteen of Bellon's photographs from this series. She also photographed the international Surrealist exhibition held at the Galerie Maeght, Paris in 1947, and many of the Surrealists themselves.

Black and white photograph, 23 × 13.5
Purchased 1999
GMA A63/6

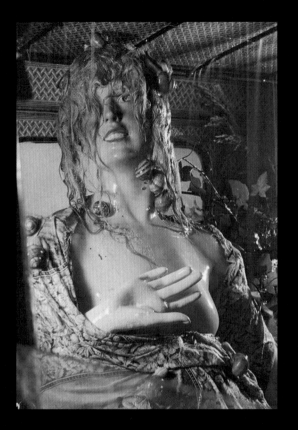

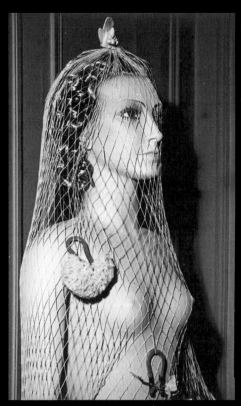

Raoul Ubac 1910–1985
Salvador Dalí's *Rainy Taxi* at the
*Exposition Internationale du
Surréalisme* 1938

Painter, sculptor and graphic artist, Raoul
Ubac was born in Belgium but studied paint-
ing in Paris. Having travelled extensively in
Europe, from 1934 to 1942 he devoted himself
to photography, joining the Surrealist group
in Paris. In 1942 he abandoned photography
and returned to drawing and painting. The
Gallery of Modern Art Archive holds five of
his photographs of the 1938 exhibition.

Black and white photograph, 23 × 17
Purchased 1994
GMA A35/1/3/190/9

Man Ray 1890–1976
Marcel Jean's mannequin at the
*Exposition Internationale du
Surréalisme* 1938

Man Ray moved from New York to Paris in
1921. While earning a living as a fashion and
portrait photographer, he also made paintings,
objects and collages. He acted as lighting
director to the 1938 exhibition, with ambi-
tious but technically impracticable plans for
movement-sensitive lights. He contributed
a dressed mannequin to the show as well as
making photographs of the installation: the
Gallery of Modern Art Archive holds four of
these photographs.

Black and white photograph, 23 × 13.5
Purchased 1994
GMA A35/1/3/190/3

Marcel Duchamp 1887–1968 *Please Touch (Prière de toucher)* cover of the book *Surrealism in 1947 (Le Surréalisme en 1947)* 1947

Later in his career, Duchamp liked to give the impression that he had given up making art and was more interested in playing chess; but he did in fact work in secret for the last twenty years of his life on a large tableau called *Etant donnés*, 1946–66. Viewed through a peephole, it shows a truncated female body in a strange landscape setting. The three works illustrated opposite and overleaf are not part of that work, but they do relate to its subject and manufacturing process.

Please Touch was conceived as the cover for the catalogue of the exhibition *Le Surréalisme en 1947*, held at the Galerie Maeght in Paris that year. The exhibition, organised by André Breton and Duchamp, marked the return of Surrealism as a force in Europe, after so many of the artists had spent the war years abroad. Produced in an edition of 999 de luxe copies, the cover features a female breast made of foam rubber. Duchamp originally tried to cast the left breast of the artist Maria Martins, but this proved too complicated. So, with characteristic ingenuity, Duchamp bought 999 false breasts (normally used in bras as enhancers), and with the help of his friend, the artist Enrico Donati, glued them to the book covers and hand coloured the nipples. The breast sits on a velvet backing, attached to the pink cover. The back cover bears the label *'Prière de toucher'*. The book features original prints by Tanguy, Dorothea Tanning, Victor Brauner, Ernst, Miró, Bellmer, Arp and others. The 1947 exhibition is often seen as the last major 'official' flowering of Surrealism.

Paris, Maeght 1947
Book by André Breton and others, with cover by
Marcel Duchamp in moulded rubber and velvet,
24 × 20.5 × 4 (edition: 999)
Purchased 1999
GMA A33/3/DSL/019

Marcel Duchamp 1887–1968
Female Fig Leaf (Feuille de vigne femelle) 1950 / 1961

Duchamp made two versions of this work in
1950. One was made in galvanised plaster, and
was given to Man Ray; the other was made
in painted plaster, and was kept by the artist.
In 1951 Man Ray supervised the production
of ten plaster casts, which were then painted
brown to resemble bronze. In 1961 Duchamp
authorised an edition of ten bronze casts.
The title, *Female Fig Leaf*, gives a clue to the
object's origins. Instead of hiding the genitals,
as a fig leaf would, this work displays them. It
is either actually cast from a woman's genitals,
or, more probably, has the appearance of
having been so. Duchamp remained silent on
the technical process, but the artist Richard
Hamilton, who produced several authorised
copies of Duchamp's works in the 1960s,
stated that it was modelled by hand.

Bronze, 9 × 14 × 12.5
Bequeathed by Gabrielle Keiller 1995
GMA 3967

Marcel Duchamp 1887–1968
Wedge of Chastity (Coin de chasteté) 1954 / 1963

Duchamp gave the original version of this sculpture to his wife, Alexina (Teeny) on their wedding day on 16 January 1954 (she was previously married to Pierre Matisse, son of Henri Matisse and a celebrated art dealer in his own right). Assisted by a friend who was a dental mechanic, Duchamp made it out of galvanised plaster and dental plastic. Duchamp explained: 'It was my wedding present to her. We still have it on our table. We usually take it with us, like a wedding ring, no?' In or around 1963 Duchamp authorised an edition of eight casts in bronze and dental plastic, and two additional casts, one of which he kept for himself. The bronze wedge has the appearance of being cast from a woman's genitals, though, like *Female Fig Leaf*, it was probably modelled to seem that way. Whatever the case, the satisfyingly snug fit of the two halves, and the pink, fleshy tone of the casing, give it an enigmatic, erotic charge. This sculpture, bequeathed by Gabrielle Keiller, is Duchamp's own cast.

Bronze and dental plastic, 5.7 × 8.5 × 4.2
Bequeathed by Gabrielle Keiller 1995
GMA 3968

Salvador Dalí 1904–1989
Exploding Raphaelesque Head (Tête Raphaëlesque éclatée) 1951

Dalí was fascinated by advances in nuclear physics, once remarking: 'What distinguishes our age from the Renaissance is that now for the first time we realise that matter, instead of being something continuous, is discontinuous ... If one wanted to give an accurate representation of a table, instead of being compact the table should resemble something like a swarm of flies.' In the 1950s he painted a number of fragmented heads and figures; they partly suggest an atomic explosion and partly the splitting of an object into its constituent atomic particles. Here, the forms are gathered into the form of a woman's head, based on a painting of the Virgin by Raphael. While some of the Surrealists were openly hostile to the art of the past, Dalí was a great admirer of the old masters and of scrupulously detailed nineteenth-century academic painting. Throughout his life, Dalí made repeated use of double imagery and in this painting the skull part of the Virgin's head is transformed into the open-topped cupola of the Pantheon building in Rome. The wheelbarrow in the bottom left corner derives from Jean-François Millet's celebrated painting *The Angelus*, 1857–9.

Oil on canvas, 43.2 × 33.1
Private collection

Salvador Dalí 1904–1989
Landscape at Port Lligat (Paysage de Port Lligat) 1958

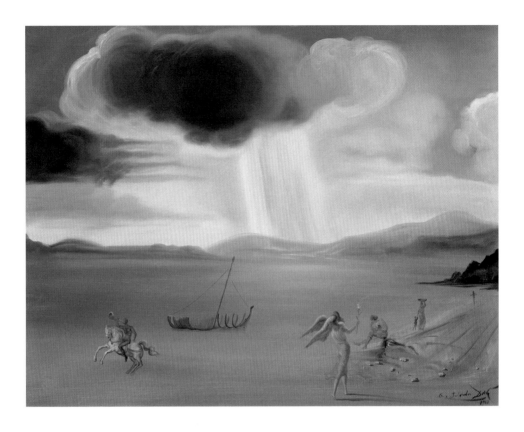

The Dalí family had lived and owned property in Cadaqués, a secluded fishing town on the Costa Brava, Spain, since the early nineteenth century, and although Dalí's parents lived in Figueres, they still spent time there and Dalí himself made regular visits to the family property. In the summer of 1929 Magritte and a group of friends visited Dalí in Cadaqués: Magritte's *Threatening Weather* (pp.66–7) depicts the bay. At the end of 1929 Dalí had a spectacular falling out with his father (he had exhibited a picture which made a blasphemous reference to his own mother) and was banished from the house. Dalí loved the area so much that the following year he acquired a fisherman's shack in the tiny village of Port Lligat, just twenty minutes' walk away further up the coast. Bought for 250 pesetas, the house had no water or electricity and the village itself was home to only about twenty fishermen and their families. Nevertheless, Dalí's house, enlarged over the years, remained his main residence thereafter. 'I am home only here; elsewhere I am camping out,' he wrote.

The enclosed bay in front of the house (Port Lligat means 'tied in harbour' in Catalan, and the surrounding islands make the bay seem like a lake) became a favourite backdrop in Dalí's work: Christ's Crucifixion, the Madonna and Child and countless mythological scenes are enacted in it and above it. Here the winged figure seems to be the angel Gabriel, with Madonna lily in hand, about to declare the Annunciation to an unsuspecting villager.

Oil on canvas, 59 × 76.2
Private collection, courtesy The Halcyon Gallery, London

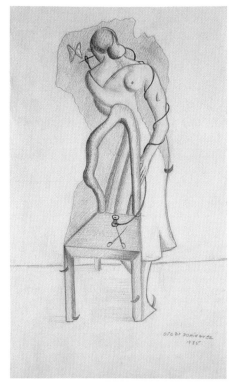

This is one of four albums of Surrealist draw-ings which were put together and offered for sale at the *International Surrealist Exhibition*, held at the New Burlington Galleries in London in 1936. Priced at 1200 francs (approximately £15 at the time), the revenue from the sales was intended to fund Surrealist publications. This album, which is numbered '4', was bought by Roland Penrose. Wolfgang Paalen instigated the project, and presumably asked his friends to contribute drawings. In this album, six of the works are dated 1936 (by Dalí, Maurice Henry, Marcel Jean, Paalen, Penrose and Tanguy), two are dated 1935 (Oscar Domínguez and Stanley William Hayter), one is dated 1932 (Victor Brauner), five are undated (Arp, Bellmer, Leonor Fini, Magritte and Miró), and the Max Ernst (the frottage *She Keeps her Secret*: see p.56) is dated 1925. It seems, then, that some artists made new work for the album while others selected pre-existing works which matched Paalen's size specifications. The cover, with its collaged title, was almost certainly made by Penrose.

The whereabouts of the first two albums is unknown, and they are presumed to have been dismembered and the drawings sold off individually. The third album was acquired by the collector Edward James, and was only split up and sold in 1983. It also carried the collaged title on the album cover. The hand-written list of works contained within the album is in Paalen's writing. Oddly, he states that the album contains fourteen works, but lists fifteen. Paalen's text also notes that the albums were assembled in May 1936.

Album containing fifteen drawings and watercolours, 60 × 40.5 (cover)
Purchased with assistance from the Heritage Lottery Fund and The Art Fund 1995
GMA 3895–3908
Clockwise from above: Oscar Domínguez; Victor Brauner; Salvador Dalí; Maurice Henry; Hans Bellmer

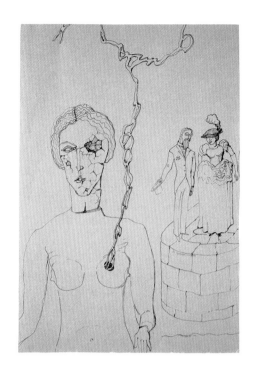

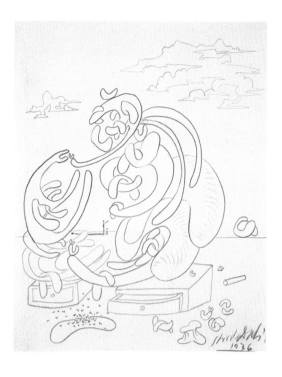

John Armstrong 1893–1973
The Jetty 1929

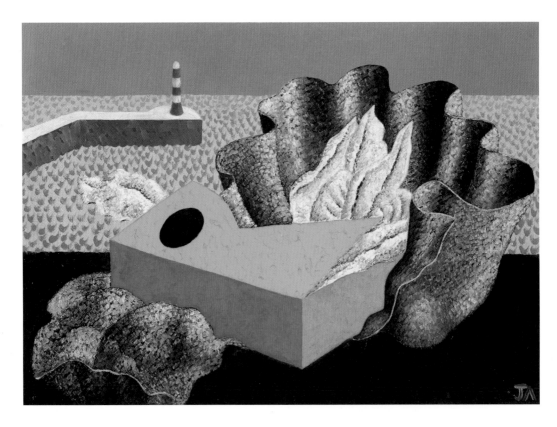

John Armstrong grew up in West Dean, near Chichester, where his father was a parson (by coincidence, Edward James, the great collector of Surrealist art, was a near neighbour). He studied at St John's Wood School of Art in London, where he learned how to paint in tempera. He had solo exhibitions at the Leicester Galleries, London, in 1928 and 1929. Like Edward Wadsworth, Tristram Hillier and John Tunnard, he was often referred to as a Surrealist, but he never joined the official British Surrealist group and he did not show at the great 1936 *International Surrealist Exhibition* in London – or indeed in any other Surrealist shows of the period. There is, however, a very clear correspondence with De Chirico's work and also Magritte's early work. Armstrong's only affiliation was to another group, Unit One, which was formed by Paul Nash in 1933 and embraced abstraction as well as Surrealism. It is intriguing that Nash, who was on the selection committee for the 1936 Surrealist exhibition, seems not to have put Armstrong's name forward. Armstrong himself said many years later: 'I realised I didn't belong there.' *The Jetty*, a highly ambiguous composition, shows a group of objects of indeterminate type and scale against a seascape with a jetty. It is one of Armstrong's 'Furled leaf' compositions, so called because of the crumpled leaves which are emerging from the blue, box-like construction.

Oil on canvas, 51.5 × 72
Huddersfield Art Gallery

Paul Nash 1889–1946
Token c.1929–30

Paul Nash was a key figure in the development of Modernism in Britain. He had studied at the Slade School in London and was familiar with Cubism and abstraction. He was primarily a landscape painter until the late 1920s when he became interested, for a relatively short period, in adopting certain aspects of Surrealism in his work. This change in his art was in part due to an exhibition of De Chirico's paintings held at Tooth's Gallery in London in October 1928.

Nash admired the way De Chirico painted recognisable objects in a straightforward way, while managing, through deep perspective, raking shadows and combinations of incongruous objects, to create enigmatic, sometimes menacing effects. Nash himself wrote that he was drawn to an art in which 'still lifes come alive or figures become still': indeed, in his landscapes he aimed to imbue trees with living, human qualities. Nash served on the selection committee of the *International Surrealist Exhibition* at the New Burlington Galleries, London in 1936, and he contributed twelve works, including collages and found objects.

Oil on canvas, 51.4 × 61.2
Purchased 1986
GMA 2984

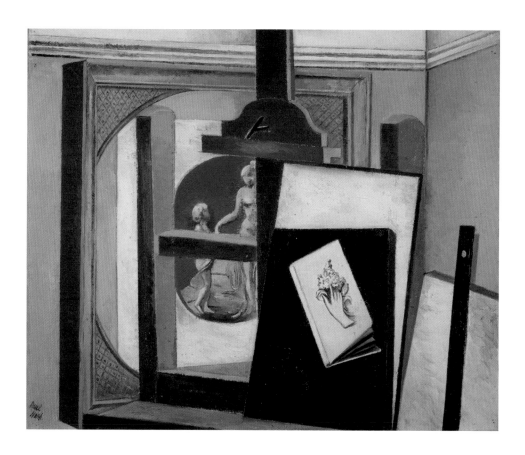

Tristram Hillier 1905–1983
Pylons 1933

Tristram Hillier was born in China but his family moved to England soon after his birth. He was a member of the Unit One group, which was launched in 1933 by Paul Nash and included Ben Nicholson, Henry Moore, John Armstrong, and Barbara Hepworth among its members. Inspired by European abstraction and Surrealism, the group was the most radical British art movement of the period; however it was short-lived, folding in 1935. *Pylons* was exhibited at the first and only Unit One exhibition, held in London in 1934, where it aroused a good deal of interest.

Hillier was interested in Surrealism but he did not take part in any 'official' Surrealist exhibitions and nor did he join the British Surrealist group. He stated in 1934: 'Generally my aim is to build up a composition in a representative manner, assembling objects which have a mutual plastic complement and a similar evocative nature irrespective of their individual functions. Unlike Monsieur Dalí I have no wish to shock people's sensibilities by juxtaposing the most unlikely objects in an improbable landscape setting.' Elizabeth Watt bought *Pylons* from the Unit One exhibition and bequeathed it to the Gallery of Modern Art more than fifty years later.

Oil on canvas, 92 × 60.3
Bequeathed by Miss Elizabeth Watt 1989
GMA 3488

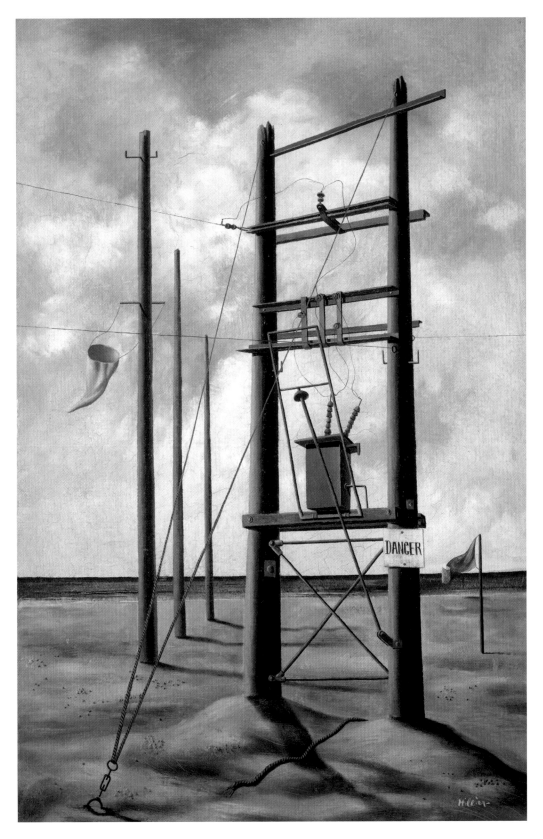

Edward Wadsworth 1889–1949
Pendent 1942

Edward Wadsworth was not part of the
British Surrealist group. He never claimed to
be a Surrealist, nor did he take part in any of
the official group shows, and yet he produced
some of the greatest Surrealist paintings
made in Britain. His credentials were impres-
sive. He had studied engineering in Germany
and been a key member of the British Vorticist
group at the start of the First World War. He
held a solo exhibition in Paris in 1928 and
exhibited at Léonce Rosenberg's celebrated
L'Effort Moderne gallery (De Chirico, whom
he knew, was part of the same stable of
artists). In 1932 he became a member of the
Abstraction-Création group and in 1933 he
joined Unit One. By that date his reputation
on the continent was probably higher than
that of any other avant-garde British artist.
His use of classic Surrealist tropes – group-
ing together unrelated, enigmatic objects
(particularly shells and maritime equipment)
and tampering with scale – began around
1926, a decade before the formation of the
official British Surrealist group. It is one of the
curiosities of British Surrealism that two of
its leading exponents, Wadsworth and Hillier,
did not see themselves as Surrealists.

Tempera on panel, 87 × 62.5
Huddersfield Art Gallery

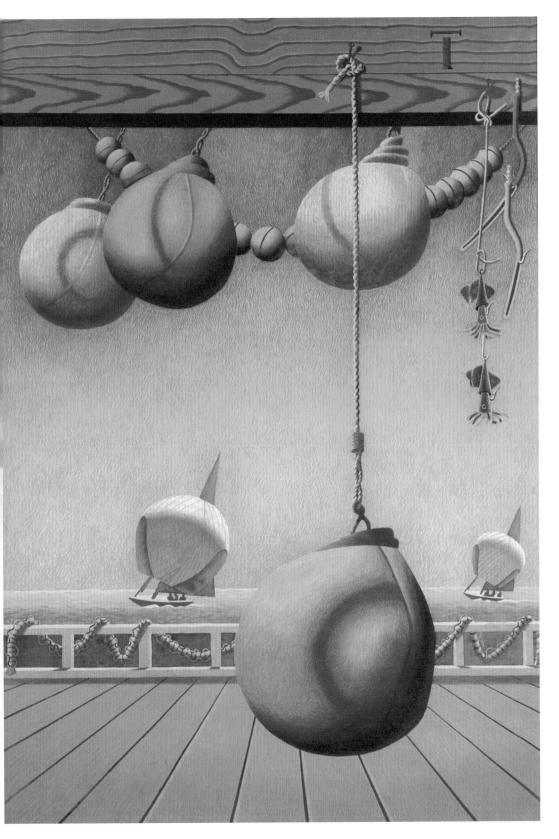

Stanley William Hayter 1901–1988 and George Reavey 1907–1976

Stanley William Hayter worked in Iran for the Anglo-Persian Oil Company from 1922 to 1925; during this time he began to paint and made the decision to become a professional artist. He moved to Paris and, in 1927, opened a printmaking studio in collaboration with Joseph Hecht. In 1933 the studio moved to 17, rue Campagne-Première, a few doors down from Man Ray's home and studio. Atelier 17, as it came to be known, became a centre for innovative printmaking.

Hayter was soon working with some of the leading Surrealist artists, many of whom came to rely upon his technical mastery and willingness to experiment. The etchings he made to accompany the poetry of his friends, Eluard, Hugnet and George Reavey, are characterised by wiry transparent figures and dream-like horses reminiscent of the wire sculptures of his friend Calder. Hayter exhibited with the Surrealist group in Paris in 1933 and continued to exhibit with them throughout the 1930s. His daily contact with leading Surrealist artists allowed him to introduce many visiting British artists into this milieu.

George Reavey, the Irish-Russian Surrealist poet, literary agent, critic and publisher, worked with Hayter and Atelier 17 on several projects. Like Hayter, Reavey became involved in the Surrealist movement in the 1930s when he moved to Paris. There he founded the Europa Press with the aim of producing 'limited editions in collaboration with modern artists and engravers'. He was one of several poets to work on *Thorns of Thunder*, 1936, a collection of Eluard's poems translated into English. He also contributed to Herbert Read's book *Surrealism*, 1936, and to several issues of the *London Bulletin*, the mouthpiece of Surrealism in Britain.

Faust's Metamorphoses is a collection of twenty monologues based on Christopher Marlowe's *Doctor Faustus*, 1604. Although *Faust's Metamorphoses* was published in May 1932, just a few weeks after *Ombres portées* (Worn Shadows) this was in fact Hayter's first *livre d'artiste* since the six engravings date from 1931. Hayter also produced engravings for Reavey's *Nostradam*, 1935.

Stanley William Hayter 1901–1988
and Georges Hugnet 1906–1974

left to right

Faust's Metamorphoses, Poems 1932

Paris, New Revue Editions 1932
Book by George Reavey with six etchings by
Stanley William Hayter; book 25.6 × 19.7
(edition: no.40/137)
Bequeathed by Gabrielle Keiller 1995
GMA A42/2/GKL0428

Ombres portées 1932

Paris, Editions de la Montaigne 1932
Book by Georges Hugnet with five etchings by
Stanley William Hayter; book 26.2 × 16.7
(edition: no.13/79)
Bequeathed by Gabrielle Keiller 1995
GMA A42/2/GKL0012

L'Apocalypse 1937

Paris, Editions G.L.M. 1937
Book by Georges Hugnet with frontispiece fold-out
etching by Stanley William Hayter; book 15.3 × 10.5
(edition: Hors commerce copy/70)
Bequeathed by Gabrielle Keiller 1995
GMA A42/2/GKL0050

Georges Hugnet met the French poet, painter
and critic Max Jacob in 1920 and through
him was introduced to many avant-garde
artists and poets, including Picasso, Man
Ray, Picabia and Ernst. Published in 1932, the
poems of *Ombres portées* mark the point at
which Hugnet turned to Surrealism. Hayter's
five etchings provide appropriate illustra-
tions for Hugnet's poems while in their other
collaboration of the same year, *L'Apocalypse*,
the roles were reversed: Hayter provided six
engravings, and Hugnet's text was written
specifically to accompany them. This type
of creative collaboration between poets and
artists was a cherished ideal of the Surrealist
movement. In the 1937 edition of *L'Apocalypse*
the process was again reversed; Hugnet
reprinted the text he had written for Hayter
in 1932, and Hayter created an entirely new
fold-out etching to accompany it.

Edward Burra 1905–1976
Collage 1930

Edward Burra had a lifelong antipathy to organisers and organisations. Although he participated in some of the great manifestations of Surrealist art, including the *International Surrealist Exhibition* in London in 1936, *Fantastic Art, Dada, Surrealism* in New York in 1936 and the *Exposition Internationale du Surréalisme*, held in Paris in 1938, he was far too independent a character to join the club. He studied at Chelsea Polytechnic from 1923 to 1925. From 1925 he visited Paris frequently, and would have encountered Surrealism first hand in the second half of the 1920s. Additionally, he knew John Banting who was semi-resident in Paris and was connected to Surrealist circles. In 1929 he travelled through France with Paul Nash, another devotee of Surrealism, and on their return through Paris they met Picasso and Max Ernst.

Burra began making collages around 1929, perhaps under the influence of Ernst. However, his approach to collage was more akin to Ernst's earlier Dada work, and to that of the German satirists, Grosz, Höch and Heartfield in terms of combining figurative and mechanical illustrations. Burra only made a handful of collages: by the end of 1930 he had returned to his preferred medium, watercolour.

Collage, gouache, pen and ink and pencil on paper, 62.2 × 50.6
Bequeathed by Gabrielle Keiller 1995
GMA 3948

Humphrey Jennings 1907–1950
Life and Death 1934

Humphrey Jennings was born in Walberswick, Suffolk; his father was an architect and his mother an artist. He is probably best known as a documentary film-maker. He joined the GPO Film Unit in 1934 and during the war made several now-celebrated semi-documentary films which incorporate montage techniques. Jennings used the related technique of collage in his artworks. In 1937 he helped establish Mass-Observation, an ambitious documentary project which set out to study the daily life and thoughts of ordinary British people, as recorded by hundreds of volunteers.

While a student at Cambridge, Jennings had been an active promoter of French contemporary art. In 1934 he began making collages, placing apparently unrelated photographs and reproductions next to each other. In 1936 he helped organise the *International Surrealist Exhibition* at the New Burlington Galleries in London, featuring alongside Roland Penrose and Herbert Read on the selection committee. *Life and Death* was included in this exhibition, together with five other works by Jennings. Jennings died on the Greek island of Poros, when he slipped off a cliff while working on a film.

Collage on card, 22.9 × 40.6
Purchased 2006
GMA 4806

Surrealism arrived in Britain later than in the rest of Europe. It erupted onto the scene in the form of the *International Surrealist Exhibition*, which opened at 3pm on 11 June 1936, at the New Burlington Galleries in Burlington Gardens, behind the Royal Academy in London. The prime movers behind the show were David Gascoyne, a nineteen-year-old English poet and author of *A Short Survey of Surrealism*, 1935, and Roland Penrose, artist, collector and friend of the Surrealists in Paris. Penrose and Gascoyne met in Paris in or shortly after July 1935, when they were introduced by their mutual friend Paul Eluard. Together, the English pair resolved to bring Surrealism to Britain.

The task of organising fell largely to these two, together with the critic and poet Herbert Read. The show was of course discussed with Breton and Eluard, and a London committee was formed, consisting also of Humphrey Jennings, Henry Moore, Rupert Lee, Diana Brinton Lee, Hugh Sykes Davies and Paul Nash. The selection of work by British artists was difficult as no formal British Surrealist group existed. The consequence was that the work of artists such as Eileen Agar and Graham Sutherland – who had not thought of themselves as Surrealists – was included in the show alongside work by Penrose, Moore and Nash, whose work could be more closely associated with Surrealism. Max Ernst designed the poster, and a programme of lectures, debates and poetry readings was arranged to accompany the show. A parallel French committee of Breton, Eluard, Man Ray and Hugnet, together with the Belgian E.L.T. Mesens, selected works by non-British artists such as Dalí, Miró, Duchamp, Ernst, Picasso and Magritte. In the months before the opening, Penrose shuttled between London and Paris, arranging loans with the artists and collectors.

Over 390 paintings, sculptures and objects by sixty-eight artists were selected. Works were hung in double or triple rows, alternating large and small paintings, so that the viewer had to step forward and back to view them. Ethnographic sculptures and objets trouvés (found objects) were interspersed throughout. The exhibition opening attracted over 1,150 people who listened to an introductory speech by André Breton. Salvador Dalí attempted to deliver a lecture whilst wearing a deep-sea diver's suit and holding two hounds on a leash. Dramatically, he nearly suffocated and had to be released from his helmet with a spanner. During its three-week run the exhibition attracted over 23,000 visitors. A British Surrealist group was formed in response to the show and their work was selected for subsequent Surrealist exhibitions in New York, Paris, and Tokyo. The group continued to meet, exhibit and write until its eventual dissolution in 1946.

The exhibition is fully documented in the Gallery of Modern Art's Roland Penrose Archive, which contains correspondence, installation photographs and snapshots of events, hanging plans, minutes of meetings, catalogues, cards, typescripts of lectures, and news cuttings. This is complemented by material on the show and on the British Surrealists in the Grace Pailthorpe and E.L.T. Mesens archives.

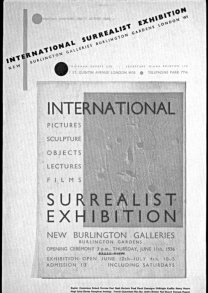

INTERNATIONAL SURREALIST EXHIBITION
NEW BURLINGTON GALLERIES BURLINGTON GARDENS LONDON W1

CHAIRMAN RUPERT LEE · SECRETARY DIANA BRINTON LEE
7 ST. QUINTIN AVENUE LONDON W10 · TELEPHONE PARK 7114

INTERNATIONAL
PICTURES
SCULPTURE
OBJECTS
LECTURES
FILMS

SURREALIST
EXHIBITION

NEW BURLINGTON GALLERIES
BURLINGTON GARDENS
OPENING CEREMONY 3 p.m., THURSDAY, JUNE 11th, 1936
EXHIBITION OPEN JUNE 12th–JULY 4th, 10–5
ADMISSION 1/3 INCLUDING SATURDAYS

In connection with the
INTERNATIONAL
SURREALIST EXHIBITION
a series of
LECTURES
will be given at the
NEW BURLINGTON GALLERIES,
BURLINGTON GARDENS, W. 1.

Tuesday, 16th June, at 5 p.m.
M. ANDRÉ BRETON (in French)
" Limites non Frontières du Surréalisme "

Friday, 19th June, at 5 p.m.
Mr. HERBERT READ
" Art and the Unconscious "

Wednesday, 24th June, at 5 p.m.
M. PAUL ELUARD (in French)
" La Poésie Surréaliste "

Friday, 26th June, at 5 p.m.
Mr. HUGH SYKES DAVIES
" Biology and Surrealism "

Wednesday, 1st July, at 5 p.m.
M. SALVADOR DALI
will speak on one of the following subjects :
" Paranoia "
" The Pre-Raphaelites "
" Harpo Marx "
" Phantoms "

Lectures will be free to visitors to the Gallery. Admission to the
Exhibition : 1/3 ; Season Tickets 5/9.
A translation of the French lectures will be read at the end of the
lecture.
The above announcement is issued subject to revision.

INTERNATIONAL
SURREALIST EXHIBITION
NEW BURLINGTON GALLERIES
BURLINGTON GARDENS

The Committee have the honour to announce that
M. ANDRÉ BRETON
WILL OPEN THE EXHIBITION
on THURSDAY, JUNE 11th

MM. HANS ARP, SALVADOR DALI, MAX ERNST,
MAN RAY, and other distinguished members of the
Surrealist Movement abroad will be present

The Committee hope to have the pleasure of your company at 3 p.m.

SURREALISM
CATALOGUE · PRICE SIXPENCE

Photograph album, photoboards
and printed ephemera
Purchased 1994
GMA A35/1/3/378;
GMA A35/1/3/392–3;
GMA A35/1/1/RPA719

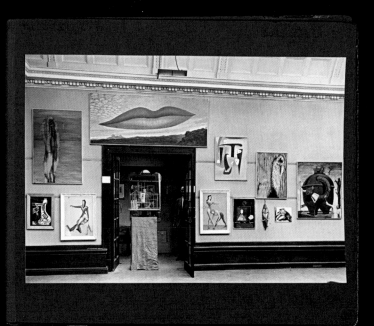

Roland Penrose 1900–1984

Roland Penrose played a central role in both the history of Surrealism in Britain, and in the creation of the Gallery of Modern Art's collection of Surrealist art (see pp.15–21). Penrose was born in London into a well-to-do Quaker family; his father was a painter. He studied History and then Architecture at the University of Cambridge and under the influence of John Maynard Keynes, and later Roger Fry, became interested in modern art. He studied art in Paris from 1922 and in 1926 met Max Ernst, who became a close friend. Ernst introduced him to other members of the Surrealist group. Ernst's work had a lasting impact on Penrose, particularly in the form of collages and frottages.

In or around July 1935 Penrose met David Gascoyne and together they planned the *International Surrealist Exhibition*, London, 1936 (see pp.136–7). The following year, 1937, Penrose and E.L.T. Mesens took control of the London Gallery where they staged a series of exhibitions of Surrealist art. The gallery's journal, the *London Bulletin*, became the main organ of the British Surrealist movement. Penrose's purchase of dozens of major Cubist and Surrealist works, from the Gaffé and Eluard collections in 1937 and 1938 respectively, turned his Hampstead home into a museum of Surrealism. His close friendship with many of the leading Surrealists, and with Picasso, cemented his position at the heart of the movement.

Untitled, 1937 is a classic example of Penrose's postcard collages, which he began making in the summer of 1937. As he later stated: 'Attracted by the vivid colour of the picture postcards on sale everywhere, I began to experiment with them in collages. Sometimes I found that repetitive clusters could take the effect of a spread of feathers or a single image cut out and set at a peculiar angle could transform completely its original meaning.' Magritte was so impressed he co-wrote, with Paul Nougé, an article on them. *My Windows Look Sideways* relates more to Magritte and Miró, incorporating words and images to deliberately enigmatic effect.

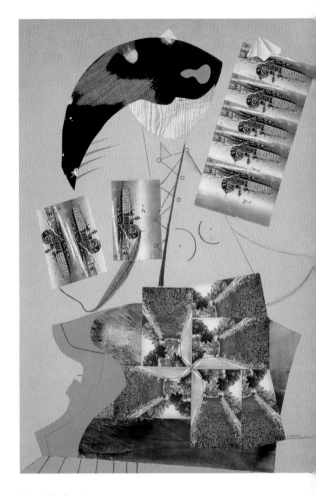

Untitled 1937

Collage, gouache and pencil on card, 79 × 54.5
Bequeathed by Gabrielle Keiller 1995
GMA 4070

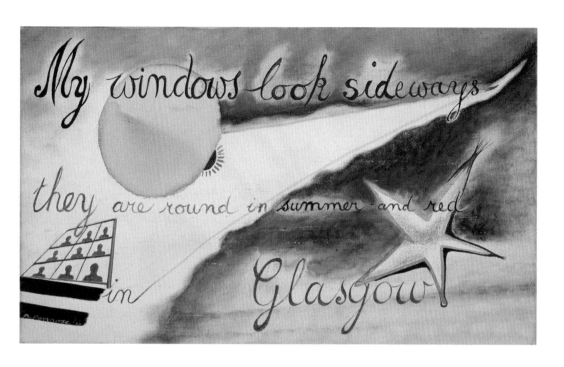

My Windows Look Sideways 1939
Oil on canvas, 30.5 × 51
Presented by Antony Penrose 1995
GMA 3911

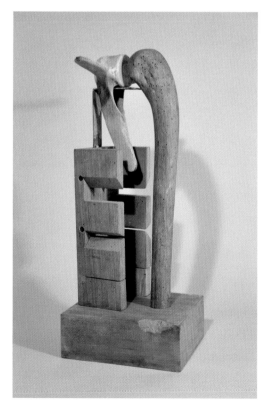

Kidderminster c.1937
Bone (dolphin's vertebra), wood and metal,
42.7 × 23 × 14.8
The Penrose Collection

Kidderminster (the name is written under the piece and is assumed to be the original title) is a rare surviving object-sculpture by Penrose. Never previously exhibited or published, it was probably made around the time of the *Surrealist Objects and Poems* exhibition held at the London Gallery in November 1937.

139

Surrealist Scrapbooks

These two scrapbooks, compiled during the Second World War, look back over a period of intense involvement with Surrealism. Despite his youth, David Gascoyne had become one of the most influential members of the British Surrealist group. He published a book of poetry aged sixteen, and at the age of seventeen moved to Paris. He began writing Surrealist verse and in May 1935 published the 'First Manifesto of English Surrealism' in the periodical *Cahiers d'Art*. Gascoyne's *A Short Survey of Surrealism*, (the first book in English on Surrealism) published in November 1935, gives an account of the movement together with translations of poems and texts by Breton, Eluard, Péret, Dalí and others. He assisted Penrose with the organisation of the *International Surrealist Exhibition*, London, 1936 for which he made several objects and collages, and he exhibited in the *Surrealist Objects and Poems* show held in London the following year.

The scrapbook is one of a series produced by Gascoyne during the 1940s, using material he had gathered whilst preparing *A Short Survey of Surrealism*. It was compiled at his parents' home at Teddington, during the war. It is a compendium of photographs, catalogues, prospectuses, published and manuscript texts and press cuttings, together with several original collages and painted ornaments by Gascoyne himself. The material has been ordered thematically, so that there are sections devoted to the London exhibition, the Paris exhibition of 1938, and to leading figures in the movement, including Breton, Dalí, Ernst and Magritte. Gascoyne gave it to Anthony Zwemmer, the London book dealer, in payment for books he had acquired just after the war.

The pages of the Penrose scrapbook are composed with the eye of a Surrealist. The cover has a collaged label by Penrose bearing the inscription in red and blue crayon 'My Wartime Scrapbook', and he provides hand-written captions to some pages. Unrelated photographs, postcards, prints and cuttings are set against each other in strange and often witty combinations. While one page shows the grim reality of war, another takes a light-hearted look at the art of camouflage (Penrose lectured on camouflage to the Home Guard during the war). There is a print by Miró, *Aidez L'Espagne*, placed beside a photograph of the Lewes War Memorial, and a page on the Surrealist demonstration against Neville Chamberlain in Hyde Park, London in May 1938, set beside photographs of Morris dancing. Scattered throughout the book is a series of original collages. Penrose used the scrapbook format again when he came to write his autobiography, *Scrap Book 1900–1981*.

David Gascoyne 1916–2001
Scrapbook c.1940–4

Scrapbook, 25.5 × 19
Bequeathed by Gabrielle Keiller 1995
GMA A42/2/GKL1014

Roland Penrose 1900–1984
My Wartime Scrapbook 1940–6

Scrapbook, 30 × 25
Purchased 1994
GMA A35/1/4/012

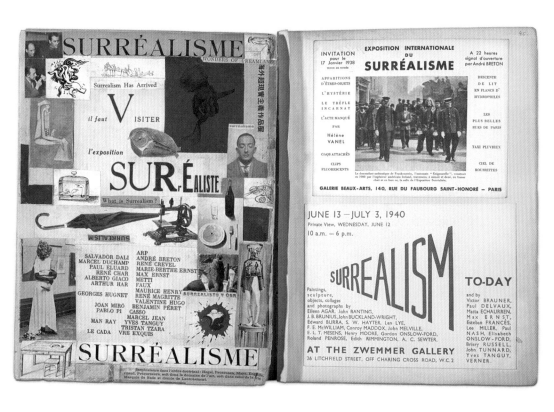

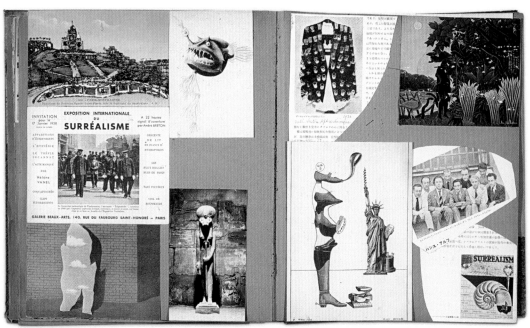

Ceri Richards 1903–1971
Relief Construction (Bird and Beast) 1936

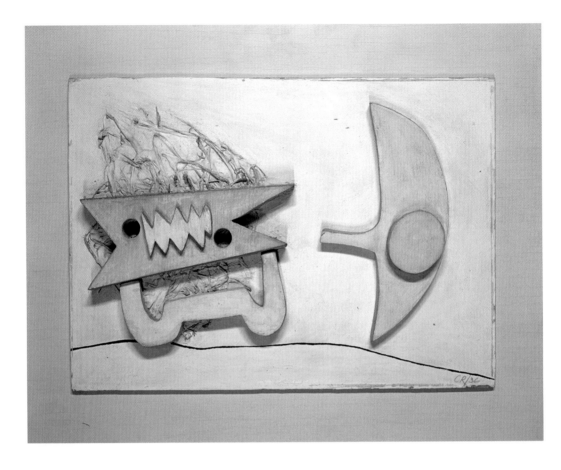

Although not a member of the British Surrealist group which came together after London's *International Surrealism Exhibition* in 1936, Welsh artist Ceri Richards became closely associated with Surrealist art. In 1937 he participated with other Surrealist artists in the efforts of the Artists' International Association to support republican Spain.

Richards began making relief constructions in 1934. They were developed from the papiers collés of the Cubists, and the reliefs and collages of the Dadaists which incorporated found materials. This is an early example of Richards's relief constructions. The roughly sawn wood and raffia give the work a coarse appearance. Some critics have commented on the erotic subtext of the piece, interpreting the aggressively jagged 'beast' as female and the wide-eyed bird as male. Even without reading sexual references into the

relief, the construction is both comical and sinister. The relief was made around the time of the *International Surrealist Exhibition*, where Richards would have seen relief compositions by the Paris-based Surrealists.

Oil on wood relief, raffia and plaster, relief 42.8 × 60.3; board 60.3 × 78.1
Purchased 1975
GMA 1517

Cecil Collins 1908–1989
The Joy of the Worlds 1937

Cecil Collins was too independent and idiosyncratic a figure to follow a party line, and his links with the British Surrealist group were brief and tenuous. He participated in the *International Surrealist Exhibition*, London, 1936 but broke with the group two years later and was subsequently critical of it. While some of the Surrealists adopted a cynical or humorous approach, Collins was genuinely and passionately interested in the mysteries of life and the universe. His sympathies were more with William Blake than with André Breton.

Collins studied at Plymouth School of Art and then, from 1927 to 1931, at the Royal College of Art in London. This work was painted in Totnes, Devon, where Collins lived from 1936. He read widely on subjects such as biology, cosmic rays and astronomy, and he harnessed this interest to create a poetic, humanist vision of man. In his paintings he introduced forms which suggest the macro-cosm and the microcosm, the incidental and the infinite. Here the painting is dominated by a womb-like form filled with cells or amniotic fluid, while planet-like forms circulate above. In the centre stands a man with a staff and halo, a kind of alter-ego whom Collins called 'The Pilgrim'.

Oil on plywood, 127 × 127
Bequeathed by Mrs Elisabeth Collins through The Art Fund 2001
GMA 4372

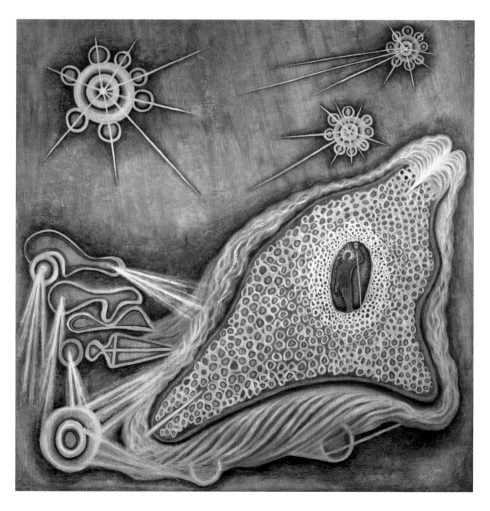

Edward Baird 1904–1949
The Birth of Venus 1934

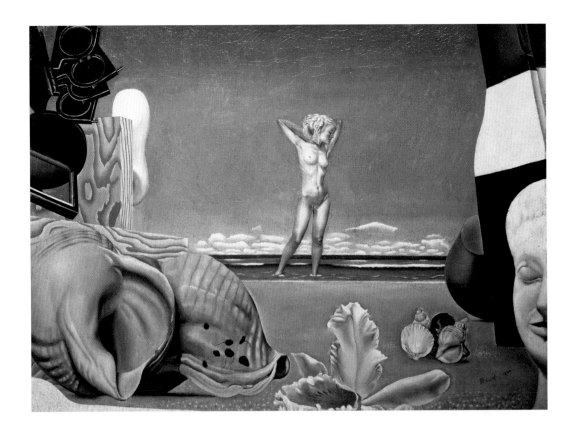

Edward Baird was one of very few Scottish artists to take an interest in Surrealism. Born in Montrose, he studied at Glasgow School of Art from 1924 to 1927. He spent so long on each painting that, in his career, he probably finished fewer than forty oils. After graduating, he returned to Montrose and lived there for the rest of his short life.

The Birth of Venus was painted as a wedding present for Baird's friend, the artist James McIntosh Patrick. It shows an incongruous group of objects piled up on Montrose beach: two giant seashells, one with a distinctly vaginal opening; lenses which belong to a sextant; an Etruscan head of Apollo; a boat's rudder; and a lusciously erotic orchid. (Baird was a keen sailor and he came from a line of six generations of seamen on his father's side.) The nude woman, rising from the sea, is modelled on Ann Fairweather, to whom Baird became engaged in 1931 (they married only in 1945). He has changed her hair from dark brown to platinum blond, perhaps in order to disguise her identity. The painting has affinities with works by the English artist Edward Wadsworth, who painted a number of surreal still lifes in beach settings.

Oil on canvas, 51 × 69
Accepted by H.M. Government in lieu of Inheritance Tax, and allocated to the Scottish National Gallery of Modern Art 2002
GMA 4473

Sam Haile 1909–1948
Non Payment of Taxes, Congo, Christian Era 1937

Born in London, Sam Haile studied at the Royal College of Art from 1931 to 1934, initially as a painter. His interest in modern art was not encouraged, so he subsequently transferred to the pottery department. He held his first solo show of pottery in London in 1937, and joined the British Surrealist group that year, participating in the Surrealist section of the Artists' International Association exhibition.

Haile held strong political views, rallying against fascism, Nazism, capitalism and imperialism. *Non Payment of Taxes, Congo, Christian Era* dates from January 1937.

Painted in sombre browns and black, it may at first seem to show a tree marked by deep cuts. The Congo – or Congo Free State as it then was – was a Belgian colony, and one of its particular riches was rubber, made by cutting through the bark of the rubber tree; much of this work was done with forced labour. Closer inspection shows that the spindly vertical forms at the top are arms and that the 'tree' has a wizened head with bulbous eyes. This is not a tree; this is a Congolese native who has been strung up and viciously whipped, and who seems to have already lost a leg. A bottle and glass of wine sit incongruously on a table next to him.

Oil on canvas, 76.3 × 51.1
Purchased 2006
GMA 4816

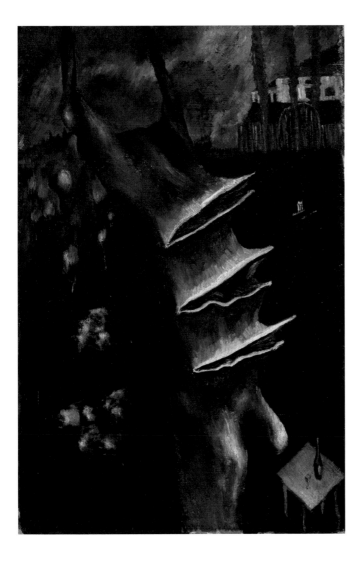

Eileen Agar 1899–1991

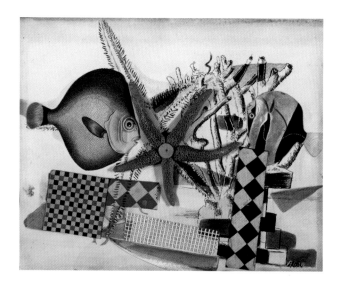

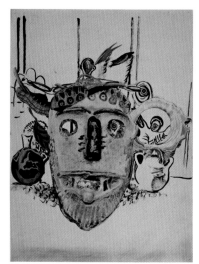

Eileen Agar studied at the Slade School of Art in London, and in Paris in the late 1920s. She began making collages in 1935. In a letter to the Gallery of Modern Art she wrote: 'In 1935 I was in Swanage when I came across some pages in a book containing dried leaves and I did a few collages incorporating them. Paul Nash who was in Swanage at the time showed interest, saying that he didn't know of anyone who had used leaves. From leaves I moved to masks hence the "Lotus-Eater", and since then I have done collages on and off through the years. I believe it to be a vital and moving part of Surrealist art, the painter's answer to Photographs.' Through Nash she met Roland Penrose and Herbert Read, who invited her to take part in the forthcoming *International Surrealist Exhibition* in London: 'One day I was an artist exploring highly personal combinations of form and content and the next I was calmly informed I was a Surrealist.'

Angel of Mercy is one of three related plaster heads which Agar made in the mid-1930s. All three are based on portrait busts of the artist's husband, Joseph Bard. A variant, *Angel of Anarchy*, was made in 1937 and was then lost in transit; a second version of *Angel of Anarchy*, which is wrapped in brightly coloured material, is in the collection of Tate, London. Although it is inscribed with the date 1934, *Angel of Mercy* may have been made around 1937, the year of the London Gallery's *Surrealist Objects and Poems* exhibition.

Fish Circus 1939

Collage, pen and ink and watercolour on paper, 21 × 26
Bequeathed by Gabrielle Keiller 1995
GMA 3938

The Lotus Eater 1939

Paper collage with watercolour and ink on paper, 38.1 × 28.2
Purchased 1979
GMA 2079

Angel of Mercy c.1934

Plaster with collage and watercolour, 44.5 tall
The Sherwin Collection

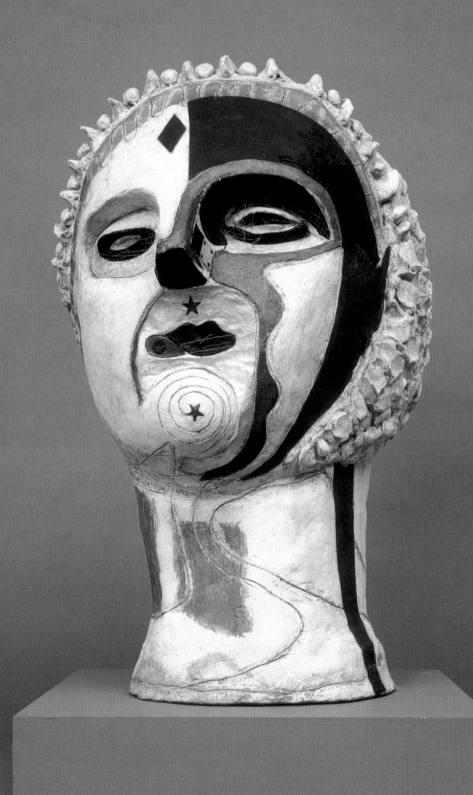

Henry Moore 1898–1986

By the 1930s Henry Moore had established a reputation as Britain's leading modern sculptor. He was closely involved with the British Surrealist group, serving on the selection committee of London's 1936 *International Surrealist Exhibition*.

Made during the early months of the Second World War, *The Helmet* is Moore's first work to combine exterior and interior forms, a theme which preoccupied him in later years. A strange, vulnerable-looking figure stands inside the helmet which is both protective and menacing. Moore described the helmet motif as 'One form inside another, so you get the mystery of not entirely knowing the form inside ... it's rather like armour which protects – the outer shell protecting the softer shell inside.' The sculpture grew out of several themes. In the 1930s Moore had made drawings of shells, examining the way in which a complex internal structure is enclosed by a simpler outer form. Other ideas suggested by *The Helmet* are the mother protecting its child; the embryo within the womb; and the Freudian idea of the mind inhabiting the body. However, the imagery in *The Helmet* derives from two specific sources: in 1937, Moore made studies of an ancient Greek helmet with eye-like holes pierced in the top; and in 1939 he made a drawing and a print of a Spanish republican prisoner, his head rendered as a cage-like form behind a barbed-wire fence. These various ideas come together in *The Helmet*, one of Moore's most complex and richly metaphorical works.

Until the late 1930s most of Moore's sculptures were carved in stone, but he then began modelling works in wax or clay and casting them in lead. Casting allowed him to obtain thin, sinuous forms, and lead, unlike bronze, has a low melting point, so Moore could do the casting himself, using, as he put it, 'ordinary cooking pans and my wife's kitchen stove'. The sculpture was first exhibited at the Zwemmer Gallery's *Surrealism To-day* exhibition in June 1940. Priced at seventy guineas, it was bought by Roland Penrose; it remained in the Penrose collection until 1992, when it was acquired by the Gallery of Modern Art. A single bronze cast of *The*

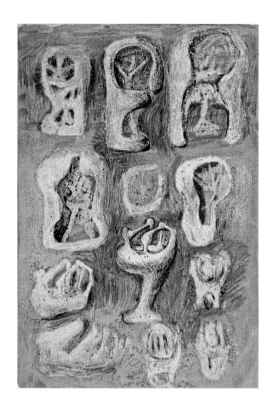

Helmet exists, and there are also three bronze casts of the interior figure alone.

The Gallery of Modern Art's collection also has a sheet of Moore's drawings, featuring a little sketch of a similar helmet motif in the top right-hand corner. While most sculptors make drawings in preparation for sculptures, Moore often made drawings *of* his sculptures, putting them into landscape settings and introducing new details. This drawing dates from 1940 and probably post-dates the sculpture.

Ideas for Sculpture 1940

Pencil, wax crayon, watercolour wash, pen and ink, 26.8 × 18.2
Bequeathed by Mr H.J. Paterson 1988
GMA 3423

The Helmet 1939–40

Lead, 29.1 × 18 × 16.5 (excluding base)
Purchased with assistance from the National Heritage Memorial Fund, The Art Fund (Scottish Fund) and the Henry Moore Foundation 1992
GMA 3602

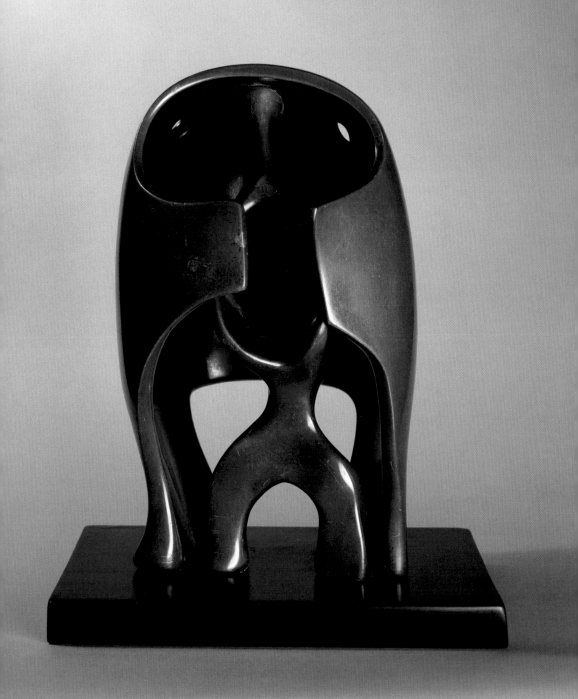

Grace Pailthorpe 1883–1971
Birth Trauma Series 3: May 4 1938, no.4 1938

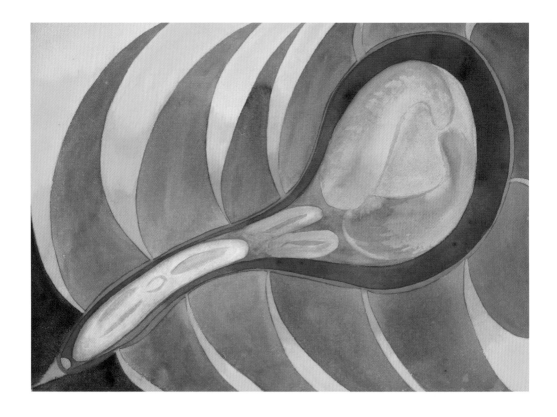

Watercolour on paper, 28.5 × 39.5
Purchased with assistance from the Friends of the
National Libraries 1999
GMA A62/2/2/03/04

Grace Pailthorpe qualified as a surgeon in 1914
and served with the French and British Red
Cross during the First World War. Returning to
England in 1922 she re-trained in psychological
medicine, specialising in criminal psychology.
She published her research on the psychology
of delinquency in 1923 and in 1932 became
a founder member of the Institute for the
Scientific Treatment of Delinquency. It was
during this time that she began analysing the
drawings of her patients as part of their therapy.

Reuben Mednikoff studied at St Martin's
School of Art from 1920 to 1923, after which he
worked in advertising. He became interested
in psychoanalysis in the early 1930s, initially
using it to confront his own personal problems.
Pailthorpe met Mednikoff in February 1935 and
they began a lifelong collaboration, investigat-
ing the relationship between art and psychoa-
nalysis. They embarked upon a programme of
research which focused on the spontaneous
creation of art for therapeutic ends, practised in
conjunction with psychoanalysis. As Pailthorpe

Reuben Mednikoff 1906–1972
Stairway to Paradise 1936

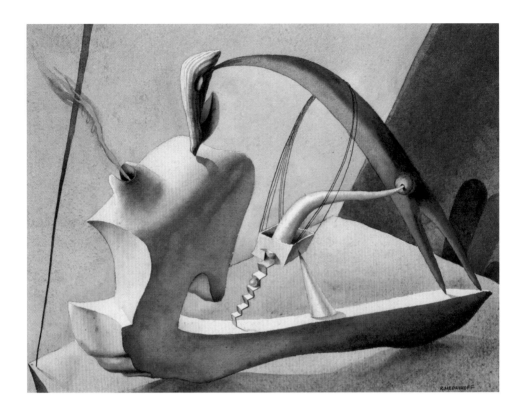

said, 'I feel that there must be somewhere a quicker way to the deeper layers of the unconscious than by the long drawn-out couch method and I had a feeling that it was through art.' The parallels between this approach and the Surrealists' theories of automatism were obvious, and the paintings and drawings created by Pailthorpe and Mednikoff in their research attracted the attention of the Surrealists.

They exhibited a number of works, including Mednikoff's *Stairway to Paradise*, at the 1936 *International Surrealist Exhibition* held in London. André Breton declared these 'the best and most truly Surrealist of the works exhibited by British artists'. Pailthorpe and Mednikoff went on to participate closely in the British Surrealist group. In 1938 Pailthorpe gave her first 'Birth Trauma Lecture' and wrote 'The Scientific Aspect of Surrealism' which was published in the *London Bulletin*. In 1939 they held a joint exhibition at the Guggenheim Jeune Gallery,

London. Having participated regularly in their meetings they were, however, expelled from the British Surrealist group in 1940. Pailthorpe and Mednikoff moved to New York in 1940 but returned to London in 1951.

The Gallery of Modern Art's Archive holds the Pailthorpe and Mednikoff papers. These include material on British Surrealism and the documentation of their research projects. The extensive notes made during the course of their 'Birth Trauma' and 'Toe Dance' experiments of 1938 are accompanied by a large number of watercolours drawn from the unconscious.

Watercolour on paper, 26 × 34.5
Private collection, courtesy the Mayor Gallery,
London

John Banting 1902–1972

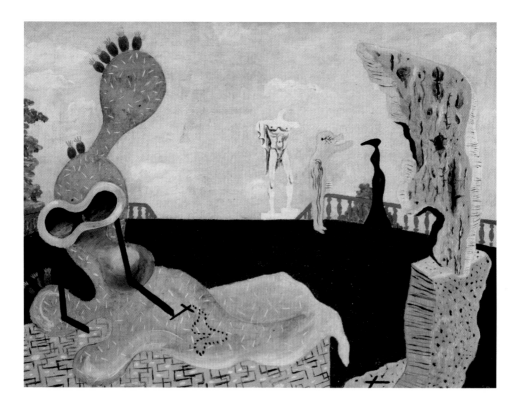

Born in London, John Banting studied painting at evening classes in London and also, in 1922, at the Académie Colarossi in Paris. From 1930 he spent much time in Paris: through his close friend Nancy Cunard, the shipping heiress and social activist, he met and became friendly with a number of the French Surrealists, notably Breton and Duchamp. An unconventional man, he was known to dye his hair green and cut the tops off his shoes. His exhibition at the Wertheim Gallery in London in 1931 was one of the earliest exhibitions of Surrealist art by a British artist. He participated in the *International Surrealist Exhibition* in London in 1936 and, at Duchamp's invitation, at the 1938 Surrealist exhibition held at the Galerie des Beaux-Arts in Paris. Many of his early Surrealist works show hollowed-out forms and bones, as if to reference the emptiness of human existence. In the foreground of *The Couple*, Banting depicts an anthropomorphic cactus, apparently in conversation with a cracked stone figure; both carry little crucifixes.

The Couple c.1932–3

Oil on board, 29 × 39
The Sherwin Collection

Guardian Bust 1936

Oil on board, 50 × 43
Private collection, courtesy the
Mayor Gallery, London

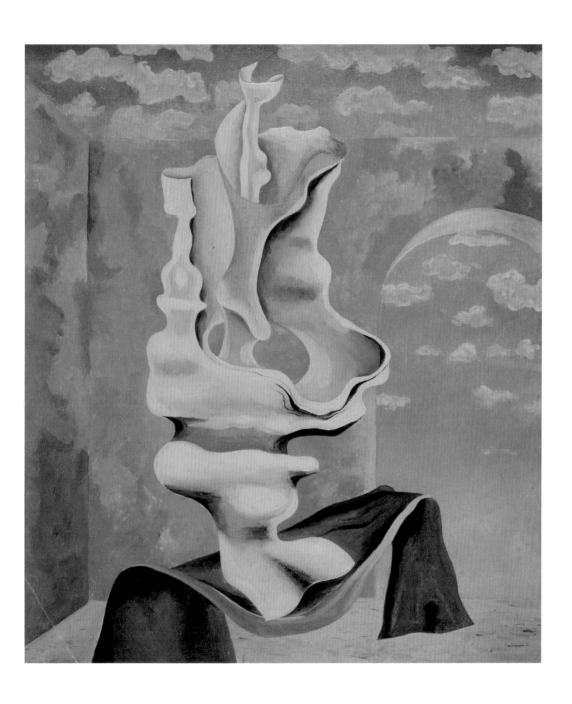

John Selby-Bigge 1892–1973
Untitled c.1935–6

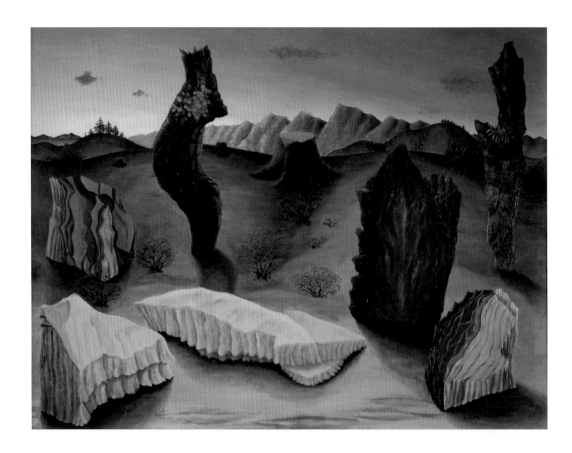

John Selby-Bigge was born in Oxford. He studied at the Slade School of Art in London and was then called for national service in the British army. In 1919 his father was awarded the Baronetcy for Kings Sutton, Northamptonshire, and this later passed to the son, whose full name became Sir John Amherst Selby-Bigge. Through his friendship with Edward Wadsworth (see pp.130–1), in the 1920s he became interested in abstract painting and later worked on the fringes of the Surrealist group. He had solo exhibitions at the Wertheim Gallery in London in 1931 (as did John Banting) and at the Lefevre Gallery, London in 1933. He featured in the celebrated Unit One exhibition held at the Mayor Gallery, London in 1934, and in the catalogue – his only major published text – he acknowledged that 'A few years ago I was implicated in the painting and literature of the Surréaliste movement', but that he was 'now'

more interested in abstract art. He nevertheless showed two works at the *International Surrealist Exhibition*, London, in 1936 and one of his paintings was reproduced in Herbert Read's book on Surrealism published that same year. The following year he moved to France and he exhibited with less frequency thereafter.

Oil on wood, 45 × 60.5
Private collection, courtesy the Mayor Gallery, London

John Tunnard 1900–1971
Diabolo on the Quay 1936

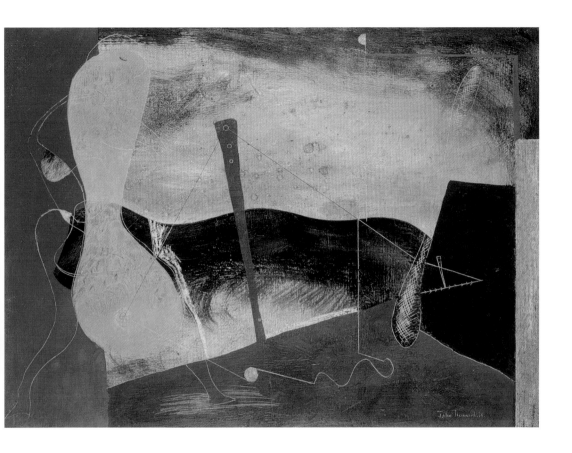

John Tunnard studied at the Royal College of Art in London, where he was a contemporary of Moore. He worked as a textile designer early in his career and from 1933 lived in the fishing village of Cadgwith in Cornwall. Influenced by the work of Miró, Klee, and British abstract artists such as Ben Nicholson, Tunnard developed a distinctive abstract idiom which amalgamated mechanical and natural elements. His works often contain allusions to electrical appliances such as radars and radios. Filament-like lines stretched across his pictures in reference both to futuristic electrical equipment and also to stringed instruments (he was an accomplished jazz musician). He employed a number of different techniques, such as scratching into the paint surface to give his work a sense of depth and transparency.

Only briefly, around 1936 and 1937, did Tunnard's work have a definite Surrealist character, as in *Diabolo on the Quay*, which contains echoes of Miró, Klee and Calder. For Christmas 1936 Tunnard received a copy of Herbert Read's book *Surrealism*, and he acknowledged that it impressed him greatly. This painting, which is dated 1936, must however predate the gift. It was exhibited in the Surrealism exhibition held in Cambridge at the Gordon Fraser Gallery in November 1937; that year Tunnard also showed in the Surrealism section of the Artists' International Association exhibition in London. However, he never formally joined the Surrealist group. This painting formerly belonged to the artist Julian Trevelyan.

Oil on canvas, 45 × 61
The Sherwin Collection

Humphrey Spender 1910–2005
Beside the Sea 1941

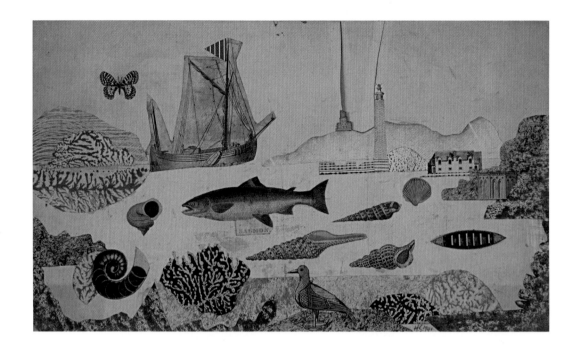

Like Humphrey Jennings, Humphrey Spender is probably best known for his work with the Mass-Observation unit (see p.135). This was set up in 1937 following the abdication of Edward VIII, and the idea was to record, dispassionately, through vast quantities of notes, photographs and film, the lives and thoughts of ordinary British citizens. Several of the founders and leading figures in Mass-Observation were involved with the British Surrealist group (including David Gascoyne and Julian Trevelyan). Spender, who at the time was working as a photographer for the *Daily Mirror*, was invited to photograph life in Bolton and Blackpool. He was already on the fringes of the Surrealist group, and even before joining the unit his photographs of empty streets contained echoes of De Chirico's paintings. Spender worked as an official war photographer during the Second World War. His collages are rare. *Beside the Sea* relates to a mural design which Spender made for The Gondola café in Wigmore Street, London. In the 1950s he gave up photography for painting, becoming a tutor at the Royal College of Art in London. His brother was the poet Stephen Spender.

Collage, 28 × 49.5
Private collection, courtesy the
Mayor Gallery, London

Toni del Renzio 1915–2007
Paranoiac Regression 1941

Toni del Renzio was a key figure in the British Surrealist movement during the Second World War. Although he painted throughout his life, he is probably best remembered for his arguments – carried out in pamphlets and articles – with other members of the British Surrealist group, notably E.L.T. Mesens and Conroy Maddox. Born in Russia to parents of mixed Russian and Italian descent, he grew up in Italy. He moved to Paris in 1938, becoming associated with the Surrealists, and then moved to London two years later. He had relationships with Emmy Bridgwater (see p.158) and Ithell Colquhoun (see pp.160–1); he married the latter in 1943.

The war left a vacuum in the heart of the London Surrealist group and Del Renzio was the man who filled it. In March 1942 he published the polemical *Arson: An Ardent Review. Part One of a Surrealist Manifestation*; a few months later he organised a major Surrealism show in Bayswater, London. This well-organised, politically-engaged Surrealist activity drew contempt from Mesens, the self-appointed leader of the British Surrealist group during the war: he viewed Del Renzio as an upstart who had no right to usurp his place. Pamphlets were issued by both sides. *Paranoiac Regression*, a rare surviving painting from this period, was illustrated in *Arson*, a pamphlet which lasted one issue.

Gouache on paper, 36 × 28
The Sherwin Collection

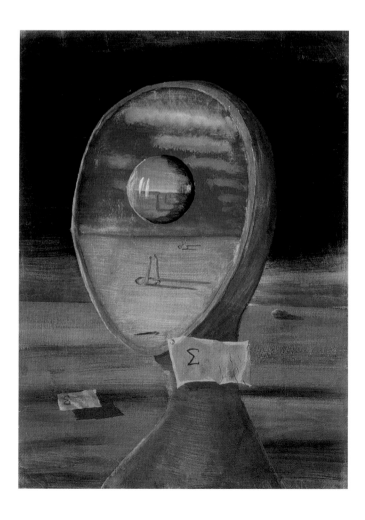

Emmy Bridgwater 1906–1999
Necessary Bandages c.1942

Emmy Bridgwater was part of the Birmingham Surrealist group, which was second only to London in the volume and ambition of its exhibition activities: key figures in the group included Conroy Maddox, the brothers John and Robert Melville, Oscar Mellor, and, later, Desmond Morris. She visited the *International Surrealist Exhibition* in London in 1936 and soon began painting in a Surrealist style. In 1940 she joined the British Surrealist group in London, becoming friendly in particular with Edith Rimmington and Ithell Colquhoun.

The figure smoking a cigarette in the background of *Necessary Bandages* may be Toni del Renzio (see p.157), with whom Bridgwater had an affair in the early 1940s. If this is true, the bandages may indicate the pain of the break up, compounded by the fact that Del Renzio moved in with, and then married, their mutual friend Colquhoun. Bridgwater exhibited at the London Gallery and in the major international Surrealist exhibition held at the Galerie Maeght in Paris in 1947.

Oil on panel, 35 × 29.2
The Sherwin Collection

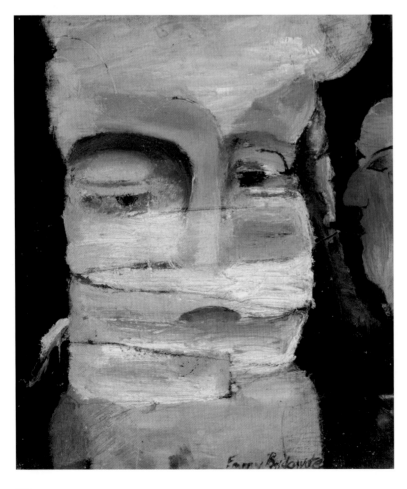

Desmond Morris b.1928
War-Woman 1949

The zoologist and artist Desmond Morris was born in Wiltshire. He held his first solo exhibition in Swindon in 1948, followed by an exhibition at the London Gallery with Miró in 1950, when he was just twenty-two years old. In 1957 he organised an exhibition of paintings by chimpanzees at the Institute of Contemporary Arts in London and in 1962 published *The Biology of Art*, a study of the picture-making of great apes and its relationship to human art. From 1967 to 1968 he was Director of the ICA in London, at the same time as he published his most famous book *The Naked Ape*.

War-Woman was completed on 15 September 1949 following a week in Paris (Morris's first ever trip abroad) where he met some of the Surrealists. It is one of very few surviving 'object paintings' by him. As a schoolboy he

had been impressed by an illustration of a painting by Ernst which had various objects attached to it: this probably provided the inspiration for *War-Woman*. In this work Morris used a fishing float, a door knob, a small picture frame, and pieces of wood, cork and rubber, all stitched to a painted panel. He later commented that 'the angular, geometric figure reflects the hardened lifestyle and loss of femininity experienced by many women during the wartime years'. Morris restored the painting himself in about 1986.

Mixed media on board, 71 × 43
Purchased with funds from the Cecil and
Mary Gibson Bequest 2007
GMA 4830

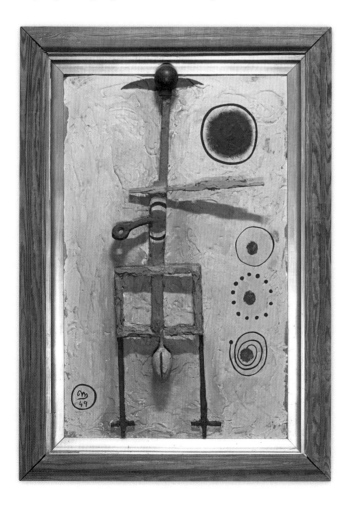

Ithell Colquhoun 1906–1988

Ithell Colquhoun was, in the 1930s and 1940s in particular, one of the most imaginative and accomplished artists affiliated to the British Surrealist group. Born and raised in India, she studied at the Slade School of Art, London from 1927. As part of a student trip, she visited Paris in 1931 and saw Dalí's work, which impressed her greatly. She held a joint exhibition with Penrose at the Mayor Gallery, London, in June 1939; she met Breton later that year in Paris.

Rivières tièdes and *Gouffres amers* were both shown at Colquhoun's Mayor Gallery exhibition. They are part of what she called her *Méditerranée* series, being inspired by several trips to the Mediterranean area in the 1930s. She often titled her works after phrases she found in French poems: *Rivières tièdes* (tepid rivers) comes from a poem by Stéphane Mallarmé and *Gouffres amers* (bitter chasms) is taken from Baudelaire's *L'Albatros,* 1857. However, the actual theme of *Gouffres amers* derives from Shakespeare's *The Tempest*: 'Full fathom five thy father lies; Of his bones are coral made; Those are pearls that were his eyes'. When the Tate Gallery acquired another painting from the same *Méditerranée* series, Colquhoun wrote that all the paintings shown at the Mayor Gallery exhibition of 1939 'were influenced more or less by Dali. Not by particular paintings, mostly by his technical expertise and his concept of the double image.'

Independent-minded, her involvement with the British Surrealist group came to an end in 1940 when she fell out with E.L.T. Mesens. From 1943 to 1947 she was married to Toni del Renzio (see p.157). Colquhoun had a life-long interest in alchemy and the occult and later in life became a Deaconess of the Ancient Celtic Church, a member of The Hermetic Order of the Golden Dawn, and a Priestess of Isis. Of Scottish descent, she was also the Clan Bardess of the Clan Colquhoun Society.

Gouffres amers 1939

Oil on panel, 71.2 × 91.3
Hunterian Museum and Art Gallery,
University of Glasgow

Rivières tièdes 1939

Oil on panel, 91.1 × 61.2
Southampton Art Gallery

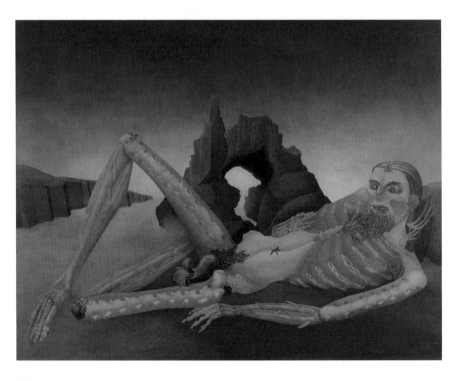

Marion Adnams 1898–1995

Marion Adnams lived and worked in Derby for most of her life. She remains a little-known figure, never joining any of the British Surrealist groups, rarely featuring in the press and exhibiting mainly in the Midlands. She trained as a modern languages teacher, but in the 1930s took evening classes at Derby School of Art where she was taught by Alfred Bladen, a Derby artist who shared her interest in Surrealism. In 1938 she became an art teacher at a girls' grammar school in Derby; she started painting in a Surrealist style around this time, putting apparently unrelated objects together in mysterious scenes, and seldom if ever including figures. She became head of the art department at Derby Training College in 1946, the year *Aftermath* was painted. The skull and barbed wire may allude to the war, but they were also standard Surrealist motifs, seen also, for example, in the work of John Banting. Adnams stopped painting around 1968 owing to deteriorating

eyesight, and lived for the rest of her long life in her parents' small house in Derby. A retrospective exhibition was held in Nottingham in 1971. Two of her paintings are in Manchester Art Gallery. *Nightmare at Noon* was exhibited during the Second World War at The Modern Gallery, London, which was the brainchild of the eccentric German-born artist Jack Bilbo. The gallery opened at the height of the Blitz but managed to stage impressive shows of contemporary art, including a Picasso exhibition.

Nightmare at Noon c.1941–5

Oil on gesso-board, 45 × 35
Private collection, courtesy the
Mayor Gallery, London

Aftermath 1946

Oil on wood, 32.3 × 23.1
Purchased 2006
GMA 4815

Edith Rimmington 1902–1986
The Decoy 1948

Edith Rimmington was born in Leicester and worked in Manchester. She moved to London in 1937 and that year took part in the London Gallery's *Surrealist Objects and Poems* exhibition. Her poems and automatic drawings appeared regularly in the publications of the movement, including the *London Bulletin*. Like her friends Emmy Bridgwater and Conroy Maddox, Rimmington was one of the mainstays of Surrealism in England for decades. The original Surrealist group in London disbanded in 1947, but Rimmington's fidelity to the movement's basic aims and principles persisted until the end of her life.

Many of Rimmington's paintings feature images of metamorphosis, with subjects relating to death and the sea. This work features stages from a butterfly's life cycle. The exquisitely painted butterflies contrast with the more disquieting imagery of caterpillars emerging from the flayed palm of the hand. By 1950, Rimmington had begun to experiment with photography, on which she concentrated in her later years. This painting was formerly in the collection of E.L.T. Mesens.

Oil on canvas, 35.5 × 30.5
Purchased by the Patrons of the National Galleries of Scotland 2002
GMA 4654

John Pemberton 1910–1960
Since the Bombardment c.1948

John Pemberton was not a leading British Surrealist – indeed, he was a latecomer to the group and only peripherally involved with it. He was from Bidford-on-Avon and worked professionally as a scene painter for the Old Vic Company in London: his credits include a Lawrence Olivier production of *King Lear*. He painted in an Impressionist style until shortly after the Second World War, before shifting his allegiance to Surrealism.

In November 1948 he held an exhibition at the London Gallery in Cork Street (Lucian Freud had a small show in a separate room at the same time). Sixteen paintings were on show, including *Since the Bombardment*. A year later he was included in a mixed show at the same gallery, alongside Picasso, Penrose and Arp. Pemberton moved to Paris in the early 1950s and died there in 1960.

Oil on canvas, 76.6 × 63.7
Bequeathed by Elizabeth Watt 1989
GMA 3506

Conroy Maddox 1912–2005

Conroy Maddox had no formal training as an artist. He moved to Erdington, a suburb of Birmingham, in 1933 and the chance discovery of a book by R.H. Wilenski awakened his interest in Surrealism. Through the brothers John and Robert Melville, who also lived in Birmingham, Maddox was drawn into the British Surrealist group. In 1936 he met Dalí, Breton and Ernst at the *International Surrealist Exhibition* in London; he had refused an invitation to take part in the show believing that a number of the participating artists were not sufficiently Surrealist. As the early painting *The Lesson* shows, his work was much indebted to Magritte.

Many of the Surrealists incorporated mannequins into their work (see pp.116–17). Maddox seems to have began making object sculptures in the late 1930s. He was sufficiently interested in the subject to write an article for the *London Bulletin* in June 1940, announcing that the object sculpture 'discredits completely the world of the immediate reality'. In 1995, in response to a query about *The Cloak of Secrecy* from the art historian Silvano Levy, Maddox wrote:

I can only speak indirectly of some of my thoughts of what was a fortuitous encounter back in 1940, when I saw various shop window models in a gown shop that was being demolished in one of the suburbs around Birmingham. They lay amidst the dust on the window floor. I had little difficulty in acquiring some, since they were going to be destroyed. I carefully selected two, which were in good condition although without heads and arms. Since there were a number of arms among the debris, I chose some of those as well. Hailing a taxi, I took them back to my studio in Erdington.

The Cloak of Secrecy was first shown at the London Gallery in 1947. It is likely that some of the component pieces were added or altered at a later date.

The Lesson 1938

Oil on canvas, 80.5 × 70.2
The Sherwin Collection

The Cloak of Secrecy 1940

Mixed media, including mannequin parts, plastic lobster, painted bottle, netting, sequins, doll's head, wire, 173 tall
Purchased with assistance from the Elephant Trust 1999
GMA 4283

Gordon Onslow Ford 1912–2003
Checkmate 1940

Although his grandfather was a celebrated
sculptor, Gordon Onslow Ford was discour-
aged from becoming an artist, and instead
joined the Royal Navy. He left in 1937 to study
art in Paris. He became a close friend of the
artist Roberto Matta, through whom he met
many of the Surrealists. He moved to London
in 1939 and became involved with the British
Surrealist group, exhibiting in the Zwemmer
Gallery's *Surrealism To-day* exhibition in
1940, and acting as co-editor of the last – and
Surrealist – issue of the *London Bulletin* in
June that year. He moved to America later
that year, and remained there until his death
in 2003. *Checkmate* was painted during his
brief spell in England. Writing about the
painting, Onslow Ford stated: 'this painting
is in transition from the symbolic world of
dreams to the spaces of mind beyond. It deals
with the interconnectedness of all forms
of life ... I was more guided by spontaneous
intuition than preconceived ideas.'

Oil on canvas, 76 × 102
The Sherwin Collection

Julian Trevelyan 1910–1988
Ethiop Queen c.1933

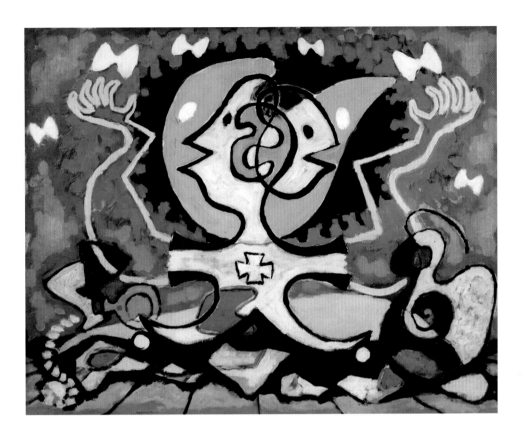

Julian Trevelyan viewed himself as an 'independent' artist, but his participation in the *International Surrealist Exhibition*, 1936 and the 1937 *Surrealist Objects and Poems* exhibition make him seem more attached to the Surrealist group than he really was. He studied English at the University of Cambridge where fellow students Humphrey Jennings and Hugh Sykes Davies were showing a prescient interest in Surrealism. His article in the literary review *transition*, in June 1930, is one of the first Surrealist texts written by a British artist. Encouraged by Jennings, Trevelyan left Cambridge in 1931 to study art in Paris. Working at Stanley William Hayter's etching studio, he met some of the leading Surrealists who also came to work there, including Miró, Ernst, Giacometti and Calder. This painting was probably painted in Paris, and with its double-headed figure reflects Picasso's strong influence. Its title is not certain, but it is probably *Ethiop*

Queen, a work included in Trevelyan's first solo exhibition at the Bloomsbury Gallery in 1934 – the year he returned to London. Back in London, Trevelyan created a remarkable group of paintings on slate and etchings which depict fragile, scaffold-like structures; these are indebted to Miró, Klee and Calder. Roland Penrose and Herbert Read selected three for the 1936 Surrealist exhibition, 'and so, overnight, so to speak, I became a Surrealist', as Trevelyan put it in *Indigo Days*, 1957, his autobiography. He later said that while he was interested in Surrealism, 'I do not think my heart was really in it,' at the same time acknowledging that it had been 'a magic door opening into a world of poetry'.

Oil on canvas, 54 × 79
The Sherwin Collection

F. E. McWilliam 1909–1992

Frederick Edward McWilliam was born in
County Down in Ireland. In 1928 he moved to
London to study painting at the Slade School
of Art. He lived in France for a year in 1931
and by that time had determined to concen-
trate on sculpture. He was deeply impressed
by the *International Surrealist Exhibition*
held in London in 1936 and shortly afterwards
moved to Hampstead where he became a
neighbour of Moore, Nicholson, Hepworth,
Read and Penrose. McWilliam later stated:
'My involvement with the Surrealists started
with the big Grosvenor Square exhibition in
1938 in aid of the Spanish Republic ... But it
would be true to say that I remained more
of a fellow-traveller than a zealot.' *Spanish
Head,* one of McWilliam's most important
works, dates from 1939; that year he held his
first solo exhibition, at the London Gallery,
where *Spanish Head* was prominently placed.
It offers an interesting counterpoint to Henry
Moore's *The Helmet,* 1939–40 (see pp.148–9)
which also responds to the Spanish Civil War.
 The year 1947 was an important one for
McWilliam. He visited Constantin Brancusi
in Paris and started teaching sculpture at the
Slade School of Art, London. He also received
his first commission, when Roland Penrose
asked him to make a large figure for his garden
at 36 Downshire Hill in Hampstead: *Kneeling
Woman.* Penrose's diary records that he went
to McWilliam's house in New Malden on
4 November 1947, presumably to check the
work. It was first shown at the Institute
of Contemporary Art's *Forty Years
of Modern Art* exhibition at the
Academy Hall in Oxford Street,
London in February 1948. Exhibited
outside, it caused some controversy:
the police even claimed that it was an
obstruction and tried unsuccessfully to
have it removed.

Spanish Head 1939

Hoptonwood stone, 120 × 61 × 23
The Sherwin Collection

Kneeling Woman 1947

Cast concrete, 146 × 54 × 55
Purchased 2001
GMA 4403

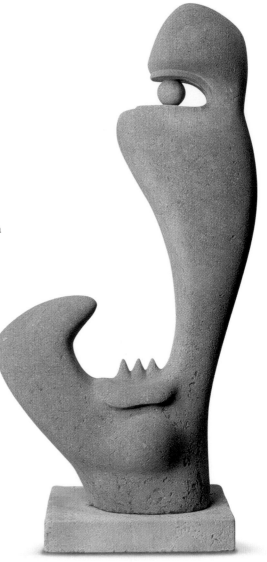

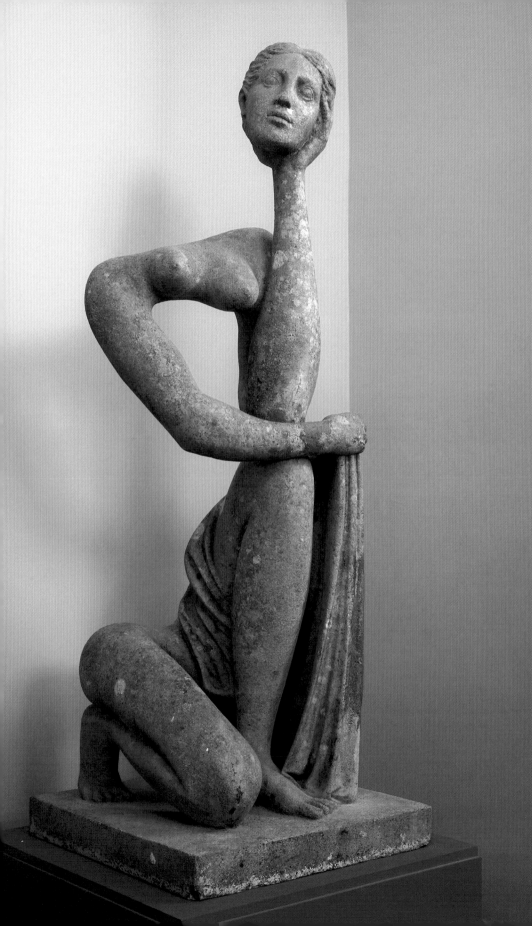

Short General Bibliography

Ades 1978
Dawn Ades, *Dada and Surrealism Reviewed*, exhibition catalogue, Hayward Gallery, London, 1978

Ades 2006
Dawn Ades (ed.), *The Dada Reader: A Critical Anthology*, London, 2006

Ades and Baker 2006
Dawn Ades and Simon Baker (eds), *Undercover Surrealism: Georges Bataille and Documents*, exhibition catalogue, Hayward Gallery, London, 2006

Agar 1988
Eileen Agar, with Andrew Lambirth, *A Look at My Life*, London, 1988

Allmer 2009
Patricia Allmer (ed.), *Angels of Anarchy: Women Artists and Surrealism*, exhibition catalogue, Manchester Art Gallery, 2009

Baron 1999
Jacques Baron, et al., *Surrealism: Two Private Eyes. The Nesuhi Ertegun and Daniel Filipacchi Collections*, exhibition catalogue, Solomon R. Guggenheim Museum, New York, 1999

Breton 1936
André Breton, *What is Surrealism?*, (trans. David Gascoyne), London, 1936

Breton 1972
André Breton, *Manifestoes of Surrealism*, (trans. Richard Seaver and Helen R. Lane), Ann Arbor, Michigan, 1972

Buck 1988
Louisa Buck, *The Surrealist Spirit in Britain*, exhibition catalogue, Whitford and Hughes, London, 1988

Caws 1991
Mary Ann Caws (ed.), *Surrealism and Women*, Cambridge, Massachusetts, 1991

Caws 2004
Mary Ann Caws, *Surrealism*, London, 2004

Chadwick 1985
Whitney Chadwick, *Women Artists and the Surrealist Movement*, London, 1985

Coleby 1998
Nicola Coleby (ed.), *A Surreal Life: Edward James 1907–1984*, exhibition catalogue, Brighton Museum and Art Gallery, 1998

Cowling 1988
Elizabeth Cowling, *The Magic Mirror: Dada and Surrealism from a Private Collection*, exhibition catalogue, Scottish National Gallery of Modern Art, Edinburgh, 1988

Cowling 1997
Elizabeth Cowling, *Surrealism and After: The Gabrielle Keiller Collection*, exhibition catalogue, Scottish National Gallery of Modern Art, Edinburgh, 1997

Cowling 2006
Elizabeth Cowling, *Visiting Picasso: The Notebooks and Letters of Roland Penrose*, London, 2006

Dickerman 2008
Leah Dickerman (ed.), *Dada: Zurich, Berlin, Hannover, Cologne, New York, Paris*, exhibition catalogue, National Gallery of Art, Washington DC; Centre Pompidou, Paris; Museum of Modern Art, New York, 2008

Gale 1997
Matthew Gale, *Dada & Surrealism*, London, 1997

Gascoyne 1978
David Gascoyne, *Paris Journal 1937–1939*, London, 1978

Gascoyne 1980
David Gascoyne, *Journal 1936–1937*, London, 1980

Gascoyne 2000
David Gascoyne, *A Short Survey of Surrealism* [1935], London, 2000

Greeley 2006
Robin Adèle Greeley, *Surrealism and the Spanish Civil War*, New Haven and London, 2006

Hartley 2001
Keith Hartley (ed.), *The Surrealist and the Photographer: Roland Penrose & Lee Miller*, exhibition catalogue, Scottish National Gallery of Modern Art, Edinburgh, 2001

Hubert 1988
Renée Riese Hubert, *Surrealism and the Book*, Berkeley, California, 1988

King 1990
James King, *The Last Modern: A Life of Herbert Read*, London, 1990

Kuenzli 2006
Rudolf Kuenzli, *Dada: Themes and Movements*, London, 2006

Levy and Pirsig-Marshall 2009
Silvano Levy and Tanja Pirsig-Marshall (eds), *British Surrealism in Context: A Collector's Eye*, exhibition catalogue, Leeds Art Gallery, 2009

Lippard 1970
Lucy Lippard (ed.), *Surrealists on Art*, Englewood Cliffs, New Jersey, 1970

Matheson 2006
Neil Matheson (ed.), *The Sources of Surrealism: Art in Context*, Aldershot, 2006

Melly 1997
George Melly, *Don't Tell Sybil: An Intimate Memoir of E.L.T. Mesens*, London, 1997

Mundy 2001
Jennifer Mundy (ed.), *Surrealism: Desire Unbound*, exhibition catalogue, Tate, London; Metropolitan Museum of Art, New York, 2001

Nadeau 1973
Maurice Nadeau, *The History of Surrealism*, Harmondsworth, 1973

Naumann 1996
Francis M. Naumann, *Making Mischief: Dada Invades New York*, exhibition catalogue, Whitney Museum of American Art, New York, 1996

Penrose 1981
Roland Penrose, *Scrap Book 1900–1981*, London, 1981

Penrose 1985
Antony Penrose, *The Lives of Lee Miller*, London, 1985

Penrose 2001
Antony Penrose, *Roland Penrose: The Friendly Surrealist*, London, 2001

Ray 1971
Paul C. Ray, *The Surrealist Movement in England*, Ithaca and London, 1971

Read 1936
Herbert Read (ed.), *Surrealism*, London, 1936

Read and Thistlewood 1993
Benedict Read and David Thistlewood (eds), *Herbert Read: A British Vision of World Art*, exhibition catalogue, Leeds Art Gallery, 1993

Remy 1985
Michel Remy (ed.), *A Salute to British Surrealism 1930–1950*, exhibition catalogue, The Minories, Colchester; Blond Fine Art, London; Ferens Art Gallery, Hull, 1985

Remy 1999
Michel Remy, *Surrealism in Britain*, Aldershot, 1999

Renzio 1986
Toni del Renzio, et al., *Surrealism in England: 1936 and After*, exhibition catalogue, Herbert Read Gallery, Canterbury, 1986

Richter 1978
Hans Richter, *Dada: Art and Anti-Art*, Oxford, 1978

Robertson 1986
Alexander Robertson, et al., *Surrealism in Britain in the Thirties: Angels of Anarchy and Machines for Making Clouds*, exhibition catalogue, Leeds Art Gallery, 1986

Sanouillet 2009
Michel Sanouillet, *Dada in Paris*, Cambridge, Massachusetts, 2009

Sidey 2000
Tessa Sidey (ed.), *Surrealism in Birmingham 1935–1954*, exhibition catalogue, Birmingham Museum and Art Gallery, 2000

Stich 1990
Sidra Stich (ed.), *Anxious Visions: Surrealist Art*, exhibition catalogue, University Art Museum, University of California, Berkeley, 1990

Trevelyan 1957
Julian Trevelyan, *Indigo Days*, London, 1957

Umland and Sudhalter 2008
Anne Umland and Adrian Sudhalter (eds), *Dada in the Collection of the Museum of Modern Art*, exhibition catalogue, Museum of Modern Art, New York, 2008

Wood 2007
Ghislaine Wood (ed.), *Surreal Things: Surrealism and Design*, exhibition catalogue, Victoria and Albert Museum, London, 2007

Scottish National Gallery of Modern Art Archive & Library

The Scottish National Gallery of Modern Art Archive & Library has extensive Dada and Surrealism holdings including:

Roland Penrose GMA A35

Gabrielle Keiller GMA A42

David Gascoyne GMA A51

E.L.T. Mesens GMA A55

René Magritte / William and Norma Copley
GMA A61

Grace Pailthorpe / Reuben Mednikoff
GMA A62

Denise Bellon GMA A63

Georges Hugnet GMA A66

Conroy Maddox GMA AL/06

Copyright and Photographic Credits

Index of Artists